The Psy
Artists an

The Psychology of Artists and the Arts

EDWARD W. L. SMITH

McFarland & Company, Inc., Publishers
Jefferson, North Carolina, and London

Acknowledgment: Thank you to the Otto Rank Estate for permission to quote from *Art and Artist: Creative Urge and Personality Development* by Otto Rank, originally published in 1932 by Tudor Publishing Company of New York. Permission granted by Ruhama Veltfort (Otto Rank Estate) and Barbara W. Stuhlmann, author's representative. All rights reserved.

LIBRARY OF CONGRESS CATALOGUING-IN-PUBLICATION DATA

Smith, Edward W.L., 1942–
　　The psychology of artists and the arts / Edward W.L. Smith.
　　　　p.　　cm.
　　Includes bibliographical references and index.

ISBN 978-0-7864-6813-3
softcover : acid free paper ∞

　　1. Art—Psychology.　2. Artists—Psychology.　I. Title.
N71.S62　2012
701'.15—dc23

2012008415

BRITISH LIBRARY CATALOGUING DATA ARE AVAILABLE

On the cover: *top left* Salvador Dalí (Library of Congress); *bottom* Sigmund Freud (Freud Museum, London); *background* © 2012 Shutterstock

Manufactured in the United States of America

McFarland & Company, Inc., Publishers
　Box 611, Jefferson, North Carolina 28640
　　www.mcfarlandpub.com

Dedicated to the memory of my late wife Lynda,
and to the future yet to unfold.

Table of Contents

But I consort with long-haired things
In velvet collar-rolls,
Who talk about the Aims of Art,
And "theories" and "goals,"
And moo and coo with women-folk
About their blessed souls.

— Rudyard Kipling (*Abaft the Funnel*, "In Partibus")

Preface

The present volume is the first nearly comprehensive work covering the psychodynamic theories of the arts and of artistic creativity. All of the major psychodynamic writers and many of the minor ones who have addressed the arts are included. In addition, the many forms of art are covered — painting and sculpture, music and dance, poetry and prose — to the extent that these several theorists addressed each of these forms.

In most cases, the theorists did not dedicate a book to their explorations, but discussed the arts or the act of artistic creation in scattered chapters and articles in professional books and journals. Such scattered and archival material is often not easily discovered or conveniently gotten. This is especially true for some of the minor theorists who do not enjoy a high level of name recognition. Therefore, I thought it worthwhile to pull this material together into a single volume, easily available to any interested reader. In this manner, I have set the relevant work of recognized theorists side-by-side with that of those whose names may be new.

Although many of the psychodynamic theorists included wrote in styles that offer easy understanding, some expressed themselves in less accessible ways. Therefore, and in all cases, the task that I set for myself was to explicate the theories in a fashion that would be readable and comprehendible for any educated person. This is not a work aimed at professional psychologists and their brethren alone.

With very minor exceptions, I did not approach application of the theories to the lives or the works of particular artists. So great is the corpus of theory that I have explored that to do the former would surely require multiple volumes. There is an existing literature constituted of such works in which one specific theory — most often that of Freud — has been applied to a particular artist and his or her oeuvre. These books are easily enough found.

My hope is that, supplied with these theories, the reader will find that his or her appreciation of all of the arts is enhanced. Having these theories at his or her disposal, the reader will hopefully have a far richer vocabulary for describing his or her experience of art, and a significant number of psychodynamic concepts that open up a deeper understanding of the artist's creativity. In teaching the course "The Psychology of Art" to undergraduate and graduate students alike, and receiving course feedback from them, I found that was the case for most. I must warn, however, that the theories are complex and their understanding is not easily gained. I firmly believe, however, that the effort of learning them will be well rewarded.

Introduction

Returning from a garage sale, my wife handed me a paperback, the edges of its pages yellowed, and with a decidedly musty smell. Pulled literally from someone's garage (not likely a basement, insofar as those are rare in coastal Georgia), the stained cover revealed the title *The Philosophy of Art History*. Arnold Hauser published this book in 1958 in Germany, and in that same year in the United States, with these more than 400 pages priced at $2.25. This potential treasure for any bibliophile sat for several months in my queue of books to read.

On a slow and sultry summer afternoon, I sat down in Savannah's Colonial Park Cemetery, in the shade of a live oak. Surrounded by cracked and crumbling crypts, and gently swaying strands of Spanish moss, I opened the book. I began reading "The Psychological Approach: Psychoanalysis and Art." With this, a new world opened to me.

Wanting to generate renewed passion for my university teaching, I requested and was granted the opportunity to offer a dual-numbered (undergraduate and graduate credit) Special Topics course. I titled it The Psychology of Art and Artists. In the months prior to offering the course, as I was reading widely in the literature and crafting a course syllabus, not surprisingly I found there was no such thing as a textbook in this area. Therefore I collated a course packet and submitted it to the university print shop for copyright permissions, printing, and spiral binding. In order to make it look less sterile, and perhaps a bit *artsy*, I placed the face of Salvador Dali on the cover, with a face of Freud looking toward him with a rather quizzical expression. The material consisted of selected book chapters, or parts thereof, and articles from professional psychology journals that dealt with the psychology of artists or of artistic creativity. It is rare for undergraduate students to read primary sources, and sometimes even

3

graduate students spend precious little time doing so, for professors typically rely on textbooks or even trade books that are secondary sources; that is, authors writing about the work of others. Valuing exposure to primary sources, I therefore selected some material by several of the luminaries in the area of the psychology of art and artists, including Freud, Jung, and Rank. In addition to the reading of this course packet, two books were required reading: *The Demon and the Angel* by Edward Hirsch (2002) and *The Courage to Create* by Rollo May (1975).

The class format was one of lecture and discussion. In addition, dispersed throughout the semester, I invited half a dozen or so artists to present their work and be interviewed by the class and me concerning their understanding of their creativity. All were professors at Georgia Southern University; among them were a recent Georgia Poet of the Year, a recent contributor of multimedia photographs to the *New Yorker*, a published husband-and-wife team of mystery writers, an award-winning science fiction author, an award-winning painter, a multi-media artist, an award-winning composer of opera and classical music, and an amateur (dual-career) composer of classical music and rock-and-roll.

Having been sated with the ubiquitous term paper, I eschewed reading yet another batch in this, the course that was to help me mine my passion. I designed, therefore, a project at once unique and nonce. I wanted to offer students an experience that would bring to life the psychological material that they were studying, and at the same time involve them in the creation of their own art piece. To affect this, I selected ten Rorschach-like inkblot plates from two out-of-print and now obscure inkblot tests. (Although this is a gray area ethically, because of ethical considerations I did not want to expose the students to the actual Rorschach plates.) I presented the plates in a group administration using the opaque projection capabilities of a *smart* classroom. The instructions were as follows:

> I am going to show you a series of inkblots. For each one, as I show it to you, I invite you to write down on a piece of paper whatever the inkblot looks like to you, what it reminds you of, or what it might symbolize. You may have more than one association to some or all of the inkblots. When you feel finished with each one, please lay your pen or pencil on your desk to signal me that you are ready for the next image. Please do not talk while we are doing this, as any comments that anyone makes could affect the associations of others to the inkblots.

I then presented the ten inkblots, one by one, calling out each respective number and leaving each image on the screen until all students had placed their pens or pencils on their desks. Continuing, I said,

I suggest that in the next day or two you look over your associations in private and select the one that is most appealing, most intriguing, most frightening, somehow most interesting to you. Your project is to take that image that you have selected and to create art with it. You may choose to paint it, draw it, sculpt it, make a piece of jewelry with it, dance it and make a videotape of your dance, write a poem about it, write a short story about it, draw it, express it in a musical composition, whatever. I do suggest that if you are currently creating art in any medium that you choose some other medium for your project. Allow yourself to engage with some medium with which you are not highly practiced. After you have created your art, write a short paper, three or four pages perhaps, describing the image that you chose, how you chose your artistic medium, and what the process was like for you. Discuss what you learned about yourself and about your artistic creativity. Remember, use your association to the inkblot to work from, not the inkblot itself.

Near the end of the semester we devoted time for students to show their artistic products and discuss their creative processes, if they so wished. We saw sculptures in metal and in *papier-mâché*; paintings in oil, acrylic, and watercolors; drawings in ink, in pencil, in charcoal; an illustrated children's book; collages; and a diorama; we heard short stories; poems; and watched a music video. I had emphasized that grading would not be based on the demonstration of artistic *skill*, but rather on evidence that the student had allowed unconscious material to come forward and had engaged that material through artistic exploration. Student responses at the end of the semester were almost unanimous in enthusiasm and in amazement at the wealth of unconscious material into which they had tapped. As we discussed the artwork of those students who opted to present, the theoretical material from the course came to life. Access to unconscious material and manifestation of such material through various art media became real experiences for most of the students. The anonymous, university mandated course evaluations attested to a high level of student involvement in the project and to the personally meaningful growth and learning that attended it.

I taught this Special Topics course two times, one year apart, and found my passion, as I had hoped. Studying the literature on the psychology of art and artists, interpreting that literature in my lectures, and

interviewing the several artists who were guests in my classroom evoked an excitement in me that seemed to imbue my entire life.

As I continued studying the literature, I envisioned, in inchoate form, a book that would explore some of the most insightful psychological theories of art, artists, and artistic creativity. Some of the literature I personally found sterile and dry. It seemed irrelevant to my experience of art, too specific to allow any trustworthy generalization or extrapolation, or to be pedantic and petty. This I would cull. I would select the writing that I, myself, found most exciting and sagacious and present it as I understood it. I would present my interpretation of those theories that lent me a sense of greater understanding as I encountered a work of art or the person of an artist.

In assessing the theories of artists and artistic creativity that I studied, I found that those which informed me and intrigued me the most were representative of the broadly *psychodynamic* orientation and that of *Gestalt therapy*. The former included not only *psychoanalysis* as articulated by Freud and his followers, but the work of Jung, Kris, Rank, Reich, and their respective colleagues and followers. It is these psychodynamic schools, known collectively also as *depth psychology*, that seek to understand unconscious motivation and the interaction of the various aspects or structures of the psyche (thus, *psycho-dynamics*). The orienting goal of psychodynamic psychology-cum-depth psychology is, then, *insight*. With alternative wording, one might say that psychodynamic theory, including psychoanalysis, aims at an understanding of the deep or unconscious urges and their inevitable conflicts that underlie the surface behavior that we may observe. *Unconscious processes* and *psychic determinism* thus constitute the core beliefs of these schools, although each school presents its own inflection of these assumptions.

Gestalt therapy is certainly less well known than the psychodynamic orientation, and particularly psychoanalysis. Itself a rather eclectic position, Gestalt therapy is an integration of aspects of psychoanalysis, including considerable disagreement and revision of the classical Freudian position, Gestalt psychology, Reichian Character Analysis, existential philosophy and a bit of Taoist or Zen philosophy (Smith, 1997). The Gestalt psychology element provided a solid background of research in perception, leading to laws of perception. Thus, Gestalt therapy attends heavily to individual *perspective*.

My plan thus evolved for a book perhaps titled *Arts and Artists:*

Psychodynamic Insights and Gestalt Perspectives. Pleased with this title, at once clever and surprisingly revelatory, I proceeded. Fate intervened, however, in the form of an invitation from the editor and the publisher of the *International Gestalt Journal* to guest-edit an issue as a work for hire. I was offered free rein as to my thematic focus. Given my level of excitement with theory of art and artists, I chose to produce an issue of the journal focused on that, selecting the title *Art, Artists, and the Gestalt Approach* (Smith, 2007). Along with twelve contributions that I edited, I included an introductory article that explored that theory which would have constituted the second section of my proposed book. Based on the limited amount of that material compared to the amount of psychodynamic material concerning art and artists, and the fact that I had already published my presentation and interpretation of the Gestalt theory, I decided to dedicate the present volume exclusively to the psychodynamic approaches.

Some would argue that art should only be experienced, not thought about, interpreted, or analyzed. Aside from my penchant as a psychologist to think about, interpret, and analyze my world, I find that experiencing art through the several theoretical templates that I have learned enhances that experience. I can respond emotionally to a piece of art, setting aside all theories (at least consciously). But, I can then go beyond this affective experience by adding a cognitive dimension, trying on several theories arbitrarily. I feel exhilarated when I find a theory that suggests to me a dimension of understanding, which brings together my feelings for a piece of art and my cognitive grasp of it. It is such theories that I want to present, interpret, and critique.

Prior to the presentation and examination of specific theories that pertain to the arts and to artists, it would be good to look into the nature of theory itself. Clarity about the nature of theory and the meaning of interpretation can only enhance the understanding and appreciation of particular theories. Knowing what theory itself offers and what its limitations are can contribute to a fuller and richer use of theory, as well as the avoidance of inappropriate expectations and consequent disillusionment with it. Let us turn, then, to a brief discussion of *meta*-theory, or theory of theory.

An early spokesperson for theory in psychology was Edwin R. Guthrie. In a 1946 article, "Psychological Facts and Psychological Theory," he wrote:

It is theories that endure, not facts. Events are ephemeral and their descriptions also may be ephemeral. It is theory that lasts for years or for generations. It is theory rather than fact that leads to new controls over nature and events [Wolman, 1960, p. 98].

Having stated the above, Guthrie has clearly placed theory in a position of honor. Interestingly, Guthrie was appreciative not only of their pragmatic contribution, but of their durability. Theories have a lasting quality.

Theories are analogous to languages. Each language offers a particular *vocabulary* for labeling observed or imagined phenomena, and a particular *grammar* or *syntax* for organizing that vocabulary into juxtaposed categories-cum-concepts that aspire to the understanding of the phenomena in question. Likewise, each theory is constituted of a vocabulary peculiar to it, and a syntax that allows the manipulation of that patois into a structure of explanation-cum-understanding. Theories, like languages may, however, borrow vocabulary and concepts from other theories, appearing thereafter as hybrids. In this manner, languages and theories evolve. Consider, for instance, the abundance of French words and phrases adopted by English, from *avoirdupois* to *verdant*. In addition to such Gallicisms that have penetrated English, consider words and phrases that are tacked on to the surface without any pretense of Anglicization, such as *film noir, haute cuisine, de rigueur*, and *gauche*. Theories, too, are sometimes hybridized. For example, as echoes of its roots in psychoanalysis, Gestalt therapy is replete with psychoanalytic terms: *ego, repression, introjection, projection*, and so forth.

Languages and theories evolve, too, as over time new phenomena are encountered that require new terminology and acknowledgement of new relationships. A very obvious example in modern languages is the creation of vocabulary and concepts to accommodate high-tech developments. Thus entered *compact disc* and *multitasking* into our language, and a host of acronyms, such as *CD-ROM* and *RAM*. Likewise in psychology, the not-too-distant past saw the emergence of *here-and-now experience*, and the *awareness continuum*, of *PTSD*, and *EMDR*.

Which language we choose to employ is ultimately arbitrary. Assuming that I know the languages in question, I may choose to label this phenomenon beside me as a *chair*, or as a *chaise* (French), *silla* (Spanish), *sedia* (Italian), *stol* (Danish, Norwegian, Swedish), *stóll* (Icelandic), or *Stuhl* (German). What it is, is a phenomenon to which I can point, giving it ostensive definition, or I can call it by any of its many arbitrary but agreed

upon sounds. What a foolish argument it would be to debate whether it is really a *chair* or a *stol*. Yet, theoretical arguments based on this misunderstanding can be found in the literature. The point is that the language chosen or the theory chosen from the array of those known is ultimately arbitrary.

From the above, we can come to a definition of a theory: *A theory is an optional, coherent system of vocabulary and concepts that can be used to describe and understand some phenomenon in the realm of that theory.*

The tasks of a theory, then, are to describe phenomena with its vocabulary and lend understanding of those phenomena through its conceptual framework. We may judge the adequacy of a theory in terms of both of these tasks: *Does the theory offer a rich and precise vocabulary for its descriptive task? Does the theory allow us to make predictions (or post-dictions)?* Surely predictive utility is the most stringent measure of understanding.

Each theoretical system offers a special advantage in certain areas of application. The specialized vocabulary and particular concepts of each theory system provide the user with cognitive tools which have a *major focus of application* and a *range of application*. As that system is used in areas farther from the major area of application, it is of decreasing value. As an example, much of Freud's theory of art addresses the poet, in particular. In contrast, Lowen's theory attends to music and dance in some detail. Therefore, we might do well to turn to Freud to seek understanding of the poet and to Lowen for enhanced understanding of music and dance, for these are the respective major foci of application of these two theorists. However, each theory may have something of value that would apply to the other focus, as well. That is, music may be within the range of application of Freud's theory, even though not his major focus, and the poet within the ambit of Lowen's.

A theory can be regarded as a lens through which reality is viewed, or a template that is placed on reality. As a lens, a theory brings certain aspects of a phenomenon more clearly into focus. If tinted or polarized, that lens filters out aspects of a phenomenon which may obscure, thereby selectively allowing certain other aspects to be seen more vividly. As a template, a theory organizes the phenomenon in question so as to lend a potentially meaningful structure. It should be obvious that in both the case of a filtering lens and the template, a process of data reduction takes place. That is to say, certain aspects of the viewed phenomenon are deleted. Deleted are those aspects that are deemed of less importance or that obscure

a clear view of the aspects deemed most important by the viewing device. Thus, a theory is not reality, itself, but a particular view of reality, chosen because of some advantage that accrues with that view. The question of whether a theory is true or not, therefore fades before the more astute question of whether a theory is useful in a particular case. Again, does that theory offer a rich and precise vocabulary? And, does that theory offer understanding, as ultimately measured by predictive or post-dictive hypotheses?

This present meta-theoretical discussion would remain incomplete if we did not make explicit what is inherent and implied by it, and termed *interpretation*. Following the lead of Leon Levy (1963) in his now classic work *Psychological Interpretation*, we can take interpretation to mean a defining or structuring of a phenomenon through the presentation of a theoretical framework. "The first aspect of psychological interpretation is that of a translation ... into the terms of our theory or frame of reference" (p. 24). The second aspect involves the application of theoretical concepts to generate our hypotheses about the art or artistic process in question. In other words, we interpret when we describe a phenomenon using the vocabulary of some theory, or explain it or make predictions (or post-dictions) about it by applying the concepts of that theory. We may make multiple interpretations by bringing to bear the vocabulary and concepts from different theoretical frames of reference. In terms specific to the present book, interpretation of a work of art, of the creative process of art, or of a specific artist who produces the work, consists of the application of the vocabulary and concepts of selected theories to that art, creative process, or artist. In each case, we can choose arbitrarily which theory or theories suit us as to their utility, and perhaps the interest that they arouse. And, as earlier stated, the degree of understanding may be judged by the extent to which that understanding allows for prediction (or post-diction).

In applying a theory to the description and understanding of a work of art, an act of artistic creativity, or an artist, I find the concept of *depth of interpretation* to be both useful and intriguing. Being instructed, again, by Levy (1963), we may define depth as the degree of inference involved. Thus, there may be *surface* or observable interpretations, and *subsurface* or inferable interpretations. The greater the number of inferences involved, the deeper the interpretation. (It should be noted that Levy's discussion of depth of interpretation centered on interpretations made by the psychotherapist concerning the dynamics of the person in psychotherapy. I

am extrapolating, herein, to our exploration of describing and understanding arts and artists.) Having in place this notion of depth of interpretation, I suggest two important corollaries. When interpreting, that is, applying a given theoretical framework in order to generate hypotheses concerning the art or artist, the deeper the interpretation, the less certainty one may have about that interpretive hypothesis. Otherwise stated, *the more inferential steps that one takes in generating an interpretive hypothesis, the less certainty one has of that hypothesis.* The second, and closely related corollary, is *the deeper or more inferential the hypothesis, the more evidence required to confirm the hypothesis.*

And now, having an understanding of the nature of theory, we are in a more informed position to explore specific theories. Insofar as psychoanalytic theorists have dedicated an impressive amount of attention to art and artists, it is crucial that psychoanalytic theory be given a preeminent place in our present examination. So, it is here that I shall begin my overview of theories.

All art is at once surface and symbol.
Those who go beneath the surface do so at their peril.
Those who read the symbol do so at their peril.
It is the spectator, and not life, that art really mirrors.

...

We can forgive a man for making a useful thing
as long as he does not admire it.
The only excuse for making a useless thing
is that one admires it intensely.
All art is quite useless.

— Oscar Wilde (Preface to *The Picture of Dorian Gray*)

CHAPTER 1

Neurosis and Art —
Sigmund Freud,
Otto Fenichel, and Alfred Adler

Interestingly, Freud (1963b) stated in a 1914 paper that he was "no connoisseur in art, but simply a layman ... unable rightly to appreciate many of the methods used and the effects obtained in art" (p. 80). However, he continued, "nevertheless, works of art do exercise a powerful effect on me, especially those of literature and sculpture, less often of painting" (p. 80). Freud explained that he was particularly interested in understanding to what such effect was due. "Wherever I cannot do this, as for instance with music, I am almost incapable of obtaining any pleasure" (pp. 80–81). Clearly, even though he admitted to being affected especially by literature and sculpture, Freud located his pleasure in the intellectual task of understanding the reason for the effect. Given this position, it is more understandable that he could view the artist, if not art, as belonging to the realm of psychopathology.

Still, in his psychological encyclopedism, Freud did not neglect giving thoughtful and erudite attention to the arts. In 1914, he published an anonymous work of art criticism, "The Moses of Michelangelo" (Freud, 1963b). His fidelity to his psychoanalytic methods even in a work of art criticism was recognized by the editors of *Imago*, where this piece was published. Their comments may be of interest.

> Although this paper does not, strictly speaking, conform to the conditions under which contributions are accepted for publication of this Journal, the editors have decided to print it, since the author, who is personally known to them, belongs to psychoanalytical circles, and since his mode of thought has in point of fact a certain resemblance to the methodology of psychoanalysis [Freud, 1963b, p. 80].

15

This "resemblance to the methodology of psychoanalysis" has perhaps been explained by Ludwig Binswanger (Ellenberger, 1970), in his statement that "the method used by Freud in this study belongs to the psychology of expression, which is also one of the first stages in psychoanalytic methodology" (p. 530). Having first critiqued the interpretations that had been offered by several art critiques, Freud analyzed the sculpture in great detail, interpreting the expressive meaning of Moses' posture, with particular attention to the positioning and presentation of certain body parts.

Somewhat earlier, in an 81-page 1907 monograph, Freud wrote a literary criticism of *Gradiva*, a short 1903 novel by Wilhelm Jensen. Herein, Freud demonstrated the application of psychoanalytic interpretation to the delusions and dreams of a fictional character. Freud did not, however, extend his psychoanalysis to the author of that work (Ellenberger, 1970).

Nevertheless, Freud did not always shy from the analysis of the artist. In his most famous example, his analysis was based on one of the artist's childhood memories. Earlier, the idea of exploring writers' thoughts through consideration of their heredity, constitution, and life history was expressed through a series of monographs by Moebius, which he called "pathographies" (Ellenberger, 1970). (Note that by the term that Moebius coined, he embraced a bias of sickness towards the authors about whom he wrote.) Following these examples, Freud's disciples began writing similar monographs, but based, of course, on psychoanalytic interpretations. Freud continued this line of analysis with his exemplary and classical 1910 essay, "A Childhood Memory of Leonardo da Vinci." Freud's essay "has been generally admired for its beautiful style and its indefinable charm" (p. 531).

In a 1923 essay in *Imago*, Freud was willing to base his analysis of an artist in part on the artwork, itself. Utilizing both his paintings and fragments of his diary, Freud analyzed Christoph Haizmann, a seventeenth-century artist (Ellenberger, 1970).

Perhaps Freud did even find pleasure in "The Temptation of Saint Anthony," for he interpreted this painting by Félicien Rops as a metaphor for "the typical case of repression" (Gibson, 2006, p. 98). This interpretation suggests that Freud was moved by this work, and at the same time demonstrates his view of the nexus of art and psychopathology. Rops' painting of 1878 was provocative in the piety of nineteenth-century Belgium. It shows a naked woman taking the place of Christ on the cross, both Satan and Christ behind her, and a pig looking on as skeletal cherubs

hover above. Saint Anthony, long beard flying, appears to be grabbing his ears. Above the woman reads a simple note — EROS.

Freud (1949a) seemed both to applaud the considerable efforts put forth by Marie Bonaparte in her tome, *The Life and Works of Edgar Allan Poe: A Psycho-Analytic Interpretation*, and to find within her work further example of the kinship between artistic creativity and psychopathology. In the forward to the work by his "friend and pupil" he wrote:

> Thanks to her interpretative effort, we now realise how many of the charac-
> teristics of Poe's works were conditioned by his personality, and can see how
> that personality derived from intense emotional fixations and painful infan-
> tile experiences. Investigations such as this do not claim to explain creative
> genius, but they do reveal the factors which awaken it and the sort of subject
> matter it is destined to choose. Few tasks are as appealing as enquiry into
> the laws that govern the psyche of exceptionally endowed individuals [p. xi].

In *Totem and Taboo*, Freud (1950) noted what he perceived as "striking and far-reaching points of agreement" between neuroses on the one hand, and art, philosophy, and religion on the other. Neuroses are, in a sense, a distortion of these social institutions. Being more specific, he suggested that "hysteria is a caricature of a work of art" (p. 73).

Nowhere was Freud's (1966) pathologizing of the artist more apparent than in the following bald statement from Part Three of *Introductory Lectures on Psychoanalysis*, titled "General Theory of the Neuroses." "An artist is once more in rudiments an introvert, not far removed from neurosis" (p. 376). Following that declaration is a very long and dense paragraph in which an intricate model is offered to explain the artist. Allow me to unpack said paragraph, step by step.

The artist wants to win power, wealth, fame, and the love of women, as do non-artists, according to Freud (1966), but the artist lacks the means to do so. Therefore, he turns to fantasy. (Note that Freud's use of the mas-culine pronoun is not just a writing convention of his time, but a usage consistent with the content of the sentence, demonstrating that Freud was writing only of male artists.) It is this turning to fantasy that qualifies the artist to introversion and a path that "might lead to neurosis" (p. 376). The normal man, having adequate means, would seek the extroverted, real-ity solution to the quest for power, wealth, fame, and the love of women. The artist is further set apart, in Freud's view, by being "oppressed by excessively powerful instinctual needs," while having "a certain degree of laxity in the repressions" (p. 376). Concomitant with powerful instinctual

needs and weak repression, the artist possesses a capacity for *sublimation*. The "true artist" (p. 376), in order to be successful, must develop, in addition, a critical level of technical skill. It is through this skill that the artist can remove the aspects of his fantasy that would be too personal, make the product enjoyable to others, and tone down the connection of the art to proscribed instinctual sources. Finally, the true artist must possess "the mysterious power of shaping some particular material until it has become a faithful image of his fantasy" (p. 376).

Sublimation is the very key to the problem of artistic creativity. Without a thorough appreciation of the marrowy role that it plays, Freud's theory tends to pale. Therefore, in the interest of demonstrating the robustness of Freud's theory, I want to expatiate at this point.

Freud could never lay legitimate claim to having introduced the term or the concept of sublimation to the world, for they were already well known (Ellenberger, 1970). "They were mentioned as a current idea in a novel published in 1785, and later used by Novalis, Schopenhauer, and particularly by Nietzsche" (p. 505). Freud did, however, contextualize sublimation within his complex and coherent theory, that of psychoanalysis. In his 1915 essay "Instincts and Their Vicissitudes," he clearly indicated the important position that sublimation assumed in his theory (Freud, 1963a).

> Our inquiry into the various vicissitudes which instincts undergo in the process of development and in the course of life must be confined to the sexual instincts, for these are the more familiar to us. Observation shows us that an instinct may undergo the following vicissitudes:
> Reversal into its opposite,
> Turning round upon the subject,
> Repression,
> Sublimation [p. 91].

Of the four vicissitudes, for our purposes we need be concerned only with the fourth, sublimation.

Richard Sterba (1982) recounted that in a meeting in 1931 Freud related how he had "developed the concept of sublimation" (p. 118). According to Sterba, Freud had read in Heine's "Harzreise" about a young man who, out of juvenile

> sadistic mischief, cut the tail off of every dog he could get hold of, to the great indignation of the population in the Harz Mountains. This same person later became a surgeon, the famous Johann Friedrich Dieffenbach [p. 118].

Quoting Freud, Sterba continued:

> There someone does the same thing during his whole lifetime, first out of sadistic mischief and later to the benefit of mankind. I thought one could appropriately call this change of significance of an action "sublimation." The concept of sublimation was immediately accepted, even by the enemies of psychoanalysis. People say: "This Freud is an abominable person; however, he has one rope with the help of which he can pull himself out of the sewer in which he dwells, and that is the concept of sublimation" [pp. 118–119].

Notice that although Freud (1963a) limited his 1915 discussion of the vicissitudes which instincts may undergo to the "sexual instincts," all of the following definitions include aggressive instincts as susceptible to sublimation, as well.

A current definition of sublimation is offered by the American Psychological Association, in part as follows (VandenBos, 2007):

> In psychoanalytic theory, a DEFENSE MECHANISM in which unacceptable sexual or aggressive drives are unconsciously channeled into socially acceptable modes of expression. Thus, the drives and energies are redirected into new, learned behaviors, which indirectly provide some satisfaction for the original instincts [p. 904].

The above definition, including several examples that I have deleted in the interest of space, closely mirrors the earlier definition found in the *Longman Dictionary of Psychology and Psychiatry* (Goldenson, 1984). In fact, the APA definition is almost verbatim, with two notable omissions. First, the historically earlier dictionary indicated that "a guilt-laden heterosexual drive may be transformed into romantic poetry or other artistic creation" (p. 720). Secondly, the Longman version states that "the outlets may not only protect us from the anxiety which the original drive would produce, but also bring us new satisfactions, such as recognition from other people" (p. 720). Without getting too detailed by plumbing the depth of Freud's theory, this Longman definition nicely connects the concept of sublimation with the motivation of the artist.

Not surprisingly, a more detailed, if not recondite definition, is to be found in *A Critical Dictionary of Psychoanalysis* (Rycroft, 1968). Using ellipses to indicate further references in the same volume, it reads in part:

> Developmental process ... by which instinctual ENERGIES ... are discharged ... in non-instinctual forms of behaviour. The process involves (a) displacement of energy from activities and objects of primary (biological) interest on to those of lesser instinctual interest; (b) transformation of the quality of the

EMOTION accompanying the activity such that it becomes "desexualized" and "deaggressified" ... ; (c) liberation of the activity from the dictates of instinctual TENSION. Some definitions include a social element, viz. that true sublimations are socially acceptable [p. 159].

The definition continues in a second paragraph, indicating that "all sublimations depend on SYMBOLIZATION and all EGO-DEVELOPMENT depends on sublimation" (p. 159). For our purposes, it is this relationship between symbolization and sublimation that is more important to keep in mind. The idea is that in the act of sublimation, something comes to stand in for the literal expression of the instinctual drive. The symbol is that something, that succedaneum, if you will, that takes the place of direct instinct-driven action. Thus, a paradox is revealed. On the one hand, the substituted action is ersatz, for it is only a symbol of the action that would be the direct expression of the instinct. This symbolic action allows only for indirect and partial processing of that instinctual energy. But, before simply assigning it inferior status, the symbolic action must be recognized as having social value, as well as whatever value may derive from the gained freedom from unmediated instinct-driven action. The word *sublimation* is, of course, related to *sublime*, or a high or lofty state. Thus, *sublim*ation is at once ersatz and noble. As an ersatz phenomenon, it manifests a shadow side in the form of partially frustrated instinctual drives, with the possible result of neurosis; as a lofty state, it allows for, even drives individual per-sonality growth and societal development, not to mention art.

In a 1908 paper titled "The Relation of the Poet to Day-Dreaming," Freud (1963c) indicated that the writer, like the child at play, creates a world of fantasy that the writer takes very seriously. Suggesting that it is very difficult for human beings to give up any pleasure once tasted, Freud stated that when the child grows up and gives up play, he or she substitutes fantasy, creating what are called daydreams. "Day-dreaming is a continu-ation of play" (p. 36). But, whereas the child typically does not hide his or her play from adults, the adult is usually ashamed of his or her daydreams and conceals them from other people. Daydreams may be cherished as most intimate possessions. Freud offered the following explanation for this difference between the open play of children and the concealment of adult fantasy. The play of children is determined by the *wish* to be grown-up; children play being grown-up, imitating the lives of adults as they perceive such lives. Therefore, there is no need to conceal this wish. For the adult the situation is quite different. First of all, he or she is expected not to play

as a child, or even daydream, but to be making a mark in the real world. Second, and of even greater import in terms of psychodynamics, some of the *wishes* that drive the daydreams of adults are forbidden, and therefore need to be hidden.

In a tone at once extreme and absolute, Freud (1963c) stated that "happy people never make phantasies, only unsatisfied ones. Unsatisfied wishes are the driving power behind phantasies; every separate phantasy contains the fulfillment of a wish, and improves on unsatisfactory reality" (p. 37). The unsatisfied wishes arrange themselves in two categories, ambitious wishes and erotic wishes. These derive, respectively, from the aggressive and sexual instincts. In a statement that may reflect the socio-cultural context in which Freud lived, as well as the bias of his sample of analysands, he wrote that erotic wishes dominated the fantasies of young women, whereas in young men "egoistic and ambitious wishes assert themselves plainly enough alongside their erotic desires" (p. 37). Freud did add that he did not want to make too much of this trend, for the two categories of wishes, we may say sexual and aggressive, are often united. He added, too, that nocturnal dreams are driven by wish fulfillment in the same way as are daydreams.

Before daring "to compare an imaginative writer with 'one who dreams in broad daylight,' and his creations with day-dreams," Freud (1963c, p. 39) introduced a vital point of refinement to his theory. We must, he insisted, distinguish between poets who use ready-made material such as that of myths, legends, and fairytales, and poets who create their material spontaneously. Considering the latter, those who create their material spontaneously, and focusing on the majority of popular writers, Freud found one very marked characteristic — "they all have a hero who is the centre of interest" (p. 40). It is "His Majesty the Ego, the hero of all day-dreams and all novels" (p. 40). These egocentric stories are characterized, wrote Freud, by invulnerability of the hero, the division of other people into the good ones who help the hero and the bad ones who thwart the hero, and by women who invariably fall in love with the hero. There are variations on this pattern, such as the splitting of the ego into component egos, or the ego as observer or spectator, Freud readily acknowledged. These are, though, only variations on the general pattern.

Freud (1963c) offered the following formula for the spontaneous type of creative writing. *An actual experience that makes a strong impression on the writer stirs up a memory of an earlier experience belonging to childhood, which then arouses a wish that is fulfilled in the written work.* An analysis

of the written work should, then, reveal elements of both the recent event and the old memory.

Turning to the other type of creative writing, in which ready-made material is refashioned, Freud (1963c) saw, nevertheless, ample opportunity for the expression of the author's psyche. Such writers still express themselves in their choice of material as well as in the alterations they make in that material. The selection of a particular myth, legend, or fairytale may be born of the writer's experiencing a resonance between that material and the memory of a childhood experience, in which case this type of creative writing can readily be fit into the above formula. Freud was not explicit about this, but focused rather on the myth, legend, and fairytale as representing a "racial treasure-house," of "distorted vestiges of the wish-phantasies of whole nations" (p. 42). (Let us await the exploration of the work of Carl Jung for elaboration of this view.)

The final and rather important topic that Freud (1963c) explored in his 1908 essay was the *ars poetica*. Reminding the reader that daydreamers hide their fantasies because of the shameful wishes expressed in them, and that hearing such fantasies would leave us cold, if not repel us, Freud mused that "when a man of literary talent presents his plays, or relates what we take to be his personal day-dreams, we experience great pleasure arising probably from many sources. How the writer accomplishes this is his innermost secret" (p. 43). *The essential* ars poetica *lies in the technique by which our feeling of repulsion toward the writer's personal and shameful fantasies is overcome.* The technique is constituted of two methods, the first being the use of changes and disguises in order to soften the egotistical character of the daydream. (The reader familiar with Freud's dream theory may recognize the parallel with dream formation, wherein *condensation* and *displacement* are two elements of the *dream work* that serves to disguise the forbidden wish. Of dream-condensation, Freud said there is "an inclination to form fresh unities out of elements which in our waking thoughts we should certainly have kept separate ... a single element of the manifest dream often stands for a whole number of latent dream-thoughts, as though it were a combined allusion to all of them" (Fodor & Gaynor, 2004, p. 51). In the case of dream-displacement, one dream image may symbolize another image. Freud stated that dream-condensation and dream-displacement "are the two craftsmen to whom we may chiefly ascribe the structure of the dream" (p. 52). See Freud's (1961b) tome, *The Interpretation of Dreams*, for details of his dream theory.).

Bribing the audience with the offer of a purely formal, that is, aesthetic pleasure is the second method for allaying repulsion toward the writer's fantasies. This offer is of an increment of pleasure that Freud likened to what he termed an "incitement premium" or "fore-pleasure" (Freud, 1963c, p. 43), a pleasure offered in order to release greater pleasure from deeper sources of our mind. It was Freud's opinion that the aesthetic pleasure that we gain from the art of creative writers is of the same type as this fore-pleasure, and that this enjoyment comes from the release of tensions in our own psyche. "Perhaps much that brings about this result consists in the writer's putting us into a position in which we can enjoy our own day-dreams without reproach or shame" (p. 43).

And yet, in spite of this specter of pathology that he elicited, Freud seems to have maintained a certain awe of artistic creativity, as reflected in the following passage from the 1913 work, *Totem and Taboo* (Freud, 1950):

> In only a single field of our civilization has the omnipotence of thoughts been retained, and that is in the field of art. Only in art does it still happen that a man who is consumed by desires performs something resembling the accomplishment of those desires and that what he does in play produces emotional effects — thanks to artistic illusion — just as though it were something real. People speak with justice of the "magic of art" and compare artists to magicians. But the comparison is perhaps more significant than it claims to be. There can be no doubt that art did not begin as art for art's sake. It worked originally in the service of impulses which are for the most part extinct to-day. And among them we may suspect the presence of many magical purposes [p. 90].

With decided humility, and consistent with his sense of awe, Freud wrote, "Before the problem of the creative artist analysis must, alas, lay down its arms" (von Unwerth, 2005, p. 124).

Freud's perspective on the poet was influenced, no doubt, by his association with Lou Andreas-Salomé, and his convoluted knowing of Rainer Maria Rilke both through brief acquaintance and through Andreas-Salomé, who was for a time Rilke's lover, and remained his eternal muse (von Unwerth, 2005). A bit of explanation seems in order at this point.

Freud began his brief 1915 essay, "On Transience," writing:

> Not long ago I went on a summer walk through a smiling countryside in the company of a taciturn friend and of a young but already famous poet. The poet admired the beauty of the scene around us but felt no joy in it. He was

disturbed by the thought that all this beauty was fated to extinction, that it would vanish when winter came [von Unwerth, 2005, p. 215].

(As an interesting aside, von Unwerth tells us that Freud's essay was written in tribute to the poet Goethe, whom Freud greatly admired.) Although Freud did not identify the friend or the poet, they have been recognized, according to von Unwerth, as the psychoanalyst Andreas-Salomé and Rilke the poet. The meeting to which Freud referred may not have been a walk in the countryside, but a meeting in Munich at the 1913 Fourth International Psycho-analytical Congress. Once, in 1915, around the time that Freud was penning his essay, Rilke visited in the Freud home. Rilke declined the invitation for a second visit, and Freud wrote to Andreas-Salomé that Rilke "made it quite clear to us in Vienna that 'no lasting [bond] can be forged with him.' Cordial as he was on his first visit, we have not been able to persuade him to pay us a second" (p. 21). And, while Rilke turned to Freud for possible help, writing in 1916 that if he could not get in control of his life, he would come to see Freud, he did not do so. Earlier, in 1912, Rilke had turned for help with his depression to Andreas-Salomé, who in turn referred him to the psychoanalyst Gepsattle (who happened to be her lover at the time). Rilke wrote to Gepsattle, but then withdrew his interest, fearing that analysis would correct the imperfections of his personality in "red ink like a child's exercise in school" (p. 19). Put more poetically, to "drive out the devils, it would drive out some of the angels too" (p. 19). Upon further consideration, Andreas-Salomé, fearing that treatment would strip him of his creative powers, advised him to follow his own heart. This concern over the loss of artistic creativity as result of being analyzed has been a perennial theme in both psychoanalytic and artistic circles.

Andreas-Salomé remained an important person in the lives of both Freud and Rilke. With Rilke, she discussed psychoanalytic ideas, and with Freud she shared her ideas about the turbulent character of the poet (von Unwerth, 2005). In a letter to Freud, she also opined that there is a

> pleasurable element in artistic activity: namely an element which, persisting in the [individual's] narcissism, did not form part of the rest of the [psychological] development.... One might almost say: the artist is given something (as a present) before he even wishes for it or noticed the lack of it. He matures through this gift, while other people have to mature by way of their deprivations [p. 117].

We can see, then, in her view several characteristics of the artist. These are packed tightly into the brief lines above. First, the artist is different from other people. Second, the artist is different by virtue of a special gift. Third, the artist matures through this gift. Fourth, the artist's impulse to create arises from a part of the personality that is in isolation from the rest of the personality. And fifth, artistic creativity contains an element of pleasure.

In 1930, Germany's highest literary award, the Goethe Prize, was bestowed upon Freud by the city of Frankfurt (von Unwerth, 2005). *Nota bene*: this was a *literary* award, not recognition for scientific accomplishment. In 1915, 1917, 1918, 1919, 1920, 1927, 1929, 1932, 1936, 1937, and 1938 Freud was nominated for a Nobel Prize for his scientific achievements (Ludy, 2003). The juxtaposition of this literary award with Freud's nominations for the Nobel Prize for his scientific work underscores the core conundrum of psychoanalysis. To wit, is psychoanalysis *art* or *science*? This identity problem was faced by Leonardo da Vinci and Goethe, too, as Freud expressed in his acceptance speech for the Goethe Prize.

> In Leonardo's nature the scientist did not harmonize with the artist, he interfered with him and perhaps in the end stifled him. In Goethe's life both personalities found room side by side: at different times each allowed the other to predominate [von Unwerth, 2005, pp. 84–85].

As the above quote reveals, Freud considered art and science to be in opposition. Art, he saw, as not concerned with truth, but aimed at emotional effect built on the real or the imagined, the true or the untrue. In art, this matters not. At the antipode of art, science seeks truth through enquiry into the world that is at once empirical and consensual. This ambiguous nature of psychoanalysis has both limited its acceptance in the academic circles of the university and opened the door into the society of artists. The latter is especially not surprising given that the subject matter of psychoanalytic thought has historically been addressed in art, literature, and philosophy. Additionally, a kinship may be felt when in reading Freud one comes upon one of his frequent references or even quotation from classical literature, at times well known, at times obscure and reflecting of Freud's profound erudition.

Even though Freud's theories paint the world of arts and artists under a cloud of psychopathology, he acknowledged his debt to that world. Relating a visit to Freud's office, the playwright H. R. Lenormand reported that

Freud claimed that the essential themes of his theories were based on the intuition of the poets (Ellenberger, 1970). Showing him the works of Shakespeare and the Greek tragedians on his book shelves, Freud proclaimed, "Here are my masters" (p. 460).

In *Freud's Requiem*, von Unwerth (2005) offered this densely packed and quite pregnant pronouncement.

> Though he could explain both the creative impulse (by the theory of sublimation) and the effect of art on the viewer (the origin lay in the infant's pleasure in his body), he could not put them together, to account for the transformation of sensual experience into an aesthetic one [p. 127].

With this in mind, let us now turn to Freud's theory of aesthetics.

The concept of the sexual origin of the sense of beauty was prevalent in the last decades of the nineteenth century, and provided a general context for Freud's theory of aesthetics (Ellenberger, 1970). Ellenberger offered a concise summary of several thinkers who held such a view. These may be of interest at this point. Espina suggested that the aesthetic feeling originated in the competition of males for winning females, the latter making themselves attractive to the males by means of brightly colored plumage, songs, and dances. In a more generic vein, Nietzsche stated that "every kind of beauty incites to reproduction, this being its specific effect from the lowest sensuality to the highest spirituality" (Ellenberger, 1970, p. 302). The idea that part of the sexual instinct was transformed into a sense of beauty in the course of the human ascent from the animal world was put forward by Steinthal. Moebius taught that the perception of beauty in nature comes from the sexual instinct, and that the aesthetic feeling, itself, is directly connected to that instinct. It was Santayana's opinion that the sexual impulse irradiates into the sense of beauty, as well as into religion, philanthropy, and the love of nature and animals. A somewhat more modest connection was formulated by Yrjö Hirn. He hypothesized that the sexual instinct was but one of four basic factors in the origin of art. Such views explicitly attributed the experience of beauty to a sexual origin.

While first stating a disclaimer, Freud (1961a) presented what may be seen as a preliminary theory of aesthetics. "Psychoanalysis, unfortunately, has scarcely anything to say about beauty.... All that seems certain is its derivation from the field of sexual feeling. The love of beauty seems a perfect example of an impulse inhibited in its aim" (p. 83). Therein, Freud is suggesting that the recognition of beauty represents a sexual impulse,

but one that is inhibited in its *aim*. An "aim-inhibition" has been defined as follows: "A relationship is said to be aim-inhibited if the subject has no conscious EROTIC interest in the OBJECT. Common examples are friendships, platonic love, and domestic affections between relatives" (Rycroft, 1968, p. 5). In order to render this definition relevant to our study, we need only expand it to include relationship of the viewer to the *art object* as an additional type of relationship. Let us turn to Freud (1963a), himself, for a more exacting clarification of aim-inhibition. In order to understand this, however, we need to carry with us Freud's technical meaning of the term *source*. "By the *source* of an instinct is meant that somatic process in an organ or part of the body from which there results a stimulus represented in mental life by an instinct" (p. 88). Freud suggested that this somatic process could be of a chemical nature or could correspond with the release of mechanical forces. Keeping this in mind, we may now proceed.

> The *aim* of an instinct is in every instance satisfaction, which can only be obtained by abolishing the condition of stimulation in the source of the instinct. But although this remains invariably the final goal of every instinct, there may yet be different ways leading to the same goal, so that an instinct may be found to have various nearer or intermediate aims, capable of combination or interchange. Experience permits us also to speak of instincts which are *inhibited in respect of their aim*, in cases where a certain advance has been permitted in the direction of satisfaction and then an inhibition or deflection has occurred. We may suppose that even in such cases a partial satisfaction is achieved" [p. 87].

Developmentally speaking, the infant's first object of erotic pleasure is its own body. Gradually a shift is made to the mother's breast, a *part-object*, and then to the mother, herself (*whole-object*). As maturation continues, the child includes others and various things as the objects for erotic relationship. Eventually, pleasure can be derived from the relationship with the art objects that have been produced by the culture. Freud's developmental theory is lengthy and complex, and to do it justice would take us far afield with respect to our present concerns. (Aspects of this theory are represented in various parts of his works, most notably in his *Three Essays on the Theory of Sexuality*, which with significant updates went through six editions between 1905 and 1925.)

Interestingly, in this context of eros, Freud (1961a) noted that even though the sight of human genitals is most often exciting, they are rarely judged to be beautiful. Beauty is attributed, instead, to selected secondary

27

sexual characteristics. And, I may add, those characteristics are defined, at times rather narrowly, within a given culture, or even sub-culture.

At the risk of oversimplification, we may summarize Freud's theory of aesthetics thus far as follows: *The perception of beauty derives from an erotic attraction to the art object, with the erotic urge remaining more or less inhibited and unconscious.*

Still, a couple of pieces remain to be placed in this puzzle before a coherent picture of aesthetics is seen. First, Freud (1961a) recognized "the interesting case in which happiness in life is predominantly sought in the enjoyment of beauty" (p. 82).

> This aesthetic attitude to the goal of life offers little protection against the threat of suffering, but it can compensate for a great deal. The enjoyment of beauty has a peculiar, mildly intoxicating quality of feeling. Beauty has no obvious use; nor is there any clear cultural necessity for it. Yet civilization could not do without it [p. 82].

This final sentence should not be depreciated for its brevity. The context in which Freud was writing was that in which "life, as we find it, is too hard for us; it brings us too many pains, disappointments and impossible tasks" (p. 75). He saw three palliative measures to this condition: powerful deflections, substitutive satisfactions, and intoxicating substances. "The substitutive satisfactions, as offered by art, are illusions in contrast with reality, but they are none the less psychically effective, thanks to the role which phantasy has assumed in mental life" (p. 75).

Evidence that "happiness sought in the enjoyment of beauty" is an effective anodyne, though it is a substitute satisfaction to be sure, is easily enough garnered. But this does not account for the horror genre, those drawings, paintings, and stories of frightening and even ghastly or gruesome subject matter. Images from the right-hand panel of Bosch's "Garden of Earthly Delights" triptych or Poe's "The Oblong Box," Munch's *Skriet* or Bram Stoker's *Dracula*, not to mention some contemporary graphic novels and highly popular horror films, or the stories by Stephen King, all fascinate and enthrall, even as they evoke unease. The phenomenon of the horror genre brings up at least two nuclear questions. First, how is horror evoked by a work or art? Second, what are the conditions that allow the seemingly unpleasant to be experienced as pleasant? Let us see what answers may be suggested in Freud's work.

As a psychoanalyst, Freud (1963d) understood aesthetics to mean not only the theory of beauty, but the theory of feeling. It is on this basis,

therefore, that he published his 1919 essay, "The 'Uncanny.'" Freud identified *silence, solitude,* and *darkness* as the actual elements that produce morbid anxiety in children. From these, "the majority of human beings have never become quite free" (p. 60). Thus, a graphic depiction of these elements, whether through the medium of painting or of the written word, or perhaps even through music, will evoke in most adults a return of some degree of childhood fear. There are vast individual differences in vulnerability to such recrudescence, of course. Those artists who work successfully in the horror genre have mastered the skill of evoking childhood fear through their well-timed images of silence, solitude, and darkness, alone, or more often in combination.

As for the uncanny,

> it undoubtedly belongs to all that is terrible — to all that arouses dread and creeping horror; it is equally certain, too, that the word is not always used in a clearly definable sense, so that it tends to coincide with whatever excites dread. Yet we may expect that it implies some intrinsic quality which justifies the use of a special name. One is curious to know what this peculiar quality is which allows us to distinguish as "uncanny" certain things within the boundaries of what is "fearful" [Freud, 1963d, p. 19].

The key to this is found in the fact that "the 'uncanny' is that class of the terrifying which leads back to something long known to us, once very familiar" (p. 20). Thus, the uncanny is at once familiar and not familiar, or otherwise stated, once known, forgotten, and known again. The etymological manifestation of this notion is embodied in the German word *heimlich. Heimlich (heimelich, heimelig)* means belonging to the house, not strange, familiar, tame, intimate, comfortable, or homely. But, Freud pointed out, it also means kept from sight, withheld from others. In his words, "among its different shades of meaning the word *heimlich* exhibits one which is identical with its opposite, *unheimlich*" (p. 28). Continuing, he wrote, "on the one hand it means that which is familiar and congenial, and on the other that which is concealed and kept out of sight" (p. 28). *Unheimlich* is the opposite of the first meaning of *heimlich*, and can mean uneasy, eerie, blood curdling; it is translated as "uncanny" in English. Freud acknowledged Schelling for the important revelation that "*'Unheimlich' is the name for everything that ought to have remained ... hidden and secret and has become visible*" (italics his) (p. 27). We could say the same for *heimlich*, in the second sense of this word.

In his essay on the uncanny, Freud (1963d) considered several of the

"things, persons, impressions, events and situations which are able to arouse in us a feeling of the uncanny in a very forcible and definite form" (p. 30). He credited Jentsch with early investigations, and the idea that the uncanny can be aroused through "doubts whether an apparently animate being is really alive; or conversely, whether a lifeless object might not be in fact animate" (p. 31). Thus, we find wax figures, dolls, and automatons as popular figures in the horror genre. Jentsch added the uncanny effect of epileptic seizures and the various manifestations of insanity, since these may suggest to the viewer that automatic, mechanical processes are at work. Quoting Jentsch, Freud wrote:

> In telling a story, one of the most successful devices for easily creating uncanny effects is to leave the reader in uncertainty whether a particular figure in the story is a human being or an automaton; and to do it in such a way that his attention is not directly focused upon his uncertainty [p. 31].

In spite of his crediting Jentsch with this observation, Freud maintained that in the story that Jentsch used as the basis for his theory, "The Sand-Man" in Hoffmann's *Nachtstücken*, there were more potent forces at work in the creation of the experience of the uncanny. Freud's suggestion is that it was injury to the eyes that mainly created the uncanny effect; losing one's eyes is a terrible fear of childhood, symbolic of castration.

"Animism, magic and witchcraft, the omnipotence of thoughts, man's attitude to death, involuntary repetition and the castration-complex comprise practically all the factors which turn something fearful into an uncanny thing" (Freud, 1963d, p. 49). Some of these may benefit from explanation. "Animism" refers to the belief in spirits separate from bodies, or the attribution of consciousness to physical objects. In the case of "omnipotence of thoughts," it is believed that thinking something will make it happen. "Involuntary repetition" refers to such things as a particular number coming to one's attention in several situations in the course of a day or so. Freud placed special emphasis on the following, even though he thought that it was covered by the categories of animism and magic.

> An uncanny effect is often and easily produced by effacing the distinction between imagination and reality, such as when something that we have hitherto regarded as imaginary appears before us in reality, or when a symbol takes over the full functions and significance of the thing it symbolizes [p. 50].

It is these childhood attitudes-cum-beliefs, re-evoked, that can catapult one from a feeling of fear to an experience of the uncanny. In words that

reveal his reductionism, Freud stated that "it may be true that the uncanny is nothing else than a hidden, familiar thing that has undergone repression and then emerged from it, and that everything that is uncanny fulfils this condition" (p. 51). Or, with an added precision that may belie the haziness between the two categories, "an uncanny experience occurs either when repressed infantile complexes have been revived by some impression, or when the primitive beliefs we have surmounted seem once more to be confirmed" (p. 55).

Referring to "The 'Uncanny,'" Vicki Goldberg (1977) suggested that "although Freud is not explicit at this point in the essay, the general psychoanalytic presumption is that fear must be eroticized to become pleasurable" (p. 24). I will not speculate as to whether Freud would agree or not with this formulation —*eroticized fear yields pleasure*— but consideration of contemporary horror films certainly seems to give evidence that this is at least sometimes the case. And, this formulation seems consistent with other elements of his theory.

Goldberg (1977) reminded us that Freud stated that one aspect of artistic skill is to be able to soften what would otherwise be harshly offensive, while at the same time bribing the audience with a promise of aesthetic pleasure. "Softening," must be taken here as quite relative, when one considers the degree of explicitness of the grisly and lurid scenes in some popular horror works, especially in film. However, given that the work involves fantasy, experiencing it is to a greater or lesser degree less harsh than experiencing the reality that any such art work represents. Contemporary and future developments in the creation of virtual reality, however, may challenge the placement of this border between fantasy and reality as it is experienced. Virtual realities may be created that approximate the experienced harshness of a horrible and frightening reality.

Even if one is not favorably disposed toward the content of a work of art that depicts ghastly or gruesome subject matter, much of this art clearly educes beauty in its execution. To return to an obvious, but nonetheless vital point, much horror in art has been produced by artists who through time-honored expert opinion are recognized as masters. In some of this work the horrible and the beautiful, reflected in content and technique respectively, stand together creating an interesting paradox. Thus, the ugly may contain beauty, and that beauty may be the bribe that brings the audience face to face with the work.

In summary, then, we can hypothesize that the unease that horror in

art brings through its content is made tolerable and even enjoyable through the artist's techniques of softening of its harshness, beautiful execution, and perhaps eroticization of the work. What makes it frightening is the elicitation of childhood fears brought on by silence, solitude, and darkness. If there is a reactivation of a childhood complex or a re-evocating of certain childhood beliefs in animism, magic and witchcraft, omnipotence of thoughts, involuntary repetitions, and beliefs about death, then fear may be transmogrified into the horror of the uncanny. The *heimlich* becomes the *unheimlich*.

Before concluding my discussion of Freud, I want to delve more deeply into his general dislike of music. At first blush, this dislike seems surprising, given Freud's erudition and worldliness, and the fact that traditionally musical education was highly valued in Jewish families. Vienna was famous for its music, and music was central to Viennese cultural life. Beethoven, Brahms, Schubert, Mahler, and Johann Strauss all made Vienna their home at some period. Freud's recent biographer, Louis Breger (2000) stated, "In later years, he did enjoy a few operas — Mozart's *Don Giovanni* and *The Marriage of Figaro*, Bizet's *Carmen*, and Wagner's *Meistersinger*— but mainly for their dramatic content; his interest and appreciation of music itself remained very circumscribed" (p. 33). Breger, referring to Freud's best known biographer, wrote:

> Ernest Jones says that Freud's aversion to music was well known to his colleagues and recalled "the pained expression on his face on entering a restaurant or beer garden where there was a band and how quickly his hands would go over his ears to drown the sound" [p. 33].

As to the reason behind Freud's dislike of music, Breger (2000) opined:

> Freud's avoidance of music was part of his wider need to control emotion, for music has the power to evoke a range of feelings in the listener, to carry one away on a tide of romantic passion or bring on sadness and grief, and these were reactions that he had to suppress at all costs [p. 33].

In an 1883 letter to his fiancée, Freud (1960b) revealed an attitude that bespoke his need for suppression of passions.

> I remember something that occurred to me while watching a performance of *Carmen*: the mob gives vent to its appetites, and we deprive ourselves. We deprive ourselves in order to maintain our integrity, we economize in our health, our capacity for enjoyment, our emotions; we save ourselves

for something, not knowing for what. And this habit of constant suppression of natural instincts gives us the quality of refinement. We also feel more deeply and so dare not demand much of ourselves. Why don't we get drunk? Because the discomfort and disgrace of the after-effects gives us more "unpleasure" than the pleasure we derived from getting drunk....
Thus we strive more toward avoiding pain than seeking pleasure [p. 50].

Delving more deeply, we find material that not only further reveals the person of Freud, but may help to elucidate a psychodynamic perspective on music. The key is exposed, almost cryptically, in a letter to Romain Rolland dated July 14, 1929. The beginning sentence offers the clue. "Your letter of December 5, 1927, containing your remarks about a feeling you describe as 'oceanic' has left me no peace" (Freud, 1960c, p. 388). Continuing, Freud stated that "in a new work ... I am making a starting point of this remark; I mention this 'oceanic' feeling and am trying to interpret it from the point of view of our psychology" (p. 388). The new work to which Freud referred was *Civilization and Its Discontents* (1961a).

In a follow-up letter later in July of 1929, Freud (1960d) seemed respectfully dismissive of the "oceanic" feeling.

I was glad to hear that your book will appear before my small effort, which is unlikely to be in print before February or March. But please don't expect from it any evaluation of the "oceanic" feeling; I am experimenting only with an analytical version of it; I am clearing it out of the way, so to speak [p. 389].

Having associated the oceanic feeling with mysticism, Freud (1960d) then went on to place the latter beside music as subjects that were closed to him. Note his wording.

How remote from me are the worlds in which you move! To me mysticism is just as closed a book as music. I cannot imagine reading all the literature which, according to your letter, you have studied. And yet it is easier for you than for us to read the human soul [p. 389].

What, then, did Freud (1961a) have to say in *Civilization and Its Discontents* about the oceanic feeling? First, he explained Rolland's view. For Rolland, the oceanic feeling was the true source of religious sentiments. "This, he says, consists in a peculiar feeling, which he himself is never without.... It is a feeling which he would like to call a sensation of 'eternity,' a feeling as of something limitless, unbounded — as it were, 'oceanic'" (p. 64). It was a feeling of being at one with the external world as a whole.

Rolland further stated, according to Freud, that one may "rightly call one-self religious on the ground of this oceanic feeling alone, even if one rejects every belief and every illusion" (p. 64).

Freud (1961a) confessed that he was unable to discover the oceanic feeling in himself. Furthermore, he declared that dealing scientifically with feelings was a difficult task. His conclusion came in this manner.

> The idea of men's receiving an intimation of their connections with the world around them through an immediate feeling which is from the outset directed to that purpose sounds so strange and fits in so badly with the fabric of our psychology that one is justified in attempting to discover a psycho-analytic — that is, a genetic — explanation of such a feeling [p. 65].

The term *genetic* requires clarification. In the psychoanalytic context, the term means *ontogenetic*, that is, related to the development of the individual, not *phylogenetic*, related to the development of the species. Therefore, no association with *genes* should be made. Thus contextualized within the psychoanalytic framework, *genetic* is synonymous with *developmental*.

Developmentally speaking, the ego detaches itself from the external world. More precisely, the ego, which originally included everything, separates an external world from itself. "Our present ego-feeling is, therefore, only a shrunken residue of a much more inclusive — indeed, an all-embracing — feeling which corresponded to a more intimate bond between the ego and the world about it" (Freud, 1961a, p. 68). Thus, Freud traced the oceanic feeling back to an early phase of ego-feeling, a restoration of "limitless narcissism" (p. 72), if you will.

> If we may assume that there are many people in whose mental life this primary ego-feeling has persisted to a greater or less degree, it would exist in them side by side with the narrower and more sharply demarcated ego-feeling of maturity, like a kind of counterpart to it. In that case, the ideational contents appropriate to it would be precisely those of limitlessness and of a bond with the universe — the same ideas with which my friend elucidated the "oceanic" feeling [p. 68].

Freud's comments on the oceanic feeling are interpreted by von Unwerth (2005) as equating the inspiration received from music (which von Unwerth referred to as the "most emotional of the arts" [p. 132]) with the mystical oceanic feeling. "What mysticism, music, and the 'oceanic feeling' had in common was their basis in 'intuition,'" opined von Unwerth (p. 201). And, what had Freud to say of intuition? He wrote of this in a letter to Rolland in January of 1930 (Freud, 1960e).

34

We seem to diverge rather far in the role we assign to intuition. Your mystics rely on it to teach them how to solve the riddle of the universe; we believe that it cannot reveal to us anything but primitive, instinctual impulses and attitudes — highly valuable for an embryology of the soul when correctly interpreted, but worthless for orientation in the alien, external world [p. 393].

Freud seemed to tell us, then, that music strongly arouses the emotions, stirs the instincts, as it were. This, in itself, is no revelation, but comes closer to a truism. There is, however, a psychodynamic implication that may provide interesting and valuable insight. The implication is that if someone dislikes music, or possibly a certain genre of music, it may be because it arouses forbidden instinctual urges. If one's goal is to repress one's passions, control one's emotions, and avoid the guilt and pain of not having done so, then music may be threatening, and dancing to it even more so. With music, eros trumps logos, and pathos trumps ethos.

While retaining a basically classical psychoanalytic orientation, Otto Fenichel (1945) nonetheless furthered psychoanalytic theory concerning art and the artist. That he retained his predecessor's penchant for locating the artist in the realm of pathology is attested to by the fact that Fenichel discussed art and the artist in his classical volume entitled *The Psychoanalytic Theory of Neurosis*, placing said discussion in his chapter on "Character Disorders." By his own admission, Fenichel's classification of character disorders is an unsystematic one. And, although he avoided a clear and concise definition, he explained his use of the term, saying that "there is no other way of reviewing the different types of neurotic character disorders than by studying separately anomalies that appear in solving the four tasks" (p. 477). The four tasks are those of the ego: "to come to grips with instinctual demands, with the superego, with the demands of the external world, and to unify these three interdependent realms according to the principle of multiple function" (p. 477). These "anomalies" are revealed through example in the following definition from the *Longman Dictionary of Psychology and Psychiatry* (Goldenson, 1984):

A persistent personality pattern characterized by (a) a specific type of maladaptive behavior, such as antisocial, paranoid, or cyclothymic tendencies, (b) emotional instability, (c) marked immaturity, (d) compulsive gambling, (e) sexual deviation, or (f) alcohol or drug addiction [p. 137].

Beginning with the premise that neurotics are persons who are alienated from their instinctual impulses, Fenichel (1945) suggested two basic

types of pathological behavior that they may assume toward the id. The "id," of course, refers to the most primitive structure of the psyche, wherein are found the instinctual, biological drives that are the source of psyche energy, or libido; residing at the deepest levels of the unconscious, it operates according to the *pleasure principle*—immediate gratification of instincts. First, is the "generally frigid" (p. 477) person who avoids emotions more or less completely. The second type of pathological behavior toward the id is manifest in intense, uncontrolled emotions. With such a person, because the emotions have not been allowed natural outlet, the emotions have flooded the person, sexualizing everything. Fenichel elucidated further, writing, "a normal person is able to remember how he felt as a child. A 'generally frigid' person has forgotten childhood emotions; the hyperemotional person is still a child" (p. 478).

Fenichel (1945) proceeded to relate these two types of pathological behavior toward the id to the two types of artists, reflecting two types of art that were commonly distinguished at his time, "classicists and romanticists" (p. 478). The classicist, he wrote, regardless of the medium, is bound by traditional forms and systems. Led by intellect, or to invoke the psychoanalytic term, *secondary process* (the rational *reality principle*, calling for delay of instinctual gratification), such an artist "flees from feared instinctual temptations to sober reality" (p. 478). If this is a mirror to a generally frigid, emotionally avoidant relationship with the id, then the romanticist may reflect the opposite extreme of intense, uncontrolled emotions. Guided by the irrational, that is, purely emotional *pleasure principle*, this artist flees into fantasy, led by feelings and impulse. Finding reality full of representatives of the feared instinctual impulses, relief is found in substitutive fantasy. Such an artist moves to create new forms, as opposed to the traditional ones.

Fenichel (1945) proffered another hypothesis that may be useful in our understanding. He suggested that an artist, in order to dispense with anxiety, may actually seek and describe what is feared. In this manner the artist may achieve a degree of mastery of that which is feared. Thus, Fenichel identified such works of art as a class of counterphobic phenomena.

Based on the premise that "for guilt-laden characters, other persons finally are only tempters or punishers, personifications of the id or of the superego," Fenichel (1945, p. 498) identified what he believed to be a mechanism that plays a decisive role in the psychology of art. "The artist who has withdrawn from reality into his fantasies, which represent deriv-

36

atives of his Oedipus wishes and about which he feels guilty, finds his way back to the objective world by presenting it with his work" (p. 498). If the public accepts the artist's work, then that public would be seen by the artist as sharing his guilt, allowing the artist a degree of relief from that guilt. Fenichel proceeded to suggest that this public would, having their own repressed Oedipal wishes, admire the artist for his courage, and would feel relief from their own feelings of guilt.

Continuing with the above line of theorizing, Fenichel (1945) drew the distinction between the "pseudo artist and the real artist" (p. 498). Needing acceptance as a person, the former requires applause at any cost. Therefore, the pseudo artist will adapt himself to his audience in order to try to ensure applause. In contrast, it is the need to have his fantasy accepted that is foremost for the real artist. Ergo, the real artist, wanting applause for the work, not himself, tries to adapt the public to himself.

Finally, still exploring the implications of the tendency of guilt-laden characters to project onto others either the role of tempters or punishers, Fenichel (1945) suggested that the admirers of a particular artist feel themselves a community. They are united by their shared admiration of a tempter or guilt-relieving figure. Giving credit to Freud for defining a group as individuals who have elected the same person to represent their superego and thereby identify themselves with each other, Fenichel pointed to the relief of guilt that is hereby promised. When others, with whom one identifies, dare to do that about which one has felt guilt, one may so act, as well, and be free from guilt.

In a 1926 paper with this title, Alfred Adler (1980) proffered his views on "The Special Situation of the Artist." Even though Adler and Freud had severed relations some fifteen years earlier over theoretical differences, Adler's opinions in this essay reflected a view that was fundamentally Freudian. Adler opened his essay by opining that love plays a special role in the life of the artist, a role more often unhappy than happy. Unrequited love is by no means unique to artists, but may be more poignant because of the exaggerated sensitivity of the artist. The artist stands out from others by the fact that "he seeks in his art a life 'aside from life,' does not work in actual reality, but seeks a substitute world (*Ersatzwelt*), and is almost repulsed by reality" (p. 117). To become an artist, however, Adler pointed out that the artist must form his creation such that it has general value in the community, and thereby finds its way back into reality. A creation becomes a work of art only by having the most general value.

In Adler's (1980) words, "In deviating from real life, one is inclined to experience the institution of love and marriage, with its emphasis on the reality of life as hostile and disturbing" (p. 117). Thus, the artist, with his extreme penchant for fantasy, develops the "ties of life" (p. 117) into shackles or obstacles that can hardly be overcome. The artist, therefore, reacts with both "the movements of a lover ... and to a much stronger degree the movements of a person fleeing from love" (p. 117). This situation, pervasive in the artist's love relationships, is mirrored in his thoughts and *creations*. Such reflection is found most clearly in the work of poets and writers.

Adler (1980) attributed the paucity of women artists in his time to the exaggerated masculine ideal in his society. Women, he believed would not keep step with this masculine ideal in which women were raised to the level of magical or frightening figures. The woman as a figure of danger has been an enduring ideal in art, as Adler pointed out, citing ancient sources such as the Bible and Homer's *Iliad*. Adler offered an example from a poet slightly his senior, Baudelaire, who wrote, "I have never been able to think of a beautiful woman without having, at the same time, the sense of an immense danger" (p. 118).

Adler's (1980) conclusion is captured in the subjoining of the two following quotes: "Men fear that devotion is synonymous with loss of personality, with bondage or slavery" and "Artists are particularly seized and captivated by the problem of love" (p. 119).

CHAPTER 2

Art and the Conflict-Free Sphere of the Ego — Ernst Kris

Representing, still, a psychoanalytic position, but dispersing the ubiquitous effluvium of pathology, the *ego-analysts* Heinz Hartmann, Ernst Kris, Rudolph Lowenstein, Erik Erickson, and of course his mentor, Anna Freud (Freud's eldest daughter) took a bold step ahead. With the publication of *Psychoanalytic Explorations in Art*, Kris (1952) became their major spokesperson in the artistic realm. Kris reminded us that when clinical data were used primarily, the objection was raised that Freud's theories were valid only within the realm of psychopathology. Arguing against this criticism, the study of culture, and particularly art, provided supplementary evidence for Freud's theories. This study of art and culture was focused on mainly three problems. First was the ubiquity of certain themes in the mythological and literary traditions that related to the fantasy lives of individuals; second was the relationship between the artist's psychological history and the work of that artist; and third was the relationship between the dynamics of the creative imagination and thought processes that were observed through clinical studies.

A fresh perspective that Kris (1952) put forward for the study of art was that of seeing it as part of the study of communication. From this perspective, then, art involves a *sender* (the artist), *receivers* (the audience for the art), and a *message* (that which the artist is trying to convey to the audience). After declaring that "the study of art is part of the study of communication" (p. 16) Kris had little more to say about this. Regarding this perspective as potentially quite rich, I would like to extrapolate from it and explore some of its implications.

For any work of art, and regardless of the medium, I suggest that we can ask who the artist is, psychologically speaking; who the intended audi-

39

ence is; and what we believe the artist is trying to convey to that audience (i.e., what emotions is the artist trying to evoke, what thoughts are invited, what actions are urged). Artist, audience, and the artist's message are all contextualized by culture, including geographical, historical, political, and ideological influences. At once, this context illuminates the artist, the intended audience, and what the intended message is, as well as what it may be taken to be.

We can ask who the artist is, psychologically, both as revealed through his or her formal style (e.g., Classic, Gothic, Baroque, Romantic, Naturalistic, Surrealistic, etc.) and as reflected in his or her unique interpretation of the subject matter of the particular work in question. Furthermore, we can ask who the artist is, as reflected by that chosen subject matter itself. The question of who the artist is, as revealed by his or her chosen subject matter, chosen style, and personal interpretation of the subject matter is surely grist for the psychoanalytic mill.

This simple, easily applied perspective suggested by Kris (1952) opens the possibility of elaboration through the integration of elements of communication theory developed by others. For example, some of the generally accepted axioms of communication today are the following. *Communication is complex and multi-channeled.* Applied to art, this means that formal style, interpretation, and subject matter each represents a channel or level of communication. Each one carries a message. *There may be congruence or incongruence within and between channels of communication.* Congruence and incongruence within a level, for example, may be represented respectively by a painting that is of Classical style throughout, and a painting in which the Classical style is invaded by Surrealistic elements. Examples of congruence and incongruence between levels are a vampire story presented in Gothic style, and a work of historical fiction concerning the life of Winston Churchill, in Gothic style, respectively. Nota bene: Congruent and incongruent are meant as descriptive terms, and imply no value judgment. It is congruence within and between levels of communication that may lend harmony to much of art, while incongruence within and between levels creates some of the most dramatic of artistic effects, as can be witnessed in some of Dali's later work. The murder mystery becomes a *cozy* when its creator imposes a somewhat lighthearted and lilting interpretation on the dark and heavy subject of murder. Light fare and comedic works oftentimes, too, owe their effect largely to various types of incongruity. *The message sent is not necessarily the message received.* Simply put, the audi-

ence does not necessarily get the message which the artist intended. An important corollary to this axiom is that there are multiple audience interpretations of any work of art. The number and variety of audience interpretations may be an index of the complexity of the work, and a testimony to its pregnancy. A further corollary of this axiom is that many artists will feel misunderstood, as their intended message is missed by some or all of their intended audience. By means of an analogy in reference to a further existing axiom of communication, I will risk creating one that is specific to art. To wit, *in general, an emotional message is carried most strongly through the* interpretation *channel, less so through the* formal style, *and even less so by the* subject matter *itself.* In less formal words, although affect may be evoked by the content of a work of art, the style employed by the artist, and even more so the artist's interpretation of the subject matter is responsible for the emotional response of members of the audience. Conversely, *it is the content or subject matter of a work of art that most strongly beckons cognitive response.* Thus, acknowledging the oversimplification, I am suggesting that the subject matter or content of a work of art invites cognitive processing, including apperception, whereas the formal style in which that work of art is rendered, and even more so the artist's interpretation of the subject matter evokes emotional response. This is not to preclude thinking about style and interpretation, nor to preclude emotional reaction to a given subject matter. Thinking about style and interpretation is, of course, a learned skill of the art critic. In general, I am hypothesizing that thinking about the style and the artist's interpretation of a particular subject matter tends not to be immediate, but to be mediated by an affective response, and emotional reaction to content tends to be mediated by thought. Note that in the above example of the "cozy," it is the lighthearted interpretation that evokes pleasant feelings even as the subject of murder is presented. Thoughts turn to murder and cold calculation to solve the crime, but the writer's interpretation of this subject matter places it in a context of warm feelings. In terms of channels of communication, and emotionally speaking, interpretation trumps subject matter.

Having indulged in these considerable extrapolations from Kris's (1952) perspective on art as communication, I want to emphasize that the introduction of this perspective, in and of itself, suggested a step away from the realm of psychopathology. But the major step in this direction was "the detachment of certain ego functions from conflict in establishing autonomy in certain activities" (p. 21). That is, the ego was seen as able

to function in a conflict-free sphere, rather than to be limited to the mediation of intrapsychic conflicts born of opposition among id impulses, superego demands, and the demands of reality. A noteworthy corollary was the recognition of functional applications of the defense mechanisms, in addition to pathological uses, a point emphasized by Anna Freud. Simply put, the defense mechanisms have healthy applications as well as neurotic applications. A modicum of denial, repression, rationalization, and so forth may be healthy when they are used to deal with a difficult reality, as opposed to inner conflicts.

In comparing dream work and "art work," Kris (1952, p. 24) explained that what in the dream appears as compromise and is understood by the principle of *overdeterminism*, appears in art as multiplicity of meaning, and arouses different responses in the audience. Since overdeterminism is a technical term, and since it is such an important concept, it deserves explanation. An "item of behavior is said to be over-determined if it has more than one meaning or expresses drives and conflicts derived from more than one level or aspect of the personality" or "if it provides a 'final common pathway' to a number of converging tendencies" (Rycroft, 1968, p. 110).

Critical for the artist is the ability to gain access to id material readily, without being overwhelmed by it. In other words, the artist needs to be in control over primary process and make appropriately rapid shifts in the level of psychic functioning, moving freely from the primary process that characterizes the id to the secondary process of the ego. Crediting Freud, Kris (1952) referred to this as the "flexibility of repression" (p. 25) of artists. Freud had considered this condition dangerous because of the intrusion of id impulses upon the ego; the protection against such danger was the ego's capacity for sublimation. Kris described sublimation as involving two closely related processes: displacement of energy discharge from a goal not socially acceptable to one that is, and a transformation of the energy itself. The latter he termed "neutralization" (p. 26), meaning the *de-sexualization* or *de-aggressivization* of psychic energy. Goal substitution and energy transformation are not necessarily synchronous in their occurrence. The substitution of the higher goal may take place without neutralization, in which case Kris wrote of "sexualization or aggressivization ... which may be responsible for malfunctions of various kinds from symptom formation to inappropriate performance" (p. 27). We therefore can understand that "instinctual energy may find a more or less direct or neutralized

discharge; the function may have become more or less autonomous" (p. 53). It is only to the extent that neutralization has remained incomplete that defenses may be necessary. This last point adds greater depth of understanding to my earlier discussion of healthy forms of defense mechanisms.

In the case of creativity, Kris (1952) speculated, sublimation may be distinguished by both a fusion of instinctual energy (i.e., neutralization of a portion of the sexual or aggressive energies) and shifts in psychic levels (i.e., the organizational functions of the ego in which it is regulative of regression and maintains control over the *primary process*. Thus, this is not neurotic regression, but *regression in the service of the ego*.).

Kris (1952) allowed that there may be typical conflict constellations that are more likely to occur in the psyche of various types of artists— rapidly changing identification in the actor, coping with exhibition in the dancer, the wish to distort others in the cartoonist, the wish to adorn others in the fashion designer. Yet, he emphasized that in order for the artist be a success, the artistic activity must, itself, have become autonomous. That is, it must be detached from the root conflict and be a function of the ego acting in a conflict-free sphere. Wisely, Kris admitted that there are innumerable other tendencies rooted in the artist's history which must also be taken into consideration. With this admission, Kris escaped the simplistic, single, hidden factor explanations that have been the easy targets for critics of psychoanalytic theory.

In eschewing an overly simplified psychoanalytic theory of the artist, Kris (1952) briefly addressed the alleged sterilizing effect of psychoanalytic treatment on the artist. (Recall that this was the concern that Rilke had, eventuating in his decision not to pursue psychoanalytic treatment for his depression.) If, indeed, Kris pointed out, the artist's creativity were simply a function of intrapsychic conflicts, only serving as a defense, then a successful analysis would render the artist void of creativity. Citing Trilling, Kris declared that clinical evidence disconfirmed such a hypothesis. In Kris's own words, "The gifted artist 'spoiled by analysis' seems to be a rare occurrence" (p. 29).

Kris (1952) acknowledged that cultural conditions have reflected periods in which skill has been the predominant value in art, other times when skill without inspiration has lost value, and even times when inspiration has risen to almost complete dominance over skill. In this context, Kris opined that the artist whose creative capacities are more closely tied to psychopathology would be more at home in the more romantic periods of

art than in the classical, a time when skill is eclipsed by inspiration. In such times, the special status that a society grants the artist is based on their awe of the artist's inspiration, rather than on admiration for the artist's skill. Related to these antipodes of skill and inspiration, Kris gave credit to the psychoanalytic technique of *free association* as a valuable method for the artist seeking inspiration from unconscious images, particularly among some of the surrealists of his day. He noted specifically the preconscious reverie that gives rise to the *stream of consciousness* novel, a style Kris credited to the French novelist Eduard Dujardin. With reference to this reverie or daydreaming with its highly varied expressions of highly varied contents, Kris suggested the term *stream of preconsciousness* (p. 311). This term, although having the advantage of specificity as a sub-type of consciousness, has not been given the honor of wide use.

This juxtaposition of free association and stream of consciousness may benefit from further exploration. Interestingly, Rycroft (1968) wrote that although *free association* has been the long-accepted term in English, it is actually a mistranslation of Freud's term *freir Einfall* on the part of Abraham Brill. (Freud gave Brill permission to translate his work into English. His early translations were important in terms of disseminating psychoanalytic thought, but they were later replaced by the more accurate translations of James Strachey [Gifford, Jacobs, & Goldman, 2005].) *Einfall* is better translated as *irruption*, or *sudden idea*. Therefore, Freud's method was one of allowing one's ideas to come to one spontaneously and without strain. To quote Rycroft (1968):

> Free association describes the mode of thinking encouraged in the patient by the analyst's injunction that he should obey the "BASIC RULE," i.e., that he should report his thoughts without reservation and that he should make no attempt to concentrate while doing so [p. 54].

Two of the assumptions upon which the method of free association rests are first, "that all lines of thought tend to lead to what is significant" and second, "that resistance is minimized by relaxation and maximized by concentration" (Rycroft, 1968, p. 54). By allowing verbalization of whatever thoughts come to mind, regardless of how embarrassing, illogical, or seemingly irrelevant, unconscious material in this manner is potentially accessed.

In his 1890 textbook, *The Principles of Psychology*, William James (1973) explored consciousness in his characteristically brilliant manner. Progressing through several steps of observation, tied together with astute argumentation, he arrived at his seminal view. The steps, in abbreviated

form, were as follows. First, "thinking of some sort goes on." Second, "every thought is part of a personal consciousness" (p. 154). Third, "no state once gone can recur and be identical with what it was before"; "there is no proof that the same bodily sensation is ever got by us twice" (p. 155), for that would require the sensation to recur "in an unmodified brain" (p. 157). Fourth, "within each personal consciousness thought is sensibly continuous" (p. 160). In conclusion, James wrote:

> Consciousness, then, does not appear to itself chopped up in bits. Such words as "chain" or "train" do not describe it fitly as it presents itself.... It is nothing jointed; it flows. A "river" or a "stream" are the metaphors by which it is most naturally described. *In talking of it hereafter, let us call it the stream of thought, or consciousness, or of subjective life.* (italics his) [p. 161].

Thus, we have James' image of consciousness, a never-ending, never-repeating stream of subjective thoughts, flowing.

As we have seen, Kris (1952) credited Dujardin with the stream of consciousness novel, to which we could add the names of James Joyce, Marcel Proust, Gertrude Stein, and Virginia Woolf, among others. It should be apparent from the above discussion that free association and stream of consciousness writing are, indeed, closely related. To express this kinship and at the same time to recognize their defining contexts, I offer the following analogy:

Free association : Psychoanalysis :: Stream-of-consciousness writing : Literature

Already, I have emphasized that Kris (1952) shared little of Freud's maladjustment bias toward artists. However, with perhaps a modicum of pathology bias, an intriguing question that Kris left open is the degree to which narrative art expresses a striving for wish fulfillment and the degree to which it is a defense against instinctual demands. He posed this question in a footnote, and referred the reader interested in the role of defense in narrative art to another source!

Addressing drama, Kris (1952) built his discussion around the concept of the *aesthetic illusion*—"a firm belief in the 'reality of play' can coexist with a certainty that it is play only" (p. 42). This aesthetic illusion is predicated on the employment of denial. What Kris suggested is that one can affirm the reality of the play, that is, deny that it is only a play, while at the same time know that it is not reality. (Keep in mind, however, that within the ego-analytic camp to which Kris belonged, defense mechanisms were seen to have healthy applications as well as pathological ones.) This

aesthetic illusion provides a protective function through *vicarious* participation. "Safety in the aesthetic illusion protects from the danger in reality, even though both dangers should be identical" (Kris, 1952, p. 45).

Kris (1952) addressed what he termed "one of the baffling and most complex questions of traditional aesthetics — the pleasure in the unpleasant in art — and hence to the question of how tragedy is possible" (p. 45). He approached this question from the perspective of Aristotle, who maintained that art purges the soul. Aristotle's *kathartic*, stated in more contemporary, if not prosaic terms, means that art allows a release of unconscious tensions. Bridging, now, to the term that Freud chose for the first step in psychoanalytic therapy, *catharsis* enables the ego to reestablish control when threatened by dammed-up instinctual energy. In this psychoanalytic context, the focus is "usually not to the purging by pity and terror effected by tragedy but to the therapeutic effect of abreaction," or the discharge of emotion which was related to a repressed experience (Rycroft, 1968, p. 16). Kris (1952) stated that the benefit, then, is a dual one. On the one hand, catharsis allows a discharge of pent-up instinctual demands, while on the other hand, the ego regains control, aided by the search for expressive outlets *per se*. In summary, *art offers socially approved occasions for catharsis through the aesthetic illusion.* Maintenance of the aesthetic illusion offers safety by virtue of the vicarious quality of participation. It offers freedom from guilt insofar as the fantasy (forbidden feelings and acts that form the content of the art) is not one's own, but that of the artist. Furthermore, it stimulates feelings which may not otherwise be permitted, given their possible connection to personal conflicts. Finally, it invites intensity of reactions that may not be allowed without the protection of the aesthetic illusion. And, as suggested above, the person in question would benefit from the good feelings of being back in (ego) control following the catharsis.

Another traditional problem in the study of art that Kris (1952) was challenged to solve is "that the dispassionate spectator alone can appreciate beauty" (p. 46). In order to do so, he invoked the work of one E. Bullough, who wrote of "underdistance" or "too strong" participation in a work of art on the part of the public, or "overdistance," in which case the public remained too detached. Applying psychoanalytic theory, Kris saw underdistance as a circumstance in which either the neutralization of instinctual energy was not complete enough, or not enough instinctual energy was neutralized, thus leaving too much libidinal or aggressive energy at work. The ego in this circumstance would be too much in the service of the id,

as opposed to functioning in the range of autonomy. In the opposite circumstance, referred to as overdistance, the spectator is unable to find a point of identification, or in other words, finds insufficient incentive for an energy discharge. Perhaps, Kris speculated, this implies that any discharge of neutralized energy presupposes an admixture with sexual and aggressive energies. Summarizing this theory, Kris suggested that we gain pleasure from art when we are in a safely balanced position between the two extremes, experiencing what Coleridge spoke of as the "willing suspension of disbelief" (p. 47).

Kris (1952) placed the questions of individual limitations and individual taste in art in this framework of underdistance and overdistance. In applying this theory, I suggest that one is limited in his or her appreciation of a work of art to the extent that, as Kris suggested, one has difficulty accessing the energy that could be discharged by that art. Strong repression of that psychic energy, be it sexual, aggressive, or partially neutralized, would limit the personal participation with the art that is necessary for identification with and catharsis through it. If such repression is strong and chronic, perhaps the individual would experience overdistance to an entire category of art. Thus, this theory may predict that this is the case, for example, with the person who claims not to understand music, more specifically jazz, or even more specifically progressive jazz. What a person likes in the way of art may, again, be driven by the opportunity afforded for energy discharge. One would like the piece of art that invites him or her to a cathartic experience within the acceptable zone of comfort. One would tend not to like art that invites either too strong an experience of identification-cum-catharsis, or art that extends little or no invitation for identification. Restated, what one likes in art is that which invites one to an encounter in the middle zone, neither pulling one into the underdistance zone where frightening id impulses are evoked, nor banishing one to the zone of overdistance where pleasurable id energy is not beckoned.

What may qualify as another important insight is found in Kris's (1952) discussion of the magical element in representational art. Interestingly, historically, Western civilization has differentiated between the artist as master of his craft and as genius. The former was admired for skill, the latter held in awe for his inspiration, as briefly discussed above. Poets and musicians were afforded the status of genius long before painters, sculptors, and builders. While the poets, in particular, were seen as those who knew history and about inner experience; painters and sculptors were seen as

those who investigated and controlled the external world, those who had many skills, masters of many of nature's secrets. As descendants of cultural heroes such as Prometheus, Hephaestus, Daedalus, and so on, who had competed with the gods, and in some cases been punished for emulation of divine prerogative, painters and sculptors are heir to the title of competitors of the gods! "The interdict against art in Hebrew and Mohammedan, and the temporary and partial interdict in Christian civilization, is based upon the belief of the magic potency of imagery ... images give power over what they depict" (p. 48). I wish to add that on occasion the lyrics of twentieth-century popular music reflected this ancient belief that engaging in the craft of art was to emulate the gods. We find, for instance, the fictile creation of a lover when "He" took a hundred pounds of clay, rolled his big sleeves up, and created a woman. Or, a few years earlier, we heard of "the old master painter from the far away hills." Interestingly, this creative prerogative of the gods was expressed by identifying the creator as a sculptor or a painter. Rather than seeing the sculptor or painter as acting as a god, the sculptor and painter are employed as metaphors in divine creation.

Turning to the receivers of the artist's communication, Kris (1952) suggested that the audience's response is a two-, sometimes three-stage process. The first involves recognition, in which the subject matter is found to be more or less familiar, and is related to memory traces. In the second stage, some experience of the subject matter that was experienced and recognized in the first stage becomes part of the spectator. "Looking long enough, one tends to become aware of a kinesthetic reaction, however slight; it may be that one tries, at first imperceptibly and later consciously, to react with one's own body, or it may be that the reaction remains unconscious" (p. 55). Kris proposed that these two stages, recognition of the subject and identification with the model, are interwoven and not by any means limited to perception of the human figure. In the third stage, which does not always occur, the audience identifies with the artist, experiencing the process by which the art was created. The audience "imitates" the lines and strokes, becoming a co-creator. This two- or three-stage process is not limited to the response to representative art, but is applicable, in Kris's view, to all art.

In passing, I want to add that it may be interesting to consider the relationship that each of these stages has to the conditions discussed above of underdistance and overdistance from a work of art. Each stage may have

a potential for an experience along the dimension of underdistance or overdistance that is peculiar to that stage. Thus, there may be underdistance or overdistance with respect to the subject matter, influenced by both one's previous experience with such matter and by one's unconscious choice to make the connection or not. It seems that one may be able to have some degree of kinesthetic reaction to a work of art, giving rise to underdistance or overdistance, independent of one's familiarity with the subject matter. One's somatic reaction need not be limited to depiction of that with which one is familiar. Finally, one may underdistance or overdistance oneself with respect to identifying with the artist-in-process. Again, this may be independent of one's recognition of or familiarity with the subject matter, or of one's bodily experience of the previous stage. What I am suggesting is that these three stages identified by Kris (1952) may be the bases for three relatively orthogonal dimensions of the underdistance-overdistance continuum.

Kris (1952) identified two phases of the process of artist creation, *inspiration* and *elaboration*. The two phases, he wrote, may be clearly demarcated, merge into each other, follow one another in slow or rapid succession, or become interwoven in various ways. The phase of elaboration was addressed but tersely by Kris. He indicated that *dedication* and *concentration*, the hallmarks of work, characterize this phase. During the phase of elaboration "work proceeds slowly, cathexis is directed to ... ego functions such as reality testing, formulation, or general purposes of communication" (p. 313). To emphasize an important point, the phase of elaboration is ruled by *ego* functions. The other phase, inspiration, has features in common with regressive processes in that otherwise hidden impulses or drives emerge. *Id* impulses and their close derivatives are received. In Kris's words, "The states of inspiration themselves may be more or less sexual in character and where inspiration is an element in creative activities of any kind a certain degree of desexualization seems to be a precondition of success" (p. 300). During this phase of inspiration, the artist feels driven, perhaps experiences rapture, and may have the sense of being acted through by some outside agent. Thoughts and images may seem to flow, driving toward expression. Although, Kris added, not all artistic creation derives from inspiration, it is, for art that reaches a certain level, a requirement. Furthermore, Kris stated explicitly that it is more often depth of meaning and expressive quality (of which inspiration is an essential quality) that are considered in the evaluation of art, rather than skill.

Elaborating further on the inspiration phase of creative activity, Kris (1952) alluded to Plato, quoting the phrases "the divine release from the ordinary ways of man," and a state of "creative madness" (p. 60). In such state the ego controls the primary process and puts it into its service. This is in contrast to the psychotic state in which the ego is overwhelmed by primary process. This contrast is elucidated by consideration of the relation to the public. "Wherever artistic creation takes place, the idea of a public exists, though the artist may attribute this role only to one real or imaginary person" (p. 60). It is acknowledgement by the audience that is necessary in order to confirm artists' belief in their own work and "to restore the very balance which the creative process may have disturbed" (p. 60). It is that the response of others alleviates the artist's guilt. From these considerations, Kris summarized, writing in psychoanalytic terms,

> We may now supplement the distinction of inspiration and elaboration as extreme phases of creative activity in stressing that they are characterized by shifts in psychic levels, in the degree of ego control and by shifts in the cathexis of the self and the representation of the audience [p. 61].

Kris (1952) quoted Freud as writing, "When our psychic apparatus does not actually act in search of some urgently needed gratifications we let this apparatus itself work for pleasure gain. *We attempt to gain pleasure from its very activity*" (italics his) (p. 315). Applying Freud's hypotheses, Kris stated that these shifts in cathexis of mental energy that are discussed in the above paragraph are pleasurable in and of themselves. The implication is one of pleasure for the artist in the very act of creation.

As stated previously, in the phase of inspiration the artist may experience a sense of being acted through by some outside agent. "The driving of the unconscious toward consciousness is experienced as an intrusion from without — an attitude of a passive nature" wrote Kris (1952, p. 302). One may be reminded, here, of the Muses of classical mythology. Nine in number, the Muses were daughters of Zeus and Mnemosyne, Memory. Although they were earlier not distinguished one from another, they were later identified with special fields. Thus, Calliope was the Muse of epic poetry, Clio of history, Erato of love-poetry, Euterpe of lyric poetry, Melpomene of tragedy, Polyhymnia of songs to the gods, Terpsichore of the dance, Thalia of comedy, and Urania of astronomy (Hamilton, 1942). The voices of the muses were "lovely beyond compare" (p. 103). Note that no voice, lovely beyond compare, was identified for architecture, for painting, or for sculpture, since in the ancient world of classical mythology

50

representational arts were seen as crafts. To use Kris's distinction of *inspiration* and *elaboration*, the crafts were seen as of the latter and reflected skill of execution rather than inspiration.

To return to Kris's theory, owing to the idea of inspiration by some outside agent, the artist's communication gains in authority. At the same time, the artist may be relieved of responsibility, ergo anxiety and guilt for what he or she has communicated. Kris (1952), quoting H. B. Lee, wrote that

> it is the reconciliation with conscience and with its projections as God or Muse, which permits the creating ego to view its work as revealed from an outside source and which results in the pleasure of the quality which we call spiritual [p. 302].

Still quoting Lee, Kris wrote, "the Muse is, of course, none other than the projection to the supernatural of the idealized mother" (p. 302).

CHAPTER 3

Artistic Creativity and the
Participation Mystique— Carl Jung

It is well known that the break between Freud and Jung was based on both personal and theoretical disagreements. The personal dimension of this parting was marked by rancor. This bitterness on the part of Freud is perhaps nowhere better documented than in his letters to Sabina Spielrein (Carotenuto, 1982). She, a Russian psychoanalyst and member of Freud's circle in Vienna, had been in analysis with Jung, and published papers that purportedly influenced Freud's conception of the *death instinct*, and Jung's idea of the *anima* and *animus*. In a letter of January 20, 1913, Freud stated, "My personal relationship with your Germanic hero has definitely been shattered. His behavior was too bad. Since I received that first letter from you, my opinion of him has greatly altered" (p. 118). In a letter four months later, Freud wrote to Spielrein, "Quite apart from our scientific differences, his personal behavior merits severe criticism.... the hatred he merits" (pp. 119–120). In exploring the theoretical differences between Freud and Jung in their view of art and artists, it may be helpful to keep this context of enmity in mind.

The psychologist, Jung suggested, is faced with two tasks when addressing art. The first is "to explain the psychological structure of a work of art," and the second is "to reveal the factors that make a person artistically creative" (Jung, 1966b, p. 86). In the former case, we confront a product that reflects complex psychic activities, but appears to be intentionally and consciously shaped by the artist. The psychic apparatus itself becomes the focus in the second task. The two tasks require a focus on the concrete artistic achievement and a focus on the creative human in his or her unique being, respectively. Although the two are interdependent, neither can explain the other.

"The personal psychology of the artist may explain many aspects of his work, but not the work itself. And if ever it did explain his work successfully, *the artist's creativity would be revealed as a mere symptom*" (italics mine) (Jung, 1966b, p. 86). Note well the clause that I have placed in italics. This is the pivotal point of Jung's theoretical departure from Freud in the understanding of art and artists.

Jung (1966b) summarized Freud's position as follows:

Freud thought he had found a key to the work of art by deriving it from the personal experience of the artist. This was a possible approach, for it was conceivable that a work of art might, like a neurosis, be traced back to complexes.... neuroses have a quite definite psychic cause, and that they originate in real or imagined emotional experiences in early childhood.... Freud considers a neurosis to be a substitute for a direct means of gratification. For him it is something inauthentic—a mistake, a subterfuge, an excuse, a refusal to face facts; in short, something essentially negative that should never have been.... By treating a work of art as something that can be analysed [*sic*] in terms of the artist's repressions we bring it into questionable proximity with a neurosis [p. 100].

Conceding that "art that is only personal, or predominantly so, truly deserves to be treated as a neurosis" (Jung, 1966b, p. 101), Jung proffers a quite different view of the possibility of art. The *essence* of a work of art is to be found in its rising above the personal. The essence is not found in personal idiosyncrasies, but in the artist's allowing of art to realize itself through him or her, to speak to humankind. Jung proclaimed that when Freud expressed the opinion that all artists are undeveloped personalities and show marked infantile autoerotic traits, such judgment may be true of the artist as a man, but it is certainly not the case for the man as an artist. The artist is, for Jung, "suprahuman."

Thus, the artist encompasses dual or even contradictory qualities. The artist is a human being with a personal unconscious, and at the same time an "impersonal creative process." His or her personal psychology is best understood in personal terms, be it healthy or morbid. But artistic psychology is collective in nature, not personal. "Art is a kind of innate drive that seizes a human being and makes him its instrument" (Jung, 1966b, p. 101).

In order to understand Jung's theoretical departure from Freud more fully, and more importantly, to bring into focus Jung's inestimably important contribution to the understanding of art and artists, we must look to the core of Jungian theory. Allusions to "personal unconscious," to "col-

lective," and to rising above the personal beg for expatiation. To this I now turn.

Freud, in 1908 in "The Relation of the Poet to Day-dreaming," distinguished between poets who create their own material and those who use the ready-made material taken from myths, legends, and fairytales. He referred to this material as a "racial treasure-house" of "distorted vestiges of the wish-fantasies of whole nations" (Freud, 1963c, p. 42). This is a precursor of Jung's "collective."

In Lecture X "Symbolism in Dreams" of Freud's *Introductory Lectures on Psychoanalysis*, Freud (1966) reminded his audience that "the distortion in dreams, which interferes with our understanding of them, is the result of a censoring activity which is directed against unacceptable, unconscious wishful impulses" (p. 149). He quickly added that this censorship is not the only factor responsible for this distortion; even with dream-censorship excluded, a *manifest dream* would not be identical with the *latent dream*-thoughts that underlie it. Another factor is *symbolism*. In his 1911 edition of *The Interpretation of Dreams* (originally appearing in 1899 but with a title page of 1900), Freud (1961b) claimed that he recognized the presence of symbolism in dreams from the very beginning, but did not come to a full appreciation of their significance until influenced by Wilhelm Stekel. In his final book, *An Outline of Psychoanalysis*, Freud (1949b) wrote:

> Dreams bring to light material which could not originate either from the dreamer's adult life or from his forgotten childhood. We are obliged to regard it as part of the *archaic heritage* (italics his) which a child brings with him into the world, before any experience of his own as result of the experiences of his ancestors [pp. 49–50].

The relevance of such symbolism to art and artists is clearly implied in Freud's (1961b) statement in the 1909 edition of *The Interpretation of Dreams*:

> This symbolism is not peculiar to dreams, but is characteristic of unconscious ideation, in particular among the people, and it is to be found in folklore, and in popular myths, legends, linguistic idioms, proverbial wisdom and current jokes, to a more complete extent than in dreams [p. 351].

The concept of the symbol is not always sharply delineated. "It shades off into such notions as those of a replacement or representation, and even approaches that of an allusion" (Freud, 1966, p. 152). The essence of the symbolic relationship is one of comparison, but even though the connection

between a symbol and that which it symbolizes is sometimes obvious, at other times this connection is cryptic. In the latter case, it is likely that the connection is "of a genetic character" (Freud, 1961b, p. 352). That is, these things that have symbolic connection today may have been united by some conceptual or linguistic identity in earlier, even prehistoric times. Additionally, a symbol may often have more than one meaning, perhaps many, thus making the meaning contextual. So, the symbol may mean one thing in one context, and mean something quite different in another context. There may be multiple contexts, thus multiple meanings even for a given person at a given time. Thus *over-determined*, the symbol admits to *over-interpretation*.

The upshot of all this is that the meaning of a dream element, or we may add, an element or the entirety of a work of art, may be enucleated by means of two classical psychoanalytic methods. First is symbolic interpretation, or what Freud referred to as *constant translation*, based on the fixed meaning of a particular symbol. Second is Freud's method of *free association*, the psychoanalytic parallel of stream-of-consciousness writing. The latter method, yielding associative meaning, reveals that which is personal or idiosyncratic. The former approaches the "collective," to return to Jung's preferred word. Freud (1966) advised the use the constant translation as a supplement to free association. Jung, however, showed even greater affinity for the collective. For him, it became central to his entire theory.

Let us consider the broader context in which Jung's emphasis on the collective occurred. We can begin sketching this context with the acknowledgement that early European explorers discovered that various peoples of Africa, Asia, and the Americas had religious practices and myths that were strikingly similar to their own (Bierlein, 1994). The conquistadores, for instance, noted parallels between Catholicism and the religion of the Incan empire of Peru and Bolivia. Much later, but in a similar vein, the nineteenth-century American historian William Prescott wrote of the parallels between Roman Catholicism as practiced in Spain and the religious practices of the Aztecs. George Catlin, a nineteenth-century American artist and traveler, lived among several tribes of Native Americans and found their rituals to resemble those of the Jews as described in the Old Testament. As discussed by Karl Jaspers, early Jesuit missionaries to Japan were surprised to find a Buddhist sect, "Pure Land" Buddhism, which seemed surprisingly like European Lutheranism. It was during the time of the

nineteenth century writings that the parallel practices between the Old World and the New World became of great interest to the public.

European colonists and missionaries developed several theories to explain the existence of parallel religious beliefs and practices. Among them were the hypotheses of the "Lost Tribes of Israel," the belief that Saint Thomas traveled to Peru, and that non–European religions were satanic imitations of Catholicism. Another of the theories was that all of the societies having similar religious beliefs and practices had received a Divine revelation, but that over time many of these revelations were corrupted. As suggested by Bierlein (1994), this last theory bears some resemblance to one of the two scientific theories that was formulated to explain parallel myths, that being the psychological theory. In this "*psychological* view ... the core elements of myth are products of the human psyche and thus universal to all human beings" (p. 271). The competing scientific view "is that of *diffusion*, which held that the myths were produced in a few myth-creating areas, such as India, and thence passed through contact between cultures during the earliest times" (pp. 270–271). Each of these theories has had and still has its supporters. These two views, and a blending of the two, compete still, but for our present purpose I will pursue the psychological view.

Impressed by the parallels between the myths of widely distant cultures — African, Asian, South American — Adolf Bastian was "one of the first to express this phenomenon as something common to all human beings in all cultures and all periods of history" (Bierlein, 1994, p. 275). By way of refinement of this view, Bastian distinguished the *Elementary Thought*, basic mythic patterns common to all people, possibly by virtue of shared brain structure and function, and *People's Thought*, or inflections of the mythic pattern peculiar to a particular people at a particular time. Thus, he suggested the idea of a collective element, perhaps biologically based, and its specific cultural manifestation.

Lucien Lévy-Bruhl, the highly influential French anthropologist, suggested that there are certain characters and plots that are found in the myths of all people. These he called *motifs*, or *representations collectives*.

The French sociologist Émile Durkeim was impressed by the power of myth to be an agent of morality and to hold a society together. Consistent with Bastian, Durkeim advanced the idea that because of neurologically based functions of the human brain, all myths, regardless of time

or place, contained the same ingredient plots and characters. He referred to this commonality as the *collective conscious*.

> Following the "Elementary Thought" advanced by Bastian, the "conscious collective" of Durkeim, and the "representations collectives" of Lévy-Bruhl, Jung believed in the "collective unconscious," that every human being carries an inborn, neurologically based element of the unconscious that is manifested in dreams and myth [Bierlein, 1994, pp. 291–292].

I may add that Jung saw evidence for the motifs of the collective unconscious to be manifest not only in dreams and myth, but in the hallucinations of psychotic individuals as well as in art. Jung referred to the elements found within the collective unconscious as *imagoes, primordial images*, or most often as *archetypes*. When represented, the "underlying creative forces" of these elements are "irrational, symbolistic currents that run through the whole history of mankind, and are so archaic in character that it is not difficult to find their parallels in archaeology and comparative religion" (Jung, 1966a, p. 50).

In his textbook exposition of Jungian theory, Richard Sharf (2004) offered a clarification of the complexity of archetypes that well deserves mention. "Archetypes are images with form but not content. Symbols are the content and thus the outward expression of archetypes. Archetypes can be expressed only through symbols that occur in dreams, fantasies, visions, myths, fairy tales, art, and so forth" (p. 87).

Jung (1966a) valued the act of artistic creation highly, not only as a means for his patients to access the collective unconscious, but as a means of allowing unconscious material to effect their psyches more fully. To these ends, he sometimes urged his patients to paint. Jung's clinical experience taught him that as long as he helped his patient to "discover the effective elements in his dreams, and so long as I try to get him to see the general meaning of his symbols, he is still, psychologically speaking, in a state of childhood" (p. 47). Furthermore, "he is dependent on my having ideas about his dreams and on my ability to increase his insight through my knowledge" (p. 47). In order to move beyond such elementary understanding into a more complex understanding, and at the same time to move beyond the limits of dependency, Jung might urge his patients to "paint in reality what they have seen in dream or fantasy" (p. 47).

Jung is credited with the invention of the method of *active imagination* for the amplification of dream or fantasy images (Dunne, 2000). The relevance of this method not only for psychotherapy, but for artistic

creativity, warrants the presentation of directions for its use. Jung is quoted as follows:

> The initial question to be directed ... would be: "Who or what has come alive? ... Who or what has entered my psychic life and created disturbances and wants to be heard?" To this you should add: "Let it speak!" Then switch off your noisy consciousness and listen quietly inwards and look at the images that appear before your inner eye, or hearken to the words which the muscles of your speech apparatus are trying to form. Write down what then comes without criticism. Images should be drawn or painted assiduously no matter whether you can do it or not.
>
> Once you have got at least fragments of these contents, then you may meditate on them afterwards. Don't criticize anything away! If any questions arise, put them to the unconscious again the next day. Don't be content with your own explanations no matter how intelligent they are.... Treat any drawings the same way. Meditate on them afterwards and every day go on developing what is unsatisfactory about them. The important thing is to let the unconscious take the lead [pp. 86–87].

"To paint what we see before us is a different art from painting what we see within" (Jung, 1966a, p. 47). We would do well not to take Jung's statement as merely a truism, but to listen to it on a more profound level, perhaps inquiring as to what it is about this process of painting from within that may yield unanticipated reward. In Jung's words:

> Here again my prime purpose is to produce an effect. In the state of psychological childhood described above, the patient remains passive; but now he begins to play an active part. To start off with, he puts down on paper what he has passively seen, thereby turning it into a deliberate act. He not only talks about it, he is actually doing something about it. ... he has to struggle for hours with refractory brush and colours.... Moreover, the concrete shaping of the image enforces a continuous study of it in all its parts, so that it can develop its effects to the full. This invests the bare fantasy with an element of reality, which lends it greater weight and greater driving power.... He is no longer dependent on his dreams or on his doctor's knowledge; instead, by painting himself he gives shape to himself. For what he paints are active fantasies — that which is active within him [pp. 48–49].

Jung (1966b) believed that "the creative urge which finds its clearest expression in art is irrational and will in the end make a mock of all our rationalistic undertakings" (p. 87). The underlying fact is that the creative act is rooted in the unconscious.

Addressing the life of the artist, Jung (1966b) wrote that the artist's life is filled with conflicts, insofar as two opposing forces are competing

within. On the one hand there are the longings of the common man, the desires for security, for satisfaction, and for happiness. On the other hand is what Jung termed "a ruthless passion for creation" (p. 102). It is not just that the two forces are in opposition, giving rise to a sense of inner conflict, but in the artist the latter often overrides the former. Thus happiness, satisfaction of ordinary needs, and security may be sacrificed. Note the power bespoken by the phrase that Jung chose, and even the individual words that constitute that phrase, "ruthless" and "passion." Jung's perspective offers an explanation for the conflict-filled life of the artist, but one that does not invoke the specter of neurosis. Where Freud saw artistic creativity as a substitute for direct, meaning healthy, gratification of instinctual needs, Jung saw the satisfaction of ordinary needs of the artist overridden by a higher calling from the unconscious, the "divine gift of creative fire" (p. 102). But for this, Jung warned, "a person must pay dearly" (p. 102). The divine gift can drain an artist of energy, for there is but a finite amount available, and even of humanity, to the extent that the "personal ego must develop all sorts of bad qualities — ruthlessness, selfishness and vanity (so-called 'auto-erotism') — and even every kind of vice, in order to maintain the spark of life and to keep itself from being wholly bereft" (Jung, 1980, p. 230). What for Freud was neurosis, for Jung was being swept away by the force of a higher calling.

From Jung's (1966b) perspective, the creative process has a feminine quality. Creative work arises from unconscious depths, identified by Jung as "the realm of the Mothers" (p. 103). A critical point must be made here concerning the accessing of archetypal material from this feminine realm. Although many such archetypal images exist, they appear in works of art or in the dreams of individuals only when they are activated by a departure from the middle way. That is to say, it is when conscious life becomes "one-sided or adopts a false attitude, that these images 'instinctively' rise to the surface in dreams and in the visions of artists and seers to restore the psychic balance, whether of the individual or of the epoch" (p. 104). Note that this restorative process can become manifest not only on the individual level, but on that of the epochal.

Herein Jung was invoking a principle which he adopted from Heraclitus called "the rule of *enantiodromia* (a running towards the opposite)" (Jung, 1971c, p. 465). Granting this the status of a metaphysical principle, Jung referred to it as "the regulative function of opposites" (Atwood & Stolorow, 1993, p. 77). "According to this principle, every tendency of the

conscious ego is balanced by the development of an opposite tendency of equal strength in the unconscious psyche" (p. 77). So it is, then, with the several personality dimensions that are the building blocks of Jungian theory. Included are the two *attitude-types*, *introversion* and *extroversion*, and the four *function-types*, the rational or judging ectopsychic functions, *thinking* and *feeling*, and the irrational or perceiving ectopsychic functions, *sensing* and *intuiting* (Jung, 1971b).

Jung (1971d) related the following:

> Experience in analytical psychology has amply shown that the conscious and the unconscious seldom agree as to their contents and their tendencies. This lack of parallelism is not just accidental or purposeless, but is due to the fact that the unconscious behaves in a compensatory or complementary manner towards the conscious. We can also put it the other way round and say that the conscious behaves in a complementary manner towards the unconscious [pp. 273–274].

As is true of the ectopsychic functions, the attitudes may interact in three ways: compensation, opposition, and unity. As already discussed, the particular attitude or function which is conscious is compensated by its opposite in the unconscious. Each function or attitude has its opposite, the two relating as a dynamic tension system. Finally, the function and its antithesis may unite. Such union is through the *transcendent function*. "The psychological 'transcendent function' arises from the union of conscious and unconscious contents" (Jung, 1971d, p. 273).

In his discussion of the transcendent function, Jung (1971d) introduced another set of antipodes, one that is highly relevant to our present exploration of art and artists. When the conscious mind confronts material from the unconscious, there are two main tendencies. "One is the way of *creative formulation*, the other the way of *understanding*" (italics his) (p. 291). Jung elaborated:

> Where the principle of creative formulation predominates, the material is continually varied and increased until a kind of condensation of motifs into more or less stereotyped symbols takes place. These stimulate the creative fantasy and serve chiefly as aesthetic motifs. This tendency leads to the aesthetic problem of artistic formulation. Where, on the other hand, the principle of understanding predominates, the aesthetic aspect is of relatively little interest and may occasionally even be felt as a hindrance. Instead, there is an intensive struggle to understand the *meaning* of the unconscious product [p. 291].
>
> *One tendency seems to be the regulating principle of the other;* both are

bound together in a compensatory relationship…. aesthetic formulations need understanding of the meaning, and understanding needs aesthetic formulation. The two supplement each other to form the transcendent function [p. 293].

When the archetype is activated within the artist, and the symbol thereof expressed, the artist is not only seeking psychic balance for him or herself, but is meeting a psychic need of the society in which the artist lives. Jung (1966b) suggested that it is too much to then ask for the artist to explain his or her work. Interpretation is better left to others, and perhaps even postponed in favor of the perspective of a future time. Always ambiguous, a work of art does not explain itself. In this, it is like a dream. Furthermore, wrote Jung,

to grasp its meaning, we must allow it to shape us as it shaped him. Then we also understand the nature of his primordial experience. He has plunged into the healing and redeeming depths of the collective psyche, where man is not lost in the isolation of consciousness and its errors and sufferings, but where all men are caught in a common rhythm which allows the individual to communicate his feelings and strivings to mankind as a whole [p. 105].

With the elegance of a well-chosen French phrase, Jung revealed what for him was the secret of artistic creativity.

This re-immersion in the state of *participation mystique* is the secret of artistic creation and of the effect which great art has upon us, for at that level of experience it is no longer the weal or woe of the individual that counts, but the life of the collective. That is why every great work of art is objective and impersonal, and yet profoundly moving [p. 105].

This *participation mystique* characterizes one mode of artistic creativity. This is the *visionary* mode, in which, as we have seen, archetypes are summoned and expressed. It is the mode which brings forth material from the hinterland of one's mind. Jung (1966b) described it in such vivid and extensive terms that I want to share his written words.

Sublime, pregnant with meaning, yet chilling the blood with its strangeness, it arises from timeless depths; glamorous, daemonic, and grotesque, it bursts asunder our human standards of value and aesthetic form, a terrifying tangle of eternal chaos…. the primordial experiences rend from top to bottom the curtain upon which is painted the picture of an ordered world, and allow a glimpse into the unfathomable abyss of the unborn and of things yet to be…. We are astonished, confused, bewildered, put on our guard or even repelled; we demand commentaries and explanations. We are reminded of nothing in

61

everyday life, but rather of dreams, night-time fears, and the dark, uncanny recesses of the human mind [pp. 90–91].

From his description, it is not surprising that Jung thought that the public repudiates such art, for the most part, unless it is, as he put it, "crudely sensational" (p. 91). Sometimes, however, visionary art may be disguised under a cloak of myth or history. Jung mentioned Dante and Wagner as masters of such disguise.

If, as Jung (1966b) wrote, "a deep darkness surrounds the sources of the visionary material" (p. 92), it is quite the opposite with the second mode of artistic creativity, the *psychological*, wherein the artist is dealing with familiar material drawn from conscious life. In this latter mode, the artist's vision is reduced to personal experience. Therefore this mode of art focuses attention on the psychology of the artist. If the visionary mode is archetypal, the psychological mode is personalistic. Drawing upon experience from conscious life, the psychological mode of artistic creation deals with powerful emotions, suffering, passion, human fate, and so forth. Writing specifically of the poet, Jung explained the value of this mode of creation.

> All this is assimilated by the psyche of the poet, raised from the commonplace to the level of poetic experience, and expressed with a power of conviction that gives us a greater depth of human insight by making us vividly aware of those everyday happenings which we tend to evade or to overlook because we perceive them only dully or with a feeling of discomfort [p. 89].

In terms of literary categories, the psychological mode of creation includes novels and short stories of romance, crime, and family; tragic and comic drama; lyrics; and didactic poetry. We could, of course, easily extrapolate from the above discussion to other arenas of art.

In a lecture delivered in 1922, focused on the relation of analytical psychology to poetry, Jung (1966b) approached the visionary mode and psychological modes of artistic creativity somewhat differently, referring to the work of Schiller. Schiller wrote of the *sentimental* and of the *naïve*; labeling these in terms of his own theory of psychological attitudes, Jung suggested *introverted* art and *extraverted* art, respectively (p. 73). Jung chose the term *introverted* in favor of Schiller's term *sentimental* in order to emphasize that the relation between the artist and the artist's work is personal, for the work springs "wholly from the author's intention to produce a particular result," and the author is "so identified with his work that his intentions and his faculties are indistinguishable from the act of creation

62

itself" (p. 72). In contrast, with *extraverted* art the works "positively force themselves upon the author" and he is "overwhelmed by a flood of thoughts and images which he never intended to create and which his own will could never have brought into being ... he is subordinate to his work" (p. 73). Jung suggested Schiller's plays and most of his poems as examples of the introverted attitude. The examples of the extraverted attitude that Jung offered are the second part of Goethe's *Faust* and Nietzsche's *Zarathustra*. Any given writer, however, may work in either mode at any given time.

Jung (1966b) spoke not only of the strength of the creative impulse that can arise from the unconscious, but of how willful and capricious that impulse can be. "The creative urge is often so imperious that it battens on their humanity and yokes everything to the service of the work, even at the cost of health and ordinary happiness" (p. 75). Invoking a metaphor, Jung spoke thusly: "The creative urge lives and grows in him like a tree in the earth from which it draws its nourishment" (p. 75). With partial concretization of his metaphor, Jung suggested, that we regard the creative process as "a living thing implanted in the human psyche," naming it an *autonomous complex* (p. 75).

If we are to accept artistic creativity as a manifestation of an autonomous complex, we would do well to know more fully what Jung meant by this term. Although it was Jung who introduced the term *complex* into psychiatry, Freud and Adler adopted it, Freud theorizing about the *Oedipus complex*, the *castration complex*, and the *Elektra complex*, and Adler giving a major role in his theory to the *inferiority complex* and the related *power complexes*. Echoing Goldenson (1984, p. 164), VandenBos (2007, p. 205) defined the complex as "a group or system of related ideas or impulses that have a common emotional tone and exert a strong but usually unconscious influence on our attitudes and behavior." June Singer (1972) provided several refining details to this definition.

> What Jung has called *complexes* are certain constellations of psychic elements (ideas, opinions, convictions, etc.) that are grouped around emotionally sensitive areas. I understand the complex as consisting of two factors. First, there is a nuclear element which acts as a magnet, and second, there is a cluster of associations that are attracted to the nucleus.... the nuclear element of the complex is characterized by its feeling-tone, the emphasis arising from the intensity of the emotion involved. This emphasis, this intensity, can be expressed in terms of energy, a value quantity. In direct relation to the amount of energy, the energic quantity, is the capacity of the nucleus to draw associations to it, thereby forming a complex. The more energic quantity, the

more associations, hence the more material from everyday life experiences gets drawn into the complexes [pp. 37–38].

Jung (1966a) emphasized that "the complex is not under the control of the will and for this reason it possesses the quality of psychic autonomy" (p. 131). Furthermore, "its autonomy consists in its power to manifest itself independently of the will and even in direct opposition to conscious tendencies: it forces itself tyrannically upon the conscious mind" (p. 131). So, independently of the conscious will, the complex "appears and disappears in accordance with its own inherent tendencies" (Jung, 1966b, p. 78).

Logically, with the activation of the autonomous complex, energy is withdrawn from conscious processes, interests, and activities. This may result in apathy, a condition that Jung (1966b) thought was common with artists (p. 79). If not apathy, there may be a regression of conscious functions to a more infantile or archaic level. Jung quoted Janet as referring to this process as an *abaissement du niveau mental*. As Jung explained, "The 'inferior parts of the functions,' as Janet calls them, push to the fore; the instinctual side of the personality prevails over the ethical, the infantile over the mature, and the unadapted over the adapted" (p. 79). "This too," wrote Jung, "is something we see in the lives of many artists" (p. 79).

As might be expected, the introverted or extraverted origin of a work of art is perceptible in the work itself. In the former case, the work would not be too difficult to comprehend. In the case of extraverted art, however, there would be something suprapersonal and transcending our understanding. Therefore, we should not be surprised to find "strangeness of form and content, thoughts that can only be apprehended intuitively, a language pregnant with meanings, and images that are true symbols because they are the best possible expressions for something unknown — bridges thrown out towards an unseen shore" (Jung, 1966b, pp. 75–76).

An understanding of the extraverted mode of creation, or the visionary mode, if you will, opens one to the comprehension of how an artist who has gone out of fashion can be *rediscovered*. A rediscovery may sometimes occur when the level of consciousness of a populace has risen to the level that the artist can express something new in his or her work. That something new may have been present earlier, but only as a hidden symbol. A new level of consciousness may now afford that symbol to be read. The visionary artist, then, may have to wait for the society to catch up in its consciousness before he or she is appreciated anew. Of course, it is possible

that not rediscovery, but initial discovery of an artist may await such awakening of new societal consciousness.

From the above discussion, it should come as no surprise that Jung (1971b) identified an affinity between the *introverted intuitive type* and the artist. This type represents an individual whose *attitude* is that of introversion, while his or her *dominant function* is intuition. "The peculiar nature of introverted intuition, if it gains the ascendancy, produces a peculiar type of man: the mystical dreamer and seer on the one hand, the artist and the crank on the other" (p. 261). Jung immediately added, "The artist might be regarded as the normal representative of this type" (p. 261). Keep in mind that intuition, along with sensation, is a *perceiving* function, whereas thinking and feeling are *judging* functions. Therefore, Jung extrapolated, "As a rule, the intuitive stops at perception; perception is his main problem, and — in the case of a creative artist — the shaping of his perception" (p. 261). Singer (1972) added clarification, if not precision to Jung's statement, indicating that the introverted intuitive person stops at *holistic* perception; "in the case of the artist, the goal is the shaping of the total view" (p. 197). Judgment of that view via thoughts and feelings would be quite secondary, if engaged in at all.

Returning to Jung's analysis (1971b), the intensification of intuition may lead to an aloofness of the person from tangible reality, thereby tending to make him or her seem an enigma to his or her associates. "If he is an artist, he reveals strange, far-off things in his art, shimmering in all colours, at once portentous and banal, beautiful and grotesque, sublime and whimsical" (p. 262). To the more reality-based observer, then, both the artist in his or her person and the art he or she creates may seem incomprehensible or even weird. Thus, we can see a basis for the artist to feel misunderstood.

The principle of enantiodromia would predict that the unconscious of the introverted intuitive type would, of course, be its opposite, a compensatory extraverted sensation function of an archaic character. In Jung's (1971b) words, "the unconscious personality can best be described as an extraverted sensation type of a rather low and primitive order" (p. 263). Jung's reasoning process was well displayed as he explained some implications of this unconscious personality.

Instinctuality and intemperance are the hallmarks of this sensation, combined with an extraordinary dependence on sense-impressions. This compensates the rarefied air of the intuitive's conscious attitude, giving it a

certain weight, so that complete "sublimation" is prevented. But if, through a forced exaggeration of the conscious attitude, there should be a complete subordination to inner perceptions, the unconscious goes over to the opposition, giving rise to compulsive sensations whose excessive dependence on the object directly contradicts the conscious attitude. The form of neurosis is a compulsion neurosis with hypochondriacal symptoms, hypersensitivity of the sense organs, and compulsive ties to particular persons or objects [p. 263].

Again, Singer (1972) commented on Jung's account, writing that the unconscious compensation; i.e., extraverted sensation, would be characterized by "impulsiveness and unrestraint" (p. 197).

If the artist and the introverted intuitive type show the greatest affinity, the next greatest would be between the artist and the *introverted sensation* type (Jung, 1971b). Sensation is greatly modified by the introverted attitude; it "is based predominantly on the subjective component of perception" (p. 253). This is well illustrated by the works of several artists of equal technical ability; with each producing a representational painting of the same landscape, for instance, each painting will be different. The differences will be "chiefly because of different ways of seeing; indeed, in some of the paintings there will be a distinct psychic difference in mood and the treatment of colour and form" (p. 253). Since subjective perception is "characterized by the meaning that clings to it … it means more than the mere image of the object, though naturally only to one for whom the subjective factor means anything at all" (p. 254). This can be a limiting factor for the artist or would-be artist, especially if mimesis is to any extent the goal. To the viewer, Jung pointed out, "the reproduced subjective impression seems to suffer from the defect of not being sufficiently like the object and therefore to have failed in its purpose" (p. 254). This situation may be a basis for the artist to feel unappreciated vis-à-vis critics and general audience alike who value mimesis highly.

It is the capacity for artistic expression that could save the impressions of the artist of the introverted sensation type from sinking into "the depths" and holding consciousness "under a spell" (Jung, 1971b, p. 257). Because he tends to be alienated from the "reality of the object … he lives in a mythological world, where men, animals, locomotives, houses, rivers, and mountains appear either as benevolent deities or as malevolent demons" (p. 257).

Singer (1972), having reminded her readers that the unconscious intuition of the introverted sensation type would be of the extraverted attitude, suggested that he has "an amazing flair for the ambiguous, gloomy and

dangerous possibilities behind the realities he observes" (p. 196). At worst, she wrote, the person "is beset with compulsive ideas and paranoid fears, stemming from the unconscious doubt that the world may not be, after all, as it appears through the impressions of his senses" (p. 196). She reasoned from this that the person of this type often may create "an atmosphere of beauty in his surroundings, and is an artist or a connoisseur of the arts" (p. 196).

It may be an important reminder at this point that the more likely introverted attitude of the artist does not prevent the artist from producing work in either the introverted mode or the extraverted mode. Jung's use of the term *introverted* for both an *attitude* of the personality and for a *mode* of artistic creation may be confusing. Perhaps this is no more so than his use of *psychological* as a synonym for the introverted mode of artistic creation, when in a broader sense, both the visionary mode and the psychological mode are, of course, psychological processes.

While considering the personality of the artistically creative, I would be remiss not to mention the *puer aeternus* and the *puella aeterna*, the archetypes of the eternal youth, male and female respectively. The former has been given much greater attention in the Jungian literature; I turn first to it. Although Jung discussed the *puer aeternus*, the most detailed study was that of Marie-Louise von Franz (2000), who worked closely with Jung for more than thirty years. In her extensive exploration, *The Problem of the* Puer Aeternus, she wrote that the name comes from Ovid's *Metamorphoses* and therein was applied to the child-god Iacchus. The child-god was later identified with Dionysus and with Eros. "He is the divine youth who is born in the night in this typical mother-cult mystery of Eleusis and who is a kind of redeemer. He is a god of vegetation and resurrection, the god of divine youth" (p. 7). Describing such a person, von Franz wrote that "the man who is identified with the archetype of the *puer aeternus* remains too long in adolescent psychology; that is, all those characteristics that are normal in a youth of seventeen or eighteen are continued into later life, coupled in most cases with too great a dependence on the mother" (p. 7). This latter characteristic, presumably observed clinically by von Franz, may result in one of two typical disturbances that Jung pointed out, "homosexuality and Don Juanism" (p. 7). The explanations offered by von Franz are worth noting.

> In the case of the former, the heterosexual libido is still tied up with the mother, who is really the only beloved object with result that sex cannot

be experienced with another woman. That would make her a rival of the mother, and therefore sexual needs are satisfied only with a member of the same sex. Generally such men lack masculinity and seek that in the partner.

In Don Juanism there is another typical form of this same disturbance. In this case, the image of the mother — the image of the perfect woman who will give everything to a man and who is without any shortcomings — is sought in every woman. He is looking for a mother goddess, so that each time he is fascinated by a woman he has later to discover that she is an ordinary human being. Once he has been intimate with her the whole fascination vanishes and he turns away disappointed, only to project the image anew onto one woman after another.... This is often accompanied by the romantic attitude of the adolescent [p. 7].

The refusal to take responsibility, refusal to carry the weight of a situation is perhaps the hypostasis of the *puer aeternus*. In some cases, there is the charm of eternal youth, in others is found "the sleepy, undisciplined, long-legged youth who merely hangs around, his mind wandering indiscriminately" (von Franz, 2000, p. 9). Although the *puer aeternus* can work when fascinated or feeling a high level of enthusiasm for the work, routine work is anathema to him. According to von Franz, Jung spoke of one cure for the *puer aeternus*, that being *work*, work, that is, that requires steadiness and a routine.

Singer (1972) described the *puella aeterna* as the woman who is afraid to grow old. A friend to her children, a coquette with the men, she may conceal her age and be vulnerable to the advertising of age-defying and rejuvenating diets and cosmetics. Behaviorally, she tends to be generally reckless and impulsive. However, in important decisions she may be indecisive and want the advice of many others.

Having explored the archetype of the *puer aeternus* to some degree, I want to consider his relationship to artistic creativity. My basis for this, once again, is the work of von Franz (2000). Unfortunately, any relationship between the *puella aeterna* and artistic creativity has yet to be identified in the literature. Regrettably, then, the remainder of the present discussion must perforce focus on the *puer*.

Boldly put, von Franz (2000) wrote that "in the really great artist there is always a *puer* at first" (p. 47). But, he can and will go beyond this. She stated further that "if a man ceases to be an artist when he ceases to be a *puer*, then he was never really an artist" (p. 47). With the interjection of a more personal comment, von Franz continued, "If analysis saves such pseudo-artists from being artists, then thank God!" (p. 47).

In order to be creative, von Franz (2000) opined, one must possess a considerable capacity for being genuine and at the same time spontaneous. One must be able to let go, so to speak. Ergo, most artists have an inclination toward playfulness. Such playfulness may serve the artist as a relaxing balance to long hours and exhausting creative efforts. However, noting the negative side of this leaning, she wrote that a "tendency to go off into surprisingly childish pleasures is not only a symptom of the *puer aeternus* problem, but also belongs to the creative personality" (p. 31). Thus the artist, in *ludic* expression of the spontaneity so necessary for his creativity, may behave childishly.

If the archetype of the *puer aeternus* provides a Jungian lens for the examination of the male artist qua person, perhaps the archetypes of the *shadow* and of the *anima* and *animus* may serve as additional lenses for gaining perspective not only on the artist but on the manifest work of art, itself. Jung (1971a) wrote, "The archetypes most clearly characterized from the empirical point of view are those which have the most frequent and the most disturbing influence on the ego. These are the *shadow*, the *anima*, and the *animus*" (italics his) (p. 145). It would be good to keep in mind both that these three archetypes exert frequent influence on the ego, and that this influence is of a disturbing nature. Holding this in our thoughts, we can proceed to examine each of these archetypes, in turn.

Of the three archetypes in question, the shadow is the most accessible and the easiest to experience. This condition is due to the fact that "its nature can in large measure be inferred from the contents of the personal unconscious" (Jung, 1971a, p. 145). (The rare exception is the case in which the positive qualities of the personality are repressed and the ego, therefore, plays a negative or unfavorable role.) Furthermore, as Jung (1966a) suggested in passing, the shadow is the "uppermost layer" of one's unconscious (p. 124). Consistent with this, Jung (1971a) wrote that although the shadow is a mythological motif, that is, an archetype, "it represents first and foremost the personal unconscious and its content can therefore be made conscious without too much difficulty" (p. 147). This accessibility is, however, not to be taken for granted. Although, if one is willing to submit to some self-criticism one can encounter one's shadow *when its nature is personal, when it appears as an archetype*, one encounters greater difficulty.

The shadow is a moral problem that challenges the whole ego-personality, for no one can become conscious of the shadow without considerable moral effort. To become conscious of it involves recognizing the dark aspects of the

personality as present and real. This act is the essential condition for any kind of self-knowledge, and it therefore, as a rule, meets with considerable resistance [p. 145].

Although the shadow can be assimilated into the conscious personality, to some extent, there are particular features that are highly resistant.

> While some traits peculiar to the shadow can be recognized without too much difficulty as one's own personal qualities, in this case both insight and good will are unavailing because the cause of the emotion appears to lie, beyond all possibility of doubt, in the *other person* [p. 146].

Such resistance involves *projections*. Projection creates an illusory relationship with one's environment, thereby isolating one from it. With a poetic turn of phrase, Jung expressed, "Projections change the world into the replica of one's own unknown face" (p. 146).

The shadow is, succinctly put, "the negative side of the personality" (Jung, 1971a, p. 147). Interestingly, when carefully examining the "dark characteristics — that is the inferiorities constituting the shadow," one finds that they have both an emotional nature and a kind of autonomy. The latter lends them what Jung first termed an "obsessive quality," but he quickly enhanced the meaning of this by altering the phrase to "possessive quality" (p. 145). Thus, one can feel taken over by the shadow, with an attendant emotional reaction. Emotions usually take over where adaptation is weakest. At the same time, they reveal the reason for the weakness, which is a degree of inferiority and "the existence of a lower level of personality" (p. 146). At this lower level, emotional control is more or less in abeyance, and the person is as a passive victim, incapable of moral judgment.

Jung (1966a) warned that the person who is ignorant of his shadow is dangerous, precisely because he does not know his shadow. On the other hand, "the man who recognizes his shadow knows very well that he is not harmless, for it brings the archaic psyche, the whole world of the archetypes, into direct contact with the conscious mind and saturates it with archaic influences" (p. 239). Raising the shadow to consciousness and integrating it with the ego is a move toward wholeness. Jung reminded his readers that wholeness is not as much a question of perfection as it is a question of *completeness*. Repression results in "one-sided development if not to stagnation, and eventually to neurotic dissociation" (p. 239). In a sense, assimilation of the shadow gives one a body, for "the animal sphere of instinct, as well as the primitive or archaic psyche, emerge into the zone of consciousness and can no longer be repressed by fictions and illusions"

(p. 239). Introducing what is a somber note, if not a paradox, Jung added, "In this way man becomes for himself the difficult problem he really is," but "he must always remain conscious of the fact that he is such a problem if he wants to develop at all" (p. 239). When assimilated, the ego and the shadow are brought together in what Jung termed an "admittedly precarious unity," a term surely to give pause.

Whereas the shadow is always of the same sex as the subject, the anima and animus represent the contra-sexual figures of a man and a woman, respectively. And, whereas "the shadow can be seen through and recognized fairly easily, the anima and animus are much further away from consciousness and in normal circumstances are seldom if ever realized" (Jung, 1971a, p. 148). Dunne (2000) quoted from one of Jung's letters as follows: "Recognizing the shadow is what I call the apprenticeship. But making out with the anima is what I call the masterpiece which not many bring off" (p. 83).

Briefly said, the anima is the female image in a man and the animus is the male image in a woman. Quoting from Jung's letters, once more, Dunne wrote:

> Anima is the soul image of a man represented in dreams or fantasies by a feminine figure. It symbolizes the function of relationship. The animus is the image of spiritual forces in a woman, symbolized by a masculine figure. If a man or woman is unconscious of these inner forces, they appear in a projection [p. 83].

Without going into the intricacies of Jung's theory on this point, we can consider Dunne's (2000) statement that the anima is influenced by the boy's experience of his mother, and the animus by the girl's experience of her father. Such influence may be positive or negative. Focusing on positive images, Dunne described the following:

> Images of the anima can range from primitive woman to romanticized beauty, the Virgin Mary as spiritualized eros, or a goddess of wisdom as mediator to the world within. The animus can be personified, or projected, as physical Tarzan, romantic poet, man of action, political power hero, or wise guide to spiritual truth and meaning [p. 84].

Balancing this description, Jung (1971a) referred to the anima as the "great illusionist, the seductress, who draws him into life ... and not only into life's reasonable and useful aspects, but into its frightful paradoxes and ambivalences where good and evil, success and ruin, hope and despair, counterbalance one another" (p. 150). Atwood and Stolorow (1993) quote

Jung as referring to the anima as *she-who-must-be-obeyed*, and one who may behave as a "jealous mistress." To this they add several more descriptive terms — "overpowering," "enchanting," "seductive," and "treacherous maternal presence with mysterious and bewitching powers" (p. 72). "Naturally," wrote Jung (1971a), "she is a typical figure in *belles-lettres*" (italics his) (p. 151).

Jung (1971a) added further clarification by contrasting the anima and the animus in the following manner: "The animus corresponds to the paternal Logos just as the anima corresponds to the maternal Eros" (p. 152). Continuing, Jung explained the Logos and Eros principles as follows. "I use Eros and Logos merely as conceptual aids to describe the fact that woman's consciousness is characterized more by the connective quality of Eros than by the discrimination and cognition associated with Logos. In men, Eros, the function of relationship, is usually less developed than Logos" (p. 152). The converse would hold for women, in Jung's view. Both in its negative and positive aspects, the anima and animus relationship is always replete with what Jung termed "animosity," meaning that it is emotional and collective (p. 154). Stated in terms more metaphorical, "when animus and anima meet, the animus draws his sword of power and the anima ejects her poison of illusion and seduction" (p. 153). The outcome, Jung added, need not, however, be negative.

In her characteristically lucid style of interpretation of Jungian theory, von Franz (1964) wrote of the anima as "a personification of all feminine psychological tendencies in a man's psyche, such as vague feelings and moods, prophetic hunches, receptiveness to the irrational, capacity for personal love, feeling for nature, and ... his relation to the unconscious" (p. 186). It is not by chance, she noted, that priestess figures such as the Greek Sibyl were used to penetrate the divine will and to connect with the gods. Furthermore, as reflection of the anima, male shamans have sometimes worn women's clothes or depicted breasts on their costumes.

As women who have commerce with forces of darkness or the spirit world, the anima is sometimes personified as a witch or sorceress, or as a priestess. Thus, the anima has two aspects, malefic and benevolent. In her negative aspect, she is the Siren or the Medusa of Classical myth, the Lorelei of Teutonic myth, the *poison damsel* of the Orient, the *femme fatale*. In her positive aspect, the anima is the guide to the spirit world or inner world. Here she has been represented by Apuleius's Isis, the Muses, Dante's Beatrice, and *the eternal feminine* in Goethe's *Faust*, by the Chinese *Lady*

of the Moon, Shakti of the Hindu world, and Fatima the daughter of Mohammed. (von Franz, 1964).

As for the animus, "the male personification of the unconscious in woman," it too appears in both positive and negative aspects (von Franz, 1964, p. 198). When "preached with a loud, insistent masculine voice or imposed on others by means of brutal emotional scenes," the animus, in the form of "a hidden 'sacred' conviction," is in evidence (p. 198). In sinister form the animus has been represented mythically as Hades, and by Blue-beard, other death-demons, and Emily Brontë's Heathcliff of *Wuthering Heights.* Consisting not only of "negative qualities such as brutality, reck-lessness, empty talk, and silent, obstinate, evil ideas," the animus, too, has its positive aspect (p. 203). Consider the fairytale prince, his creative activ-ity paramount, as one acknowledges his "enterprising spirit, courage, truth-fulness, and spiritual profundity" (p. 207).

Jung noted four stages in the development of the anima and four stages in the development of the animus (von Franz, 1964). With exemplary images, von Franz summarized these stages thusly:

> The first stage is best symbolized by the figure of Eve, which represents purely instinctual and biological relations. The second can be seen in Faust's Helen: She personifies a romantic and aesthetic level that is, however, still characterized by sexual elements. The third is represented, for instance, by the Virgin Mary — a figure who raises love (eros) to the heights of spiritual devotion. The fourth type is symbolized by Sapientia, wisdom transcending even the most holy and the most pure. Of this another symbol is the Shu-lamite in the Song of Solomon. (In the psychic development of modern man this stage is rarely reached. The Mona Lisa comes nearest to such a wisdom anima.) [p. 195].

And with the animus:

> He first appears as a personification of mere physical power — for instance, as an athletic champion or "muscle man." In the next stage he possesses ini-tiative and the capacity for planned action. In the third phase, the animus becomes the "word," often appearing as a professor or clergyman. Finally, in his fourth manifestation, the animus is the incarnation of *meaning.* On this highest level he becomes (like the anima) a mediator of the religious experi-ence whereby life acquires new meaning. He gives the woman spiritual firm-ness, an invisible inner support that compensates for her outer softness. The animus in his most developed form sometimes connects the woman's mind with the spiritual evolution of her age, and can thereby make her even more receptive than a man to new creative ideas. It is for this reason that in earlier times women were used by many nations as diviners and seers [p. 207].

As for embodiments of these four animus stages, von Franz (1964) offered the following:

> First, the wholly physical man — the fictional jungle hero Tarzan.... Second, the "romantic" man — the 19th-century British poet Shelley...; or the "man of action" — America's Ernest Hemingway, war hero, hunter, etc. Third, the bearer of the "word" — Lloyd George, the great political orator. Fourth, the wise guide to spiritual truth — ... Gandhi [p. 205].

Singer (1972) pointed out in her discussion of the shadow, the anima and the animus, that there are limitless symbols that may infuse these archetypal forms. In her words, "Each man draws from the residue of human experience those palpable symbols which for him best evoke the images of the invisible and mysterious archetypal elements which are, in themselves, forming tendencies without specific content" (p. 300). The artist's range of expression of the shadow, the anima, and the animus in his or her art is limited only by that artist's creativity. The gamut of artistic expression inspired by the *mundus archetypus* is pointed out very nicely in the profusely illustrated volume that Jung (1964) began editing shortly before his death, *Man and His Symbols*. Further beautiful examples of archetypically-inspired art adorn the pages of Claire Dunne's (2000) biography titled *Carl Jung: Wounded Healer of the Soul*.

As for music, Jung had relatively little to say, quantitatively speaking, but what has been reported is qualitatively precious. According to Dunne (2000), he spoke with the pianist Margaret Tilly, telling her that "music is dealing with such deep archetypal material and those who play don't realize this. Yet, used therapeutically from this level, music should be an essential part of every analysis" (p. 190). In another context, Jung stated that music "expresses in sounds what fantasies and visions express in visual images ... music represents the movement, development and transformation of motifs of the collective unconscious" (p. 190). Quoting from another source, Dunne reported that as for his own tastes in music, Jung was drawn to Bach, Handel, Mozart, and "early music" and had "a penchant for Negro spirituals" (p. 190). It would seem that Jung was sensitive to the effects of music, almost to the extreme, for Dunne wrote that Jung turned off a string quartet playing Schubert because "it moved him too much" (p. 190). Furthermore, Beethoven's late quartets "churned him up almost beyond endurance" (p. 190). Jung's experience of the deeply spiritual level to which music can reach is reflected in Dunne's report that Jung told a friend that "Bach speaks to God. I am gripped by Bach. But I could slay a man who

plays Bach in banal surroundings" (p. 190). Perhaps with appetite whetted by these limited remarks, we can only wish that Jung had addressed music with his usual depth and thoroughness.

If any doubt exists as to the fecundity of a Jungian analysis of an artist's work, such doubt should surely fade in the light of Jung's (1966b) own demonstrations in his essays "'Ulysses': A Monologue" and "Picasso." Referring to Joyce as Picasso's "literary brother" (p. 135), Jung addressed in his essays the many psychological parallels between the work of these artists on the one hand, and the schizophrenic, on the other. He did, however, state unequivocally, "It would never occur to me to class *Ulysses* as a product of schizophrenia" (p. 117). And later, "I regard neither Picasso nor Joyce as psychotics" (p. 137).

> The content is full of secret meaning. A series of images ... whether in drawn or written form, begins as a rule with the symbol of the Nekyia — the journey to Hades, the descent into the unconscious, and the leave-taking from the upper world. What happens afterwards, though it may still be expressed in the forms and figures of the day-world, gives intimations of a hidden meaning and is therefore symbolic in character. Thus Picasso starts with the still objective pictures of the Blue Period — the blue of night, of moonlight and water, the Tuat-blue of the Egyptian underworld.... With the change of colour, we enter the underworld [p. 138].

Thus, did Jung regard Joyce and Picasso as flamboyant representatives of the artist as explorer of the underworld of the unconscious, risking themselves to the *participation mystique*.

CHAPTER 4

Art versus Fascism —
Wilhelm Reich

Wilhelm Reich is surely the most controversial and calumniously mis-understood of the luminaries of psychodynamic theory. Some time ago, I wrote that "the contributions which Reich offered to the world can be arranged conveniently into two somewhat distinct theoretical systems, cor-responding to two periods in Reich's adult life" (Smith, 1975, p. 268). His *character analytic* work from his earlier period, best expressed I believe in his 1933 volume, *Character Analysis* (Reich, 1949), was quite influential. It constituted, for instance, one of the major roots of Gestalt therapy (Smith, 1997). Unfortunately, Reich is more often remembered for his later work on cosmic *orgone* energy and its effects on things as far-reaching as cancer and weather patterns, endeavors for which he was branded by some as a "mad scientist," as psychotically paranoid, and even as a criminal. During this later period Reich continued to address socio-political issues in his writing, as he had done earlier, even as he focused on the exploration of orgone biophysics. He never wrote extensively about art, but broached the topic tangentially. In order to understand Reich's view of art in any depth, it is necessary to place such exploration in the context of his theory of embodied character structure.

The stage was set for Reich's focus on the body in psychotherapy by earlier work by the doyen, Freud himself, and further elaboration of that work by Reich's teacher, Sándor Ferenczi. As early as 1923, Freud declared that "the ego is first and foremost a bodily ego" (Freud, 1960a, p. 16). In a footnote added in 1927, Freud continued, "I.e. the ego is ultimately derived from bodily sensations, chiefly from those springing from the sur-face of the body. It may thus be regarded as a mental projection of the surface of the body ... representing the superficies of the mental apparatus"

76

(p. 16). Interestingly, Freud did not follow through with the implications of this perspective either for the theory of ego development or for the invention of therapeutic techniques that would address problems of ego development that were the consequence of insufficient, inadequate, or traumatizing bodily experience. But, while maintaining a basic allegiance to Freud, Ferenczi experimented with new therapeutic techniques based on the above stated body-ego relationship, referring to his method as *active technique* (Ferenczi, 1952). He explained the value and the dynamics of his active technique as follows:

> The fact that the expressions of emotion or motor actions forced from the patients evoke secondarily memories from the unconscious rests partly on the reciprocity of affect and idea emphasized by Freud in *Traumdeutung*. The awakening of a memory can — as in catharsis — bring an emotional reaction with it, but an activity exacted from the patient, or an emotion set at freedom, can equally well expose the repressed ideas associated with such processes [p. 216].

Thus, Ferenczi introduced an alternative to the traditional treatment approach of Freud. At the risk of over-simplification, we can perhaps capture Freud's approach with the following model:

Talking → Memories → Feelings

In contrast, Ferenczi's active method is represented by the following model:

Body work → Feelings → Memories

(Body work refers to motor activities prescribed in the therapy session or direct touch by the therapist designed to evoke affect, e.g. encouraging the client to strike a pillow when there is evidence of suppressed anger, or a gentle hand on the client's back when nascent sadness is in evidence. For a structured and fairly comprehensive discussion of body techniques, see my book *The Body in Psychotherapy* [Smith, 1985].)

Some 20 years later, Reich (1973) described this latter approach based on direct body interventions, writing of "the possibility of avoiding, when necessary, the complicated detour via the psychic structure and of breaking through to the affects directly from the somatic attitude. In this way, the repressed affect appears before the corresponding remembrance" (p. 301). For Freud, and even more so for Reich, the expression of the feelings (affect), that is, *abreaction* or *catharsis* concomitant with the remembrances,

unlocked the door to freedom from one's prison of psychopathology. As Reich (1949) expressed this, "What matters is that these recollections occur with the corresponding affects" (p. 22).

Returning to Ferenczi, briefly, what follows is further descriptive differentiation of his active method from the traditional Freudian method of psychoanalysis, a

> purely passive association technique. The latter starts from whichever psychic superficies is present and works back to the preconscious cathexes of unconscious material: it might be described as "analysis from above," to distinguish it from the "active" method which I should like to call "analysis from below" [Ferenczi, 1952, pp. 287–288].

But it was with Reich that the body gained unequivocal primacy in the arenas of psychology and psychotherapy. Such primacy is expressed through his concept of the *muscular armor*, perhaps his most important theoretical contribution.

> Reich suggested that the neurotic solution of the infantile instinctual conflict (the chronic conflict between instinctual demands on the one hand and the counterdemands of the social world) is brought about through a generalized alteration in functioning which ultimately crystallizes into a neurotic "character" [Shapiro, 1965]. This "character" is, then, essentially a narcissistic protective mechanism, originally formed for protection against punishment of the child's instinctual expression by the parents or other agents of the social order. It is retained for protection against instinctual "dangers" from within. Character is an organismic phenomenon, manifesting on the physical plane as chronic muscular rigidities. These chronic muscular rigidities, or muscular armor, serve to negate or block impulses to action which are inconsistent with the neurotic character. In time, the muscular armor serves to bind free-floating anxiety [Smith, 1985, pp. 5–6].

Hereby, Reich introduced the notion of defense mechanisms not as purely mental phenomena, but as total organismic functions. That is to say, *character defenses are manifest in the physical structure of the body*. Reich invented body work to soften the chronic muscular rigidities that defined the client's character structure, allowing genuine expression of natural instinctual impulses. Reich (1973) claimed, based on clinical evidence, that when he was able to dissolve muscular armor by means of the application of his body techniques, "one of three basic biological excitations of the body, anxiety, hate, or sexual excitation, broke through" (p. 270). He was satisfied that "*sexual life energy can be bound by chronic muscular*

78

tensions. Anger and anxiety can also be blocked by muscular tensions" (italics his) (p. 270). Referring to his clinical research findings, he stated that "character armorings were now seen to be functionally identical with muscular hypertonia" (p. 270). In other words, Reich claimed that he had empirical evidence that patterns of muscular tension corresponded to one's character structure, or one's personality, if you will.

In his book, *The Mass Psychology of Fascism*, published in 1933 and in English translation in 1946, Reich (1970) explored the relationship between character structure and socio-political behavior, thus bridging human biology and politics. Based on his character analytic work, he suggested that there are three distinct layers in the biopsychic structure of the average person. First is the *surface layer* of the personality, "reserved, polite, compassionate, responsible, conscientious" (p. xi). This would be well and good if it were not that this layer is not in contact with the "deep biologic core of one's selfhood" (p. xi). Therefore, in *The Function of the Orgasm*, Reich (1973) described this layer as "an artificial mask of self-control, compulsive insincere politeness, and pseudo-sociality" (p. 233), terms that bespeak the lack of authenticity at this surface layer.

Concealed by the mask of the surface layer is the *intermediate layer*. It represents that which is repressed, that which is antisocial. It is the "Freudian 'unconscious,' in which sadism, avarice, lasciviousness, envy, perversions of all kinds, etc., are held in check without, however, being deprived of the slightest amount of energy" (Reich, 1973, p. 233). Note Reich's reminder that repression does not remove energy from the impulse, but only holds the impulse in check. Elsewhere, Reich (1970) offered the adjectives "cruel, sadistic, lascivious, rapacious, and envious" to describe the impulses of the intermediate layer (p. xi). In Reich's idiom, "in the language of sex-economy, it represents the sum total of all so-called 'secondary drives'" (p. xi). At variance with natural sexuality, these secondary drives are produced by the suppression of natural life and are expressed through antisocial actions. The formation of these secondary drives is explained succinctly by Reich (1949):

> The lasting frustration of primary, natural needs leads to a chronic contraction of the biosystem (muscular armor, sympatheticotonia, etc.). The conflict between inhibited primary impulse and armor leads to the formation of *secondary*, antisocial impulses (sadism, etc.). Primary biological impulses break through the armor; in doing so, they are changed into destructive-sadistic impulses [p. 150].

In passing, allow me to clarify Reich's rather esoteric term *sympatheticotonia*. By this he meant a chronic dominance of the sympathetic portion of the autonomic nervous system, a dominance that accompanies fear and the fight or flight response.

Given the arrangement of the three layers of biopsychic structure, one can predict that when the mask of cultivation is dropped, it is the perverse intermediate layer that will come into prominence. History seems to offer overwhelming support for this prediction.

Beneath this destructive second or intermediate layer is what Reich (1970) termed the *biologic core*. In this core, the person is "essentially honest, industrious, cooperative, loving, and, if motivated, rationally hating" (p. xi). But this core is unconscious, and it is feared, for, Reich (1973) wrote, "it is at variance with every aspect of authoritarian education and control" (p. 234). "People who are brought up with a negative attitude toward life and sex acquire a pleasure anxiety, which is physiologically anchored in chronic muscular spasms" (p. 7). This quote may deserve rereading in order to appreciate how pregnant it is and to unpack its full meaning.

With broad and bold strokes, Reich (1973) painted the following picture, uniting his biological theories with those of politics:

> The character structure of modern man, who reproduces a six-thousand-year-old patriarchal authoritarian culture, is typified by characterological armoring against his inner nature and against the social misery which surrounds him. This characterological armoring is the basis of isolation, indigence, craving for authority, fear of responsibility, mystic longing, sexual misery, and neurotically impotent rebelliousness, as well as pathological tolerance. Man has alienated himself from, and has grown hostile toward, life. This alienation is not of a biological but of a socio-economic origin. It is not found in the stages of human history prior to the development of patriarchy.
>
> Since the emergence of patriarchy, the natural pleasure of work and activity has been replaced by compulsive duty. The average structure of masses of people has been transformed into a distorted structure marked by impotence and fear of life. This distorted structure not only forms the psychological basis of authoritarian dictatorship, it enables these dictatorships to justify themselves by pointing to human attitudes such as irresponsibility and childishness [p. 8].

Considering the immediately above discussion as addressing the macro level, let us now shift to more of a micro level. At this level, Reich

(1970) addressed the direct relationship between the three layers of biopsychic structure and three socio-political stances which he identified as *liberalism, fascism,* and that of the *genuine revolutionaries.* The key, here, is that *"after social conditions and changes have transmuted man's original biologic demands and made them a part of his character structure, the latter reproduces the social structure of society in the form of ideologies* (italics his) (p. xii). Let us explore each of these three biopsychic-ideological relationships in turn.

From the above explication of the three-layered biopsychic structure, we can recognize that the first layer is *character*-ized by self-control and tolerance. That is, self-*control* and *tolerance* are primary defining qualities of this layer of character structure. These two qualities can be recognized, as well, in the ethical and social ideals of *liberalism.* Liberalism values keeping under tight control the antisocial secondary impulses of the intermediate layer of the biopsychic structure. Deploring these perversions, the liberal seeks to overcome them through ethical norms. The word *tolerance* may be taken as a summary term for reserved, polite, compassionate, responsible, conscientious behavior, as already discussed. Remember, however, insofar as these behaviors are not springing forth from the biological core, they are but simulacra.

The intermediate layer of character structure, in the biopsychic realm, corresponds to *fascism* on the political-ideological level. Reich (1970) wrote that his clinical experience with men and women of various classes, races, nations, and religious beliefs had taught him that *fascism is the organized political expression of the average man's character structure.* He did not believe fascism to be limited to any particular races, nations, social classes, or political parties. From the perspective of character, "'fascism' is the basic emotional attitude of the suppressed man of our authoritarian machine civilization and its mechanistic-mystical conception of life" (p. xiii). Fascism is, then, in Reich's view, a manifestation of the mechanistic-mystical character of modern man. It is constituted of the irrational reactions of the average human character.

Fascist mentality is the mentality of the *little man,* to use another of Reich's (1974) descriptive names. (In order to avoid awkward phrasing and to stay close to Reich's texts, I will use *little man* without intention of excluding women from the diatribe that Reich intended with this term.) This little man is suppressed and enslaved, as we have seen. He craves authority to tell him what to do and how to be, and at the same time he

is rebellious. The rebelliousness found in fascism occurs when revolutionary emotion is distorted, out of fear of the truth, into illusion. Therefore, defining being revolutionary as the rational rebellion against intolerable conditions in society, Reich (1970) proclaimed that fascism is *never* revolutionary.

As one might predict from the title of the book, Reich (1970) devoted the bulk of *The Mass Psychology of Fascism* to the detailed analysis of the contour between fascism as ideology and the fascist character structure. I regard *Listen, Little Man* (Reich, 1974) as a companion volume, written as a monologue, in places vitriolic in its castigations of the common man. The following excerpts will give the reader a taste of his sharp brew, and perhaps even a hint of the heady intoxication that it offers. (*Listen, Little Man* was probably written during the period 1943–1946, and was not originally intended for publication.)

> It is entirely up to you, little man, whether or not you go to war. If you only knew that you're working for life and not for death! If you only knew that all little men on this earth are exactly like yourself, for better or worse.... Someday, I say, you'll no longer be willing to work for death but only for life.... Strike by working for yourself, your children, your wife or woman, your society, your product, or your farm. Make it plain that you have no time for a war, that you have more important things to do [p. 120].

> You'll have a good, secure life when being alive means more to you than security, love more than money, your freedom more than public or partisan opinion; when the mood of Beethoven's or Bach's music becomes the mood of your whole life — you have it in you little man, somewhere deep down in a corner of your being; when your thinking is in harmony, and no longer in conflict, with your feelings; ... when you let yourself be guided by the thoughts of great sages and no longer by the crimes of great warriors; when you cease to set more store by a marriage certificate than by love between man and woman; ... when you pay the men and women who teach your children better than politicians; when truths inspire you and empty formulas repel you; when you communicate with your fellow workers in foreign countries directly, and no longer through diplomats [p. 121].

Elsworth Baker, one of Reich's most prominent students, expatiated on his mentor's socio-political psychology. The extended subtitle of his book, *Man in the Trap* (Baker, 1967), provides a succinct summary of the work: *The causes of blocked sexual energy Its neurotic effects upon human character, its influences on social and political behavior A study based on the theories of Wilhelm Reich*. Devoting nearly 50 pages to his extension of Reich's socio-political theory, Baker defined three socio-political character

82

types. The first type manifests what Reich called the *emotional plague*. This is important enough, I believe, to deserve careful definition. Although Reich (1949, 1970, 1974) devoted considerable space to the emotional plague throughout much of his work, I am partial to Baker's (1967) expository definition.

> It is the necessity of certain individuals, instead of working out their own problems, to set themselves up as the standards of normality and to make their environment, and everyone in it, conform to their own inadequacy.... Cruelty, criminality, nasty gossip, resentment of other's good fortune.... We can say that to the degree that an individual tries to tear down other people or control their lives, he is functioning as a plague character [p. 154].
>
> The emotional plague is expressed in many forms: vicious gossip and defamation of character, pornography, bureaucracy, destructive mysticism, striving for authority over others, usury, race hatred, sadistic treatment of children, criminal anti-social behavior.... People with plague make the rules for children's behavior, put the taboo on sex, write the divorce laws, and make people conform to laws *they* can tolerate ... action and the reason given for it are never congruent ... he must put restrictions not only on himself but even more importantly on those in his environment so that they conform more exactly to his way of thinking [pp. 159–160].

The other two socio-political character types derive respectively from two kinds of defense against feeling, namely *intellectual defense* and *muscular contraction*. In the former case, the person loses contact with the core impulses, thus living primarily from the characterological surface layer. In the latter case, the sensations from the biopsychic core are not completely lost, but are diminished or distorted. Baker (1967) referred to these respective types as the *liberal* and the *conservative*.

Although pure liberal or conservative types are rare, according to Baker (1967), most people tend toward one or the other. Problems are fomented on both the private, individual level and on the societal level by those who are at the extremes of either type.

Baker (1967) offered summaries of both of these socio-political types:

> The basic characteristics of the liberal are a tendency to intellectualism, mechanistic explanations of natural phenomena, and a collectivistic attitude toward social living. The conservative, on the other hand tends toward a feeling attitude toward life, a mystical explanation of natural phenomena, and a selectivistic attitude toward social living [p. 155].

Exaggerated, the liberal socio-political type takes the form of socialist, communist, or what Baker (1967) termed the modern liberal, living almost

exclusively in his or her intellect. The conservative, in exaggeration, is the extreme conservative, the reactionary, and the fascist. Placing these two socio-political character types on a continuum, and including their sub-types, Baker offered graphic presentation.

On the left: Communist ↔ Socialist ↔ Modern Liberal ↔ Liberal

In the middle: Unarmored, healthy type

On the right: Conservative ↔ Extreme Conservative ↔ Reactionary ↔ Fascist

For each of the eight nuances of these two socio-political character types — liberal and conservative — Baker (1967) presented a detailed description. As fascinating as I find his exploration, I will resist the temptation to write further about it. Such a presentation would take us too far afield.

Finally, we come to the crux of the present exploration of Reich, with regard to art and artists. Reich (1970) proclaimed that there are, relatively speaking, people who are in touch with their biological core. These people access and express their natural social and libidinous impulses without the distortions of passing through the intermediate layer of character structure. These are the individuals whom Reich regarded as true *revolutionaries*, true *scientists*, and true *artists*. In his words, "everything that is genuinely revolutionary, every genuine art and science, stems from man's natural biologic core" (p. xiii).

To be more specific, Reich (1970) favored the arts of music and painting, although he clearly held art as a genus in high regard. Consider this encomium: "The 'natural' and 'sublime' in man, that which links him to his cosmos, has found genuine expression only in great works of art, especially in music and in painting" (p. xii).

If we are to explore Reich's special interest in music and painting, we must enter more deeply the realm of his later work, that which he identified as *character analytic vegetotherapy*, to distinguish it from his earlier work in *character analysis*, and eventually *orgone therapy* (Reich, 1949). "When, in 1935 the orgasm reflex was discovered, the accent in character-analytic work shifted to the *somatic* realm" (p. 357). At this point, Reich worked directly with patient's bodies, purporting to dissolve armoring and thus release emotions. In his words, "The term 'vegetotherapy' represented the fact that now my therapeutic technique influenced the character neurosis in the *physiological* realm (pp. 357–358). But Reich found the term *character analytic vegetotherapy* cumbersome. Too long, it also reminded readers

of *vegetables* when written in English, not an association that Reich wanted. And, more importantly, the term represented a division of the organism into a psychic portion and a somatic portion, doing violence to Reich's unitary concept of the organism. The solution came, Reich (1949) wrote, with his discovery of the orgone.

> *The cosmic orgone energy functions in the living organism as specific biological energy.* As such, it governs the total organism and expresses itself in the emotions as well as the purely biophysical organ movements. Thus psychiatry, for the first time and with its own, means, had found roots in objective natural-scientific processes [p. 358].

So, with the term *orgone therapy*, Reich (1949) could eliminate the unwieldy term that he had used earlier and at the same time underscore his unitary concept of the organism. Furthermore, in his theory of the orgone Reich found a powerful construct for the understanding of emotion.

> Orgone biophysics, from the very beginning, was concerned with the central problem of all psychiatry, the *emotions.... Basically, emotion is an expressive plasmatic motion.* Pleasurable stimuli cause an "emotion" of the protoplasm from the center towards the periphery. Conversely, unpleasurable stimuli cause an "emotion"—or rather, "remotion"—from the periphery to the center of the organism. These two basic directions of biophysical plasma current correspond to the two basic affects of the psychic apparatus, pleasure and anxiety.... For a biophysical plasma excitation results in a sensation, and a sensation is expressed in a plasmatic motion. These facts, today, provide a sound fundament of orgone biophysics" [pp. 358–359].

Thus, according to Reich (1949), emotional release could be evoked through character analysis or by means of vegetotherapy. By either method, the body armor could be melted, allowing the hitherto trapped emotion to be expressed. Both methods invite plasmatic excitations and motions, that is, the flow of the orgone energy with which the bodily fluids are charged. "*The mobilization of the plasmatic currents and emotions, then, is identical with the mobilization of orgone energy in the organism*" (p. 359). Vasomotor changes in the patient's body are evidence of this, according to Reich.

So, in every case, regardless of whether childhood memories are accessed, defense mechanisms are dissolved, or muscular armoring is melted, the therapeutic work involves the organism's orgone energy. The question is one of efficacy and efficiency of method—character analysis or vegetotherapy. Although Reich (1949) came to use the term *orgone therapy* inclusively, subsuming both character analysis and vegetotherapy, he clearly came to

favor the latter. "A memory will not produce affect outbreaks like the dissolution of, say a diaphragmatic block" (p. 359). Why?

> We work on the biological depth, the plasma system, the "biological core" of the organism. We have left the realm of psychology, including the "depth psychology," and have even gone beyond the physiology of the nerves and muscles into the realm of the protoplasmic functions [p.359].

Reich (1949) regarded music and painting in a special way because they speak to us "in the form of wordless expressive movements from the depth of the living function" (p. 361). Language, Reich wrote, can reflect the state of plasmatic emotion in an immediate way, but it cannot itself reach this state. Reich explained that in its wordlessness, music is an expression of movement. It can create in the listener the experience of being moved. Music is wordless, yet it can create great emotion, for "musical expression comes from the very depths of the living" (p. 361). Indubitably, artists speak to us in the form of expressive movements from the depth, the core of the living function. Being concerned about the purity of their expressive idiom, music or painting, artists may understandably bristle at any attempts to translate their art into the language of words.

Alexander Lowen and John C. Pierrakos gave a series of lectures in New York City in the fall of 1966 which expanded upon Reich's ideas about art and movement. To put these lectures in context, Lowen and Pierrakos, both having been associated with Reich, were the co-founders of the neo-Reichian school of Bioenergetics. (Pierrakos later diverged from Lowen and identified his own work as Core Energetics [Pierrakos, 1987].) Bioenergetics is the most widely known of the neo-Reichian schools and has added several theoretical and procedural modifications to the classical Reichian position, perhaps most notably the refinement of the theory of character structure (Lowen, 1958). Given that these modifications are not highly relevant to the present discussion, I will reserve any such exploration until later.

Returning to the lectures, fortunately their content has been preserved in a monograph published by the Institute for Bioenergetic Analysis under the title *The Rhythm of Life: A Discussion of the Relation between Pleasure and the Rhythmic Activities of the Body* (1966). The core idea offered by Lowen (1966) is that "we find sensory pleasure in stimuli which harmonize with the rhythm and tone of our bodies" (p. 26). Thus, he reminded us, dance music is enjoyable when we are in the mood to dance, but not if we are trying to think, and a favorite symphony can be irritating if played when one if trying to engage in a serious conversation.

In order to follow Lowen to the next level with his theory of music, we must take a short detour into his conception of the rhythmic structure of the body. In brief, "the rhythmic activities of the body can be divided into three categories: those related to the function of the inner tube, digestion and respiration; those related to the outer tube, sensory perception and voluntary movements; and the activities of the organs and structures between them" (Lowen, 1966, p. 25). These categories roughly parallel the embryonic development of the body from three primary layers, Lowen pointed out, the endoderm, the ectoderm and the mesoderm, respectively. Thus, the body consists of a tube within a tube. Richly supplied with nerve endings the outer tube, that is, the skin, subjacent tissues and striated musculature, is concerned with perception and response to environmental stimuli. It is this part of the body that is most oriented to pleasure and pain. Furthermore, "the relation of rhythm to pleasure is most clearly seen in the motor function of the outer tube, that is, in the voluntary movements of the body. Any motor activity that is performed rhythmically is pleasurable" (p. 26).

The classical example of pleasure in rhythmic movement, Lowen reminded us in his lecture, is dancing. "The music sets the beat going in our bodies which is then translated into the rhythmic pattern of the dance step" (Lowen, 1966, p. 27). But, Lowen emphasized, it is not that the music creates the rhythm; music accentuates the natural beat in the body and increases pleasure by focusing one's attention on that natural rhythm. Given that all bodily activity is inherently rhythmical, music evokes these rhythms that are naturally within us. Relating this to the musician and to his or her audience, Lowen (1966) declared that "music is the expression of the rhythm in the composer's body which finds an echo in the body of the listener" (p. 27). By way of rescuing this statement from being disparaged as stark oversimplification, Lowen emphasized that there are manifold rhythmic patterns that correspond to the innumerable nuances of human mood and desire.

In his lecture, Lowen (1966) explored "the joy of love and the love of joy [as] bodily responses to an excitation that reaches and opens the heart" (p. 28), making use of Beethoven's Ninth Symphony as the musical invitation to this somatic experience. By doing so, Lowen interpreted the symphony through his bioenergetic theory. This is noteworthy as it is an early example of using neo-Reichian theory, in contrast to the more traditional use of primarily Freudian psychodynamic theory or Jungian theory,

in the analysis of a specific work of art. As such, I believe that it will be instructive.

Let us consider, briefly, how Lowen (1966) viewed Beethoven's Ninth Symphony through his bioenergetic lens. He began with the assertion that Beethoven wanted each listener to experience the feeling of joy in nature and in the brotherhood of man. In order for Beethoven to accomplish this, "he had to reach the hearts of his audience with the music, *literally* [italics mine] not figuratively, and to make each listener perceive the rhythmic beat of his heart as it pulses in common with the hearts of others" (p. 28). Acknowledging the power of the first movement figuratively to open the heart, Lowen returned to the theme of a literal somatic effect of the music.

> The second movement is punctuated from time to time by two loud beats of the tympany [*sic*]. These two sounds are so similar to the heart sounds as heard through a stethoscope or with an ear to the chest that the meaning of this movement is clear. One can feel the rhythm of the heart beating gently and contentedly in some passages and excitedly with anticipation in others. As each instrument takes up the theme, we sense that no heart beats alone, all beat in unison [p. 28].

Earlier, Lowen (1964) wrote a more lengthy examination of Beethoven's symphonies, emphasizing the Third, Fifth, Seventh, and Ninth, from "the framework of Reich's concept of orgonomic functionalism" (p. 31). Staying more true to the purpose of the present writing, I shall turn from the specifics of Lowen's examination of the symphonies and focus instead on his contributions to the understanding of music and the arts in general.

"Music functions in a realm beyond the power of words to reach," wrote Lowen; "music has its source in man's core" (1964, p. 31). Whereas words are the preferred language of the mind, music is the language of the heart. Music cannot, therefore, be fully understood or appreciated through its mechanics or its technical rules of composition. First it must be appreciated as first and foremost an emotional expression.

Bioenergetically speaking, music involves the movement of energy. Lowen (1964) added nuanced detail to this basic principle.

> A song is produced by the flow of energy or feeling upward and outward through the vocal cords and the mouth.... The flow of energy or excitation which creates a song has its origin in the heart. This flow of excitation is superimposed upon the deeper excitatory processes of the organism. The

most basic of these is the movement of energy outward to the periphery and the world and inward to the center, which is close to the solar plexus. The movement outward creates expansion and is perceived as pleasure while the inward flow results in contraction and is perceived as unpleasure [*sic*] or anxiety. Superimposed upon this overall movement is an upward and downward pendular flow of energy between the head and the tail end of the organism, which orients the organism in reality. Rhythm and melody are special modifications of this longitudinal streaming due to the superimposition of special currents. In this way the specific qualities of the different emotions are determined bio-energetically [p. 33].

A careful reading of this quoted material may concomitantly usher in a fresh perspective on music and also invite further questions. One such question would be the relationship between singing and crying. Lowen (1964) did not neglect to address this. In both cases, there is intense emotional expression in which the flow of energy is directed upward and outward through the throat and mouth. In both, Lowen suggests, there is a "longing for contact" (p. 34). This is reflected in the outstretched arms of the child who cries for his or her mother, or those of the singer reaching for the audience. "The child longs for contact with its mother, the lover for contact with his loved one; civilized man longs for contact with nature and the singer longs for contact with the cosmos" (p. 34). Lowen saw this concept of *longing for contact with the cosmos* as necessary for the understanding of all great music.

Instrumental music, while it has a different mechanical means of production than singing, is an expression of the same feeling of longing. It has, therefore, the same bio-energetic base in the energy flow from the heart upward and outward through the throat, mouth and arms. Whether the musical sound is produced by the throat and mouth acting on the wind instruments or the arms acting on the string instruments, we are dealing with one fundamental process emotionally and bio-energetically [p. 35].

And, not to neglect dance, Lowen (1964) wrote as follows:

The pleasurable excitation which leads to dancing is characterized by its movement downward in the body so that the excitation stimulates the legs to rhythmic motion. Music and dance are closely related in that music depends upon the rhythm of the lower half of the body to carry the melodic line of the song or the composition. Music is based on rhythm but it adds to the rhythm a special quality which transforms rhythm into song [p. 32].

In comparing the experiences of composing music and appreciative listening to music, Lowen (1964) opined that the composer and the listener

experience essentially the same excitatory process. The artist reaches out in his or her longing for contact, energy flowing upward and outward, but with intensity that exceeds that of the average person. In addition to this greater intensity of flow of energy, the artist possesses a higher degree of self-perception. As a composer, the artist must translate this intense flow of energy, whether derived from one experience or the synthesis of many experiences, into sounds that will reflect such experience with fidelity. "A great work of art is the synthesis of many similar experiences, but its greatness derives in part from the fact that it creates the impression of a single experience" (p. 36).

Addressing the issue of the relationship between suffering and creativity, Lowen (1964) took the position that creativity may follow either a happy and joyful experience, or may be a reaction to shock, grief, or depression. The key is expansion into deep contact with nature and life. In outline form, creativity, according to Lowen, has three characteristics: (1) It originates in a profound inspiration; (2) It carries a high energy charge; (3) It finds a mode of expression appropriate to that inspiration and energy charge. But, this triumvirate of creativity must exist in a most demanding context: "In his creative activity the great artist is above the neurotic disturbances of his society and free from any neurotic tendencies in his own character structure" (p. 37).

Returning to the listener, the ability to appreciate music requires that the listener have the ability to undergo the same energetic process as that of the composer at work, but in reverse. That is, the musical sounds must stimulate and excite the body and energy field of the listener. This stimulation and excitation evoke the feeling of longing. This flow of energy, from the heart upward and outward, grows in intensity until it is felt.

Marc Shapiro (1964), being a composer himself, and thus writing from an informed subjective perspective, echoed much of Reichian-cum-Lowenian theory. The nucleus of his discourse was this: "bio-energetic movement involving the physiology and character of the artist is channeled into the creative work-process" (p. 16). Again echoing the Reichian-cum-Lowenian position, Shapiro addressed the artist and audience relationship as one in which "the created structure is then able to generate in us a response comparable to the flow of thought and feeling that went into it" (p. 16). Still keeping movement at the core of his discussion, Shapiro suggested that the level of response of members of the audience depends on the state of what he termed "receptive motility" (p. 16). So, in the act of

creation, the artist's energy level is raised, flowing into the work being created and the perceiver of that work is stimulated by it, thereby having his or her energy level raised, with a concomitant increase in inner motility. This communication between artist and audience is bio-energetic and tripartite, involving *stimulation, excitation,* and *expressive response.* Art, wrote Shapiro, represents a concentration of expressive movements; more specifically, the basis of music is the moving pulsation of tension and release. It is by flowing with the movement of the music, by inner movement that the listener responds.

The two most obvious examples of the establishment of art in movement are music and dance. Shapiro (1964) attributed the great expressive range and power of music to the many bio-energetic "pulsatory levels of tension and release" (p. 17). Musical pulsation is carried by rhythm, that is, the divisions of the flow of time. Shapiro referred not to a mechanical beat, but rather to "constantly changing alternations of tension and release, from weak to strong beats, and in all kinds of proportional relationships of speed" (p. 17). Further exploring this theme, Shapiro wrote as follows:

Melody, the moving line, traces a varied curve of tension and release in its continual rise and fall. The use of pitch intervals of different relative tension is a structural element used to create pulsation. Phrases, sections, and movements all have the same function on different levels: the development and resolution of tension [p. 17].

Shapiro (1964) declared that the greatest music is characterized by an increased intensity generated by the developmental parts, not necessarily by getting louder and faster, but by increasing "the internal tension of the various elements" (p. 17). In such a unified movement, intimate and characteristic expressions can be presented.

Armoring may seriously interfere with musical performance, given that in the performance of music the bio-energetic response flows directly into the muscles that are required to activate the voice or the musical instrument. The whole body is involved as a fundamental rhythm takes control and expressive movements are transmitted to the instrument and into sound. Shapiro (1964) reminded us that as Reich found, the flow of energy characteristic of pleasure is from center to periphery. Therefore:

Any tightness or rigidity along the way of this movement from center to periphery seriously hampers the effectiveness and completeness of the performance.... Armoring, along with periphery-oriented technical disciplines, unfortunately often prevents the bio-energetic response from completing

91

itself in genuine outer movement. Emotional coldness in a performance indicates a complete blocking of feeling, while affectations in movement and expression indicate a distortion of the core impulses by the armoring [p. 19].

In dance, movement of the body is itself raised to an art form. Regulated by the rhythm of tension and release, the body employs the basic biological movements discussed by Reich, those being contraction and expansion. For the dancer, these manifest as folding of the body and stretching out with the body, respectively. Armoring is, of course, an absolute anathema for the dancer; it means the loss of flow and continuity (Shapiro, 1964).

Shapiro (1964) specifically addressed the audience of a dance performance, suggesting that one literally moves with the dancer, at least on the inside, perhaps feeling pull and streaming of energy in the arms and legs. He suggested that small muscular movements may also occur in resonance with the gross movements of the dancer.

With more than a nod to the socio-political arena, Shapiro (1964) suggested that the artist has no place in a society where work is largely engaged in compulsively, where people are alienated from their creative energy. Therefore, society is largely isolated from the artist. Artistic creativity requires that "the streamings of the body energy that give rise to it must be allowed to take their full course. Hampering of this in any way results in stagnation, or a life of torture in trying to get the impulses through" (p. 23). Quoting Reich, Shapiro declared that the blocking of motor activity is society's means of suppression, including the suppression of creative capacities.

In summary, then, and in complete compatibility with Reichian tradition, Shapiro (1964) viewed "artistic creation as an orgonotic function — a building up of charge to a high potential, and a discharge, or using up of the charge, in the artistic work-process" (p. 21). The artist's capacity to tolerate the high charge and excitement of the artistic process determines the scope and intensity of his or her work, as well as its quality. Achievement in art, therefore, depends on a relatively unblocked energy system, a body that allows bio-energetic motility, that is, relative freedom from armoring. The experiencing of art, too, is affected by bio-energetic motility. A society that espouses a compulsive work ethic suppresses creative energy, fostering people who are estranged from their artistic creativity.

We see, then, with energy pulsations and energy flow in the body as

core elements of Reichian theory, how it was that music was most emphasized in Reichian discourses on art. Wordless, and based on rhythmic expression of energy, music and dance are to art what orgonomic pulsation and streaming are to the life process itself. This is not to say that other arts, even writing, have not been viewed through a bio-energetic lens. Lawrence Barth (1964), for example, penned "The Wall with Holes: An Orgonomic Look at the Writer." Therein he emphasized the need for something more than inborn talent and the development of that talent. That additional requirement for producing good art in any art form is finding ways to allow that developed talent to "flow out through the armor" (p. 25). There is "the necessity for the muscular-emotional armor to melt away at least partly and temporarily" (p. 25).

Barth (1964) boldly stated that "the best writer is the one brought up with the least armoring. The born artist ... does his work automatically and spontaneously, because this is the way his life energy bubbles out of him" (p. 26). The first of these statements hints of socio-political implication. As Barth continued his essay, he hinted more strongly:

Such a person — especially such a writer, or artist of any kind — possessed by his drive, is somewhat less likely to let himself be thoroughly warped by the inevitable attempt to armor him. He at least fights his armor strongly, or semi-dissolves it deftly [p. 26].

Because of this "partly broken (or partly-never made) wall of armor," Barth (1964, p. 26) viewed the artist as one who feels the verve of life more frequently and more lastingly than the non-artist. He or she feels something that mystifies most of humanity. The artist is thus doubly set against society: first, he or she resists the societal pressures to produce armor; second, the artist is not understood by those lacking his or her level of sensitivity and vitality.

As an aside, I want to mention that another example of the application of Reichian theory to understanding the art form of writing can be found in the work of David Kiremidjian (1984). But, in this example, Reichian theory is used as a template for the interpretation of a specific piece of literature, that being Dante's *Inferno*, Canto 17. As such, this is a rather remarkable article. The specifics of Kiremidjian's analysis, however, lie outside the realm of the present chapter.

The above discussion of the work by Lowen, Shapiro, and Barth gives us a basis of understanding for now returning to Reich's theory for a finer grain analysis of the relationship of energy dynamics to music and dance.

Early in *The Function of the Orgasm*, Reich (1973) stated plainly that "sexuality and anxiety are functions of the living organism operating in opposite directions; pleasurable expansion and anxious contraction" (p. 9). Continuing, he presented what he termed the "orgasm formula":

Mechanical Tension → Bioelectric Charge → Biological Discharge → Mechanical Relaxation

Although in this source, published in 1942, he used the words "mechanical," and "biological," others of the Reichian tradition have deleted those words, streamlining Reich's orgasm formula as follows (Baker, 1967; Kelley, 1974; Raknes, 1970):

Tension → Charge → Discharge → Relaxation

With his typically clear thinking, Baker (1967) added precision to the above ideas of Reich. First, he noted most importantly that "normal contraction is exaggerated in anxiety states," adding that "anxiety actually is a contraction against expansion. Contraction alone does not produce anxiety, e.g., contraction from cold" (p. 9). Secondly, he explained that pleasure is felt when energy moves outward to the skin; this constitutes *expansion*. The Tension → Charge portion of the four-step orgasm formula is one of expansion, therefore pleasure is normally experienced. If, however, such expansion is not tolerated, one would contract against it, thus producing anxiety. When the discharge takes place, tension is removed and there is an experience of relief. Furthermore,

> in certain conditions, relaxation is not tolerated following discharge and contraction takes place instead. If discharge has been minimal (orgastic impotence), there is still considerable tension and anxiety is produced. Where discharge has been appreciable, tension is removed and contraction without obstruction occurs, giving rise to unpleasure (sadness). This ... has led to the axiom that "every animal is sad after the sexual act" [p. 85].

In the case of this abnormal scenario, the orgasm formula would be altered as follows:

Tension → Charge → Discharge → Contraction
(pleasure) (unpleasure)

Charles Kelley (1974), in addition to streamlining the terminology of Reich's orgasm formula, suggested emendation of Reich's basic view of this formula. He also took issue with Reich's use of the word *energy*,

preferring a more fundamental word, *radix*. "The world is neither energy nor spirit in its basic stuff. Instead, energy and spirit both arise from the same underlying stuff, which I have called radix" (p. 22). By way of explanation of his term, Kelley wrote that "energy (movement) is the objective branch of the radix process, while feeling is the subjective branch of the same process" (p. 23). For Kelley, radix is the life force involved in the processes of pulsation, charge, discharge, counterpulsation [*sic*], and "the creative life process proper in which a radix flow brings about spontaneous movement and corresponding feeling in the living body" (p. 21). "Counterpulsation," he explained, "is manifested in the muscular armor which blocks feeling and expressive movement by damming the radix flow that underlies both" (p. 21). It is the activity that results in armor, and at the same time, it is "armor in action" (p. 31).

Kelley (1974) wrote that "as a radix system pulsates, it develops a radix charge, which increases tension and the capacity for discharge" (p. 24). The radix charge is lost, then, as it is converted into *feeling* and *movement*. It was Kelley's view that the radix charge led to tension, rather than the other way around. Thus, Kelley's four-step formula:

$$\text{Charge} \rightarrow \text{Tension} \rightarrow \text{Discharge} \rightarrow \text{Relaxation}$$

"The most powerful radix discharges are convulsive," wrote Kelley (1974, p. 24). In spite of what one may take to be implied by this statement, he explicitly stated that discharges are not by any means limited to sexual orgasm, explaining that "the deepest expression of grief, of rage, of terror involve a similar surrender to an overpowering and involuntary convulsion of the whole body" (p. 25). It should be understood, however, that there is some degree of radix discharge in any emotional experience; the stronger the radix discharge, the stronger will be the feelings experienced. It seems that relatively few adults have retained the child's capacity for complete surrender to these involuntary convulsive movements that characterize a complete discharge.

Looking further at the dynamics of the pulsation between charge and tension on the one hand and discharge through feeling and movement on the other, Kelley (1974) noted that "the radix system charges on the inward stroke of the radix pulsation" (p. 25). This occurs during inhalation "when the direction of force is inward towards the center of the system" (p. 25). Exhalation encourages the other pole of the pulsation, that of discharge. Not surprisingly, discharge is more likely when the charge is high.

Some adults, according to Kelley (1974), hold a chronic level of charge and tension. Others block the process of pulsation and charge, itself, thereby maintaining a reduction of vitality. These are *overcharged* and *undercharged* individuals, respectively. Kelley reminded his readers that few persons fit one of these categories fully. Instead, "most persons have blocks that cause overcharge in some parts of the body and undercharge in others" (p. 27). Nevertheless, Kelley offered the following generalizations:

> The overcharged person ... gives the impression of considerable vitality and energy. His speech tends to be forceful and his movements hyperactive ... the chest is held high in chronic inhalation, for it is exhalation that is blocked. The muscles tend to be tight and the body tense ... usually the tension is centered in the upper chest and includes the shoulders and face. The undercharged person gives the general impression of low vitality and a lack of energy. Respiration is shallow and the chest is depressed in an attitude of prolonged exhalation.... Muscles tend to be flaccid. Movement and speech are slow and unassertive [pp. 26–27].

Throughout his published work, Stanley Keleman (1979) placed emphasis on the issue of the containment of energy, in his words, "how we chose to let our excitement expand and grow, how we choose to express or not express it" (p. 30). The model he offered was one of a continuum from *overbounded* to *underbounded*. The overbounded individual is over-restrictive, dulling him or herself, not wanting to show being excited. Not allowing excitement to grow and expand, this person exerts excessive restraint. The underbounded person, at the other pole of the continuum, lacking restraint and having weak boundaries, tends to surrender to every impulse. It is interesting that "generally they have developed patterns of explosion, in which they permit their bodies the catharsis of impulsively unloading excitement, like children instantly acting out all needs and feelings" (p. 31). In the words of Keleman, the overbounded person has an "overly rigid container," while the underbounded person has a "weak container" (p. 31). The former "pushes life down," and the latter "lets his process leak out, erupt" (p. 31). As one might guess, it is the experience of the middle zone of the continuum that is most desirable. Turning, once more, to the words chosen by Keleman, "If one is neither too bounded nor too unbounded, the steps of his own process of excitement begin to be contained, and a direction, or organization of feeling emerges" (p. 31). The issue is that of how one lets excitement arouse one's body, how one allows or disallows oneself to be excited.

The pulsation of energy is an underlying theme that runs throughout Reich's work and that of his followers such as Baker and the neo–Reichians (to use Kelley's term) such as Keleman, Kelley, and Lowen. Reich's four-step orgasm formula is the foundational model for the dynamics of that energy. To this basic model we can add the several elaborations and modifications discussed above. This elaborated and modified four-step orgasm model opens the way to a deeper understanding of the psychology of music and dance. Through relating this model to aspects of music theory, we can now extend the work of Shapiro (1964) discussed above.

The similarities between the four-step orgasm formula that I have been discussing, and *the pattern of tension and release that moves through music* are striking. Let us consider how such tension and release are understood in terms of music theory. One source of tension and release is found in the *contour* of a selection of music, that is, the shape that the upward and downward flow of pitch creates. As the pitch ascends it can give the music a more tense or lively feel. When, conversely, the pitch descends, it can lend to that section of the music a quieter, even melancholic or dark feel. Let us consider the four contours which a melody may assume, *arch*, *wave*, *inverted arch*, and *pivotal* contour (Pilhofer & Day, 2007).

In the arch form of contour, the pitch simply goes up, then down. "When music goes up in pitch ... gradually ... it results in an increase in tension in that section of the composition. The lower the pitch gets in ... a gradual arch, the more the level of tension decreases" (Pilhofer & Day, 2007, p. 220). In the case of the wave contour, the pitch goes up and then down, repeating this pattern over and over so as to resemble a series of waves. Lacking the gradual quality of the arch, "the wave contour permeates most happy-sounding pop music" (p. 220). As the name clearly reveals, the inverted arch contour assumes the converse shape from that of the arch. The pitch begins high then gradually descends, perhaps to repeat the pattern. Finally, in the pivotal contour, the pitch varies around a reference pitch; when the pitch ascends, it drops back to the reference pitch, when it descends, it returns to that reference. "A pivotal melody line essentially pivots around the central note of the piece" (p. 222). It resembles a wave melody, "except that the movement above and below the central note is very minimal and continuously returns to that central note" (p. 222). This is the melodic pattern that is often used in traditional folk music.

For a more complete understanding of the relationship between the contour of a melody and the tension that it creates, the range of the melody

must also be considered, that is, the interval between the lowest and the highest pitches of that melody.

> The rise and fall of tension in a melody is often proportional to its range. Melodies with a narrow pitch range tend to have only a slight amount of musical tension in them, whereas melodies with a wide range in pitches are more likely to have a wider expressive range. As the range of pitches in a song is widened, the potential for greater levels of tension increases [Pilhofer & Day, 2007, p. 222].

Although composers sometimes use the tension created between *consonant* harmonies and *dissonant* harmonies to give the listener a sense of the beginning and ending of a musical composition, dissonance can also be used for the creation of tension within the piece. Whereas consonant harmonies are aurally pleasing, suggesting a quality of stability, a dissonant harmony sounds unstable or in some manner not right. The tension created by a dissonant harmony may be resolved through the return to a consonant harmony. A thorough understanding of the manner in which chords are built from tones is not necessary for the aural recognition of consonant and dissonant harmony. Hearing the dissonant chord or chords, followed by a consonant chord offers the listener an immediate experience of tension and tension resolution.

"Just as most music follows a basic pulse set forth by the time signature, most Western music also follows a pulse of tension and release through changing chord progressions" (Pilhofer & Day, 2007, p. 207). The complexity of the theory surrounding the order of the progression of chords within a piece of music need not be of concern herein. Staying within the limits of a relatively simple explanation, the issue here is one of *cadence*, that is, any place in a musical composition that feels like an ending, be that the end of the piece, the end of a movement or section, or the short pause at the end of a musical phrase. Certain rules of cadence have evolved; when these rules are violated, most listeners react with dissatisfaction. A satisfying ending usually involves the use of certain chord progressions that allow the listener to predict the cadence. The rules of such chord progression are analogous to the grammar of the written or spoken word.

Foundational to most music is the *harmonic goal*. What this means is that a phrase begins with a I chord, then goes through a progression of chords before reaching a IV or V chord, depending on the type of cadence. Tension increases with the chord progression until it is released by the return to the I chord. The harmonic goal is so basic that Pilhofer and Day

(2007) wrote that "the entire history of Western music can be summed up by I-V-I or I-IV-I. From the Baroque period to rock and roll, this formula holds" (p. 208). As the simplest example, let us consider the key of C major. The first chord, taking its name from its *root note* is, of course C. This is the I or *tonic* chord. Moving up the scale, then, the IV chord, or *subdominant* chord is F, and the V chord, or *dominant* chord is G. Thus, C-F-G is the three chord progression in the key of C major. Regardless of how many chords the composition contains or how long the piece is, by virtue of the harmonic goal, the piece will reach the subdominant or dominant chord, all the while building tension, until it releases that tension through the return to the dominant chord, or as we will see shortly, intentionally leaves the tension unresolved.

If you will bear with me in this journey into music theory a bit more, I will add an additional piece concerning cadence which should be useful in understanding pulsation of tension and release. In Western harmonic music, there are four types of cadences commonly used, namely *authentic cadence*, *plagal cadence*, *deceptive cadence*, and *half- cadence* (Pilhofer & Day, 2007). Ignoring the detail of the subtypes, *perfect authentic cadence* and *imperfect authentic cadence*, we can content ourselves with knowing that authentic cadences are considered the strongest. Continuing to use the designations of major chords, they are represented by a I-V-I, or tonic-dominant-tonic progression. Incidentally, Beethoven was partial to authentic cadences, choosing one for his "Ode to Joy." In the case of the plagal cadence the IV chord is the harmonic goal, creating a I-IV-I progression. Originating with medieval church music, and well illustrated by Gregorian chants, the plagal cadence has come to be known as the *Amen cadence*. The resolution of tension with the return to the tonal chord is not as complete with the plagal cadence as it is with the authentic cadences. The return seems somewhat indecisive.

In terms of tension release, deceptive cadences and half-cadence are considerably less powerful than authentic cadences or plagal cadence. Their relative lack of puissance in this regard stems from their not returning to the I or tonic chord. In the case of deceptive cadences, an ultimate point of tension is reached on the V or dominant chord, only to resolve on something other than the tonic I chord, most usually the *submediant* chord (in the case of the key of C major, vi or A minor). Therefore this cadence is sometimes referred to as an *interrupted cadence*. With half-cadence, the phrase or passage or end of the piece finishes at the point of highest tension,

the dominant or V chord, itself, leaving the listener feeling unresolved (Pilhofer & Day, 2007).

Heavily imbued with anthropological observations concerning music and possession, Gilbert Rouget's (1985) volume *Music and Trance* offers us further clues to the creation of tension or energy charge through music. After his detailed exposition, Rouget made the following concluding remark:

> Of all the arts, music is undoubtedly the one that has the greatest capacity to move us, and the emotion it arouses can reach overwhelming proportions. Since trance is clearly an emotional form of behavior, it is not surprising that musical emotions should prove to be destined to some extent, under the pressure of cultural factors, to become institutionalized in this form. This would mean that we are dealing here with a relation between music and trance that, although strongly influenced by culture, is nevertheless based on a natural — and thus universal — property of music, or at least of a certain kind of music. Moreover, in emotional trance it is music alone that produces trance [p. 316].

Having investigated whether the trance effects of music are "due not to its acoustic characteristics, but to the manner in which they are shaped," that is, "the rhythmic, dynamic, or melodic — or more correctly modal — features of the music," Rouget (1985) formed an interesting conclusion. He found "the acceleration of tempo, to be universally used as a means of triggering trance" (p. 81). Furthermore, "as is frequently the case with all sorts of music, acceleration of tempo very often goes hand in hand with an intensification of sound ... simultaneous *accelerando* and *crescendo*" (p. 82). He did, however, caution his readers that "although the dramatization of the music by *accelerando* and *crescendo* often plays a role of primary importance in triggering trance and/or fit, this rule is nevertheless far from absolute" (p. 86). With what may be a hint of wry humor, Rouget noted that as far as he knew, *Bolero*, "which is one enormous *crescendo*," does not typically induce possession in the concert halls. I suggest, however, that its effective use in the score of the film "10" of some years back well demonstrated the emotional power of the *crescendo* in the theater, even though any pure effect was confounded by the visual stimuli that accompanied it.

In his investigations, Rouget (1985) also found that "breaks or abrupt changes in rhythm" were another characteristic of music leading to trance (p. 81). Although the data that were available to him did not justify a conclusion that such were universal, he did state that breaks and abrupt

changes in rhythm did recur frequently. Here, then, is another source of tension.

Writing of the effects of music on one's body, Rouget (1985) reminded his readers that a musical vibration can be palpable. "In an organ loft, when the organ plays loudly, one absorbs the music with one's whole body" (p. 120). "'To bathe in music,'" he wrote, "is not just a metaphor" (p. 120). Rouget acknowledged that it is this physical impact on the listener that especially pop music is seeking, and that "through the din of vast amplifiers, such music obtains effects of violence and acoustic turbulence never before achieved" (p. 120). He quoted Alain Roux as declaring that "this amount of power acts directly upon the body and creates a feeling of participation that many people never attain even during the sexual act," and "the sounds of the electric bass (infra-sounds) produce vibrations localized in internal erogenous zones of the abdomen…. The repetitive melodies and perpetual thrumming instantly produce a light hypnosis" (pp. 120–121). The identification of the effect on "erogenous zones of the abdomen" certainly makes the relevance of this to Reich's orgasm formula obvious.

Referring, once again, to the level of emotion that music can call forth, Rouget wrote as follows:

> The state of affective resonance that music—or at any rate certain kinds of music—creates in any individual is another aspect of the upheaval it creates in the structure of consciousness. Nothing is more laden with emotional associations than music, nothing is more capable of recreating situations that engage one's entire sensibility. It induces the individual into a state in which both his inward feelings and his relations with the outer world are dominated by affectivity [p. 123].

Indubitably, such "upheaval," such "engagement" can be equated with the tension → charge of Reich's four-step orgasm formula, or the charge → tension of Kelley's modification thereof.

The parallel to Reich's four-step orgasm formula seems abundantly clear in the "traditional musical sequence of events" as stated by Jamey Aebersold (1992, p. 45):

Statement of theme (motif) → Development of theme → Climax → Release

Aebersold wrote simply that "tension is that which builds intensity and excitement…. Release is the natural relaxation of tension and must follow any climax" (p. 44). His list of techniques for the achievement of tension, as would be anticipated, includes the various ones already discussed. In

addition, he mentioned several that are limited to particular instruments and musical genres, such as "jagged articulations (flutter tongue, stab the reed, over-blow)," and "dramatic devices (swoops, glissandos, shakes, trills, etc.)" (p. 45).

The artful manipulation of these several features which I have reviewed from the work of Pilhofer and Day, from that of Rouget, and of Aebersold is the wellspring of musically created tension and release. In order to aid in fixing them in mind, I will state them in bald form.

- Contour
- Range
- Consonance and Dissonance
- Cadence
- *Accelerando*
- *Crescendo*
- Breaks or abrupt changes in rhythm
- Acoustic turbulence
- Jagged articulations
- Dramatic devices

What I am suggesting is that the four-step orgasm formula of Reichian theory is a useful model for the interpretation of the pulsation of tension → release in musical composition. Interpreted in this manner, music is brought under an umbrella of more detailed psychological understanding. Before leaving this discussion, however, I want to introduce a note of precision by interpreting cadence, in particular, through Lowen's modification of the Reichian model.

Earlier, I credited Lowen with further developing Reich's views on character structure. I believe that the second major theoretical contribution that Lowen made to the Reichian tradition was his concept and emphasis on *grounding*. Lowen (1975) has declared that grounding is both unique to bioenergetics, and one of its cornerstones.

> The feeling contact between the feet and the ground is known in bioenerget-ics as *grounding*. This denotes a flow of excitation through the legs into the feet and ground. One is then connected to the ground, not "up in the air" or "hung up." ... To be grounded is another way of saying that a person has his feet on the ground. It can also be extended to mean that a person knows where he stands and therefore that he knows who he is.... In a broader sense grounding represents an individual's contact with the basic realities of his

existence. He (or she) is rooted in the earth, identified with his body, aware of his sexuality, and oriented toward pleasure [Lowen & Lowen, 1977, p. 13].

Lowen and Lowen (1977) explained that "when a person becomes highly charged or excited, he tends to go upward, to fly, or to fly off. In this condition, despite a sense of excitation, or elation, there is always an element of anxiety and danger" (p. 14). Conversely, "the direction downward is the way to the pleasure of release or discharge" (p. 14). Lowen (1975) was abundantly clear that "the more a person can feel his contact with the ground, the more he can hold his ground, the more charge he can tolerate and the more feeling he can handle" (p. 196).

Revealed in these last few lines are the three marrowy issues of bioenergetics theory and practice, namely, *grounding*, *charging*, and *discharging*. Think, then, of grounding as an anchoring, a connection with a stable base, a solid point of reference from which one can move and return, from which one can take on tension and release it. Charging is the building of tension. Discharging is the release of built up tension. "Going up is exciting and tensing, but coming down is satisfying and releasing" (Lowen, 1980, p. 272).

> The excess energy of the living organism is constantly being discharged through movement or through the sexual apparatus. Both are functions of the lower part of the body. The upper part is mainly concerned with the intake of energy in the form of food, oxygen or sensory stimulation and excitation.... The function of discharge is experienced as pleasure [Lowen, 1972, p. 55].

Now, let us interpret the musical pulse of tension → release in terms of bioenergetics, using authentic cadence as our model. Musically speaking, the pulse is from tonic chord to the harmonic goal of the dominant chord by way of various intervening chords, then back to the tonic chord. Bioenergetically speaking, the tonic chord is the grounding of the listening experience. Throughout the musical flow through various chords, the artful use of contour, range, dissonance, *accelerando*, *crescendo*, rhythmic changes, acoustical turbulence, jagged articulations, and various dramatic devices builds a charge that reaches its zenith at the dominant chord. Pleasurable discharge is found through *movement* (and *feeling*, Kelley would add), and descent is made, back to grounding on the tonic chord. I suggest the following bioenergetic diagram for authentic cadence:

ground → charge → discharge → ground

With slight modification, this scenario can be applied to the other cadences. With plagal cadence, the harmonic goal of the subdominant chord would result in a lesser charge than that experienced with authentic cadence, assuming that the other sources of charge are held constant. Ergo, the discharge would be weaker, resulting in less pleasure.

ground → weak charge → weak discharge → ground

With deceptive cadence, having reached the dominant chord, the listener is fully charged. But the process of discharge may be foreshortened or confounded, for instead of a return to ground, the cadence continues to a chord that may add charge. This may give the listener a feeling of incompleteness of the initial pulsation, for even though there was a sequence of charging and discharging, the sense of starting over with a new sequence is lacking.

ground → charge → discharge → charge

Finally, in the case of half-cadence, there is initial grounding, and there is charging, but there is no discharge. Kelley would perhaps regard this as resulting in an overcharge. In this scenario, with release through appropriate movement and emotion denied, the listener is likely left feeling tense.

ground → charge → overcharge

As we have seen, the Reichian theoretical tradition not only sheds light on artistic creativity as a whole, but it may illuminate the specific area of music more fully than does any other psychodynamic tradition. In addition, the Reichian tradition has enjoyed a special relationship with artists. Kelley (1964) asserted that "it has long been apparent that the work of Reich had more appeal to the artist than to the scientist" (p. 1). Such a declaration surely arouses curiosity and begs for explanation. In his opinion, Kelley stated that one of the reasons is that artists are not as restrained by societal conventions as are scientists, and therefore are less likely to be repelled by the revolutionary character of Reich's work. "Art," wrote Kelley, "is less rigidly codified, with fewer barriers to new ideas" (p. 1). In addition, Reichian research and art hold a requirement in common, that being "clearness of perception" (p. 1). Anecdotally, Kelley related that much of the funding for Reichian research came from people in the arts, and that those scientists who were interested in orgonomy tended to have "unusually strong interest and involvement in the arts" (p. 1).

Consistent with the above, Philip Rieff (1966) judged that among those attracted to Reich some of "the most interesting by far were writers and artists" (p. 175). Rieff referred to some of these as "first-rate creative talents" (p. 175). Rieff had his own explanations for the art-orgonomy affinity. For one thing, orgonomy did not rely heavily on words, and therefore did not compete with the writer on the writer's familiar ground in the manner that Freudian psychoanalysis did with its "incessant talk, analytical talk" (p. 175). Reich appealed to the unfamiliar, the realm of the body. But what of other art forms? "Reich did not attract portraitists of the conventionally beautiful, or commercial artists; rather, he attracted men who, proud in their alienation drew and wrote against the grain of society" (p. 175). The contemporary artist, Rieff wrote, believes that he or she must oppose society in order not to be defeated, and through orgonomy Reich offered a way of opposition.

Rieff (1966) also credited flattery as a reason that Reich attracted artists. Reich flattered artists by understanding them to come closest to the unarmored genital character type.

In spite of the artists, Reich (1970) opined that since the early "work-democratic" form of social organization broke down, the biological core has not had societal representation. Let me add this, his rather sobering comment: "Thus far, neither the genuine revolutionary nor the artist nor scientist has won favor with masses of people and acted as their leader, or if he has, he has not been able to hold them in the sphere of vital interest for any length of time" (p. xiii). This suggests that artists, at once vital to society, are at the same time peripheral, perhaps marginalized members. Members they are, though, in Reich's inclusive work-democratic value system. This is revealed in the following excerpt: "he who knows the meaning of devoted work, be he a mechanic, researcher, or artist" (p. xvii). As such, the artist is a *worker*, for in Reich's work-democratic vision, "everyone who performs vitally necessary social work [is called] a *worker*" (pp. 386–387). And alas, "the artists and writers who followed Reich were, like him, defeated men of the left; for the defeated who, nevertheless, retained their pride of alienation" (Rieff, 1966, p. 176). The artist, Rieff stated, merely by being himself is, to use Reich's term, a "genuine revolutionary" (p. 176).

CHAPTER 5

The Artist and the *Will* to Create — Otto Rank

As a young man, Otto Rank was a scholar and, interestingly, a poet. He was not medically trained, but focused his studies on art, engineering, history, philosophy, and psychology (Munroe, 1955). Recognized by Freud for his "talent for applying psychoanalysis to the arts and humanities, especially to literature, theater, and mythology," he became "Freud's early protégé" (Wadlington, 2001, p. 280). This association prevailed for more than twenty years. In time, however, as was true of Adler, Jung, and Reich, Rank seceded from Freud and developed his own formulation of psychodynamic theory and practice, calling his approach *Will Therapy* to distinguish it from Freudian psychoanalysis. More specifically,

> after his separation from Freud in 1926, Rank developed an existentially-informed theory of art and creativity; a personality typology based on the artist as an exemplar of healthy development; and an innovative approach to the analytic relationship that may well qualify as the first existential-humanistic psychotherapy [p. 281].

It is, of course, his theory of art and creativity and his use of the artist as exemplar of the healthy personality that are herein of special interest.

Turning first to the latter of these, let us explore the artist within Rank's personality typology. Wadlington (2001) has reminded his readers that, similar to other theorists of his time, "Rank conceptualized the self as embodied, and the will as individualized" (p. 282). Not only is the person, then, represented corporeally, but emphasis is placed on intentional individual striving. Furthermore, Wadlington offered a summary of such poignancy that I quote it with the addition of my italics. Nota bene! Rank *"emphasized a modern romantic vision of the artist as a unique person who strives for originality and authenticity despite a pull to cultural conformity"*

106

(p. 282). Perhaps not earth-shaking at first glance, this pronouncement is tightly packed with meaning, and when unpacked brings with it potentially exciting implications. Importantly, the artist as viewed by Rank resists conforming to the dictates of society, and follows instead his or her own self-determined, individualized direction, thereby qualifying him or her as a figure that fulfills a romantic-cum-heroic ideal.

Rank's *artist* bears striking resemblance to Nietzsche's *Übermensch.* (It is unfortunate, I believe, that this is sometimes translated as *superman.*) This is not surprising, given that, as we are told, "he ... immersed himself in the writings of Nietzsche" (Atwood & Stolorow, 1993, p. 149). Having read Nietzsche, Rank was surely familiar with the two models of authenticity that the philosopher suggested. Golomb (1995) referred to these two models, which at first appear as contradictory, as deriving inspiration from a biological metaphor and deriving from art, respectively. The first of these involves the realization of one's potential; that is, the actualization of oneself as one is, the manifestation of one's true nature. Nietzsche's second model of authenticity focuses on the awesome freedom of choice that one has in creating herself or himself. "In contrast to the biological model of authenticity which seems to put the limiting factor of one's nature on par with the opportunity for choice, the artistic model clearly highlights creative choice" (Smith, 2003, p. 123). So, for Nietzsche, the biological model takes essence or inborn nature as its starting place, "making the choice of actualizing or not actualizing that essence the crux of authenticity" (p. 123). His artistic model involves "shaping oneself heroically, in spite of the forces of cultural conditioning" (p. 123). Thus, we can enhance our understanding of Rank's view of the artist by way of analogy with Nietzsche second model of authenticity.

The self-created artist : Rank :: The artistic model of authenticity : Nietzsche

By coming to frame his patients' symptoms as indications of creative failure, Rank elucidated his artist-type through his clinical work. In his words:

> The study of a certain neurotic type, which I had already regarded as "*artiste manqué*" in my youthful work, gave me a new approach, on the basis of that analysis, to the problem of the creative personality. We have in such cases either individuals who, though they are really productive (since they possess the productive force of dynamism), produce nothing, or else artistically productive men who feel themselves restricted in their possibilities of expression [Rank, 1932, pp. 25–26].

Although, in even his own discussions of his typology, Rank typically addressed three types, in his *magnum opus, Art and Artist*, subtitled *Creative Urge and Personality Development* (Rank, 1932), he included a fourth. As background, let us consider his derivation of and recognized limitation of "types."

> Thus in the fully developed individual we have to reckon with the triad Impulse-Fear-Will, and it is the dynamic relationship between these factors that determines either the attitude at a given moment or — when equilibrium is established — the type. Unsatisfactory as it may be to express these dynamic processes in terms like "type," it remains the only method of carrying an intelligible idea of them — always assuming that the inevitable simplification in this is not lost sight of [p. 40].

Proceeding with this "intelligible idea" of types, the *neurotic* suffers from an excessive check on his or her instinctive impulses. If the check is brought about through fear, the image this person presents is one of *fear-neurosis*. On the other hand, if the check is effected by means of will, the picture presented is one of *compulsion-neurosis*. In either case, the neurotic is a thwarted individual. In the case of the *artist*, or *productive type*, "the will dominates, and exercises a far-reaching control over (but not check upon) the instincts, which are pressed into service to bring about creatively a social relief of fear" (Rank, 1932, p. 41). Thus, the productive type creates. The instincts seem to be relatively unchecked in the *psychopath*. In his or her case, the will affirms the impulse rather than controlling it. Rank regarded psychopaths, contrary to appearances, as "*weak*-willed" for they are "subjected to their instinctive impulses" (italics his) (p. 41). Now we come to the *average type*, who differs from both the artist and the neurotic in that he or she simply accepts himself or herself as he or she is.

As we see, then, the artist and the neurotic are distinguished from the average type by virtue of "their tendency to exercise their volition in reshaping themselves" (Rank, 1932, p. 41). This "reshaping," however assumes far different shapes for the two types. The neurotic, bent on self-preservation, restricts his or her experience. The artist, on the other hand, takes on a more complex task. Let us listen to the explanation offered by Rank, himself.

> There is, however, this difference: that the neurotic, in this voluntary remaking of his ego, does not get beyond the destructive preliminary work and is therefore unable to detach the whole creative process from his own person and transfer it to an ideological abstraction. The productive artist

also begins (as a satisfactory psychological understanding of the "will to style" has obliged us to conclude) with that re-creation of himself which results in an ideologically constructed ego: this ego is then in a position to shift the creative will-power from his own person to ideological representations of that person and thus to render it objective [p. 41].

The artist, thus, using the ideology available, creates an objective rendering of that ideology. That is, he or she creates art. But, for now, let us keep our focus on Rank's typology.

In his introductory essay in the 2004 translation of Rank's 1922 work, *The Myth of the Birth of the Hero*, subtitled *A Psychological Exploration of Myth* (Rank, 2004), Robert A. Segal (2004) clearly identified four types. To wit, "There are four kinds of persons: average, creative, neurotic, and antisocial (criminal and psychopathic)" (p. xvii). Segal elaborated as follows:

Average, or "normal" persons are conformists. They overcome the tension between separation and union by surrendering their independence to the community, and Rank has disdain for their easy conformity. Creative persons, for whom he has the most respect, vaunt their independence by setting themselves against the community. Their alienation from the group is willed.... Neurotic persons ... are also alienated from the community, but they are too stymied by guilt and anxiety to assert themselves. Their will is a counterwill. Where Freud deems neurosis failed normality, Rank deems it failed creativity. The neurotic is a failed artist, not a failed "normal." ... Average persons accept themselves as society defines them. Creative persons recreate themselves [p. xvii].

(About the fourth type, the antisocial, Segal remained silent.)

Several terms in the above quote could easily slip by without the definitive attention that they require in order to do justice to Rank's position. These include *separation, union, will,* and *counterwill.* These will be taken up in the context of Rank's theory of the personality development of the artist, which follows.

Rank had a perduring and keenly focused interest in the personality development of the artist, evidenced by the prominence of this thread throughout his work, from the earliest onward.

As with many of the concepts that were elaborated and made central in the theories of post–Freudian psychodynamic thinkers, it was Freud who first suggested a theory of the trauma of birth (Mullahy, 1955). It did not, however, play a major role in Freud's conceptual framework, and he rejected the centrality that Rank afforded it. For Freud, the birth trauma emanated from the physical and physiological challenges of the birth

process, and constituted a basis for anxiety. Rank, in contrast, emphasized the separation from the womb and consequent deprivation of the ideally blissful *in utero* existence. Throughout life, according to Rank, one yearns for this intrauterine life and strives to find it once more. Death, itself, in Rank's view, is unconsciously equated with a return to the womb. Mullahy offered the following perspective:

> With the exception of death ... physical birth is the most painfully anxious experience man undergoes. The earliest place of abode, namely the mother's body, where everything is given without even the asking is paradise. To be born is to be cast out of the Garden of Eden. And the rest of life is taken up with efforts to replace this lost paradise as best one can and by various means [pp. 162–163].

This *birth trauma* arouses what Rank termed *primal anxiety*, an anxiety that leads to *primal repression* of the *primal pleasure* of the womb. It is this arousal of primal anxiety that serves as a prototype of feeling. So powerful is the birth trauma that everyone needs the entire period of childhood in order to overcome it in a normal manner. During this time, the child uses each fear and anxiety as an opportunity to abreact, and thereby discharge primal anxiety affect. Thus, there is a gradual catharsis of the primal anxiety (Mullahy, 1955).

If we are to enucleate Rank's theory of personality development, or his broader theory that includes psychotherapy, for that matter, we find the birth trauma. Mullahy (1955) has summarized the broad implications by writing that "just as the primal anxiety forms the basis for every subsequent anxiety or fear, every pleasure aims to reestablish the primal pleasure of the intrauterine situation" (p. 164). Beyond the individual and on the level of society, cultural development follows from sublimated forms that serve as substitutes for the primal state of bliss.

The birth trauma leads conceptually to recognition of emergent individuality and the development of will. Separation is, of course, intrinsic to individuality. Separation from the mother, at birth, leads not only to a feeling of loss of connection with her, but a sense of loss of wholeness in oneself. There is, then, a self-creative developmental process that was characterized by Mullahy (1955) as "a basic spiritual principle" (p. 177). By way of elaboration, he wrote, "The gradual freeing of the individual from dependence by a self-creative development of personality replaces the one-sided emphasis of the biological dependence on the mother" (Mullahy, 1955, p. 177).

110

As a first developmental step, the person wills that by which he or she was earlier compelled. The compelling force may have been external, as in the case of a parental or societal moral code, or it may have been internal, that is, an instinctual urge. At this stage of development, the individual tends to experience harmony within. Concomitant with diminished likelihood of conflict, however, there is less opportunity for creativity. The person at this stage "removes the painful feeling of difference by taking over the social and sexual ideals of the majority for his own" (Mullahy, 1955, p. 183). Rank suggested that the average or normal individual may never develop beyond this stage.

At the second stage of development, there is an inner conflict between the will and the counterwill (a will set in defiance of another will). The person may feel divided within. As the person begins to develop his or her own moral standards, ideal, and goals, he or she experiences the conflict between these and the compelling forces from the earlier stage. This second stage may lead either to creativity, or to the self-criticism, guilt, and inferiority feelings that are precursors to neurosis (Mullahy, 1955).

The third stage is characterized by a return to an inner harmony and consequent unified working of the personality. This is based on an autonomous inner world, created and recreated, not a mere representation of the external reality but a truly individualized world. The artist or creative type is representative of this level of development, according to Rank (Mullahy, 1955).

Mullahy (1955) has offered a comparison of Rank's types that in spite of its pithiness is nonetheless pregnant with implications. Consider this: "The ideal of the average is to be as others are; of the 'neurotic,' to be himself largely in opposition to what others want him to be; of the creative person, to be that which he actually is" (p. 184). (I remind the reader that the meaning of the phrase "that which he actually is," is "that which he has created himself to be.")

Before shifting our focus to creativity and the making of art, however, there are two more topics central to Rank's personality typology that beg further attention, *will* and *counterwill*, *life fear* and *death fear*. It is in the context of life fear and death fear that *separation* and *union* will be defined.

In terms of its origin, willing, or the active operation of will, arises as a force to oppose a compulsion. As already noted, the compulsion may have its origin in the external world of parental and societal demands, or in one's inner world of instinctual urges. In either case, will serves as a negative force. Various compulsions, obstacles, and restraints may be met

with resistance, with a *counterwill*. The child voices this counterwill with his or her resounding "No!," the true voice of defiance. A second stage of willing is reached when the child begins comparisons with other people. Wanting to have what others possess and wanting to do what others do create jealousy and rivalry. The "no" of earlier childhood gives way to a "yes." This is overcome by a third stage in the development of will in which the mature person no longer measures his or her being in terms of that of others, but pursues his or her own desires. This, Mullahy (1955) referred to as "truly positive willing" (p. 185).

Ruth Munroe (1955) has cut through some of the complexity of Rank's theory to reveal the essence of *life fear* and *death fear*. As one might anticipate, these bear relationship to the trauma of birth. The birth trauma may be understood from the perspective of "an essentially philosophical antithesis of separation and union, of life and death" (p. 581). Birth constitutes the *death* of the blissful *in utero* existence wherein embryo and womb function as one symbiotic unit. Birth, then, is not only the prototype of anxiety, "but of the general problem of relinquishing the old integration in adopting a new one: dying in order to be born" (p. 581).

Individuals exist, then, in a field of tension. At one pole, individuals try to reestablish a unity between themselves and their environment. From the perspective of this striving, any move toward independence is experienced as a threat. The resultant fear of independence is therefore termed the *life fear*. From the perspective of the emergent will, at once assertive and creative, any symbolic union is regarded as a return to the womb, and thus a regression. This suggests a sort of death, for such a regression would mean a loss of individuality, a loss of life. As something else to fear, this threat is termed the *death fear*. Munroe (1955) offered a useful summary of this "necessary human conflict."

> It is the death fear which drives the person to vital effort, and the life fear which inhibits effort. The essential point is the polarity between life and death, between separation (individuation → life-fear) and union (loss of individuality → death-fear).... The fact that biological growth involves a relationship between union and separation similar to his concept of birth is, for Rank, a further illustration of *a general principle fundamental to all living* [p. 581].

The broad generality of this principle is perhaps best reflected not in the antinomy of life and death, or even separation and union, but in a third antinomy that Rank termed *partialization* and *totality* (p. 582).

At the risk of oversimplification, we could now say that the Rank's average man is dominated by life fear, a fear of individuating and standing apart. Against the pain of development of a unique will, the average man adopts the will of his or her society. The artist, and sometimes the neurotic, in contrast, are strongly driven by their death fear. "They have committed themselves to the pain of separation from the herd — that is, from unreflective incorporation of the views of their society" (Munroe, 1955, p. 585). But, the artist is able to integrate his or her individual will and his or her need for union through "a creative relationship to 'others'" (p. 585). The artist is, unlike the neurotic, able to reconcile the two poles of individuation and union in some constructive manner. The neurotic, alas, is unable to integrate individuation and union, and may "throw his whole ego into every experience, no matter how trivial, in order to spare himself the pain of a separating, independent act of willing" (p. 587). Thus, he or she may actually be dominated by fear of life. Or, the neurotic may be dominated by death fear and thus try to stay insulated from experiences of union.

Again waxing pithy, Mullahy (1955) offered a fascinating starting point for the consideration of Rank's theory of artistic creativity. "While the average man keeps his phantasies to himself, and the 'neurotic' represses his, the creative type affirms and reveals them to the world, is in fact compelled to reveal them" (p. 187). Herein, we have, then, the making of art.

For Rank (1932), there is a creative impulse that underlies both the process of living and the process of creating as an artist. In his words, "creativeness lies equally at the root of artistic production and of life experience ... lived experience can only be understood as the expression of volitional creative impulse, and in this the two spheres of artistic production and actual experience meet and overlap" (p. 38). It is in the personality that the creative impulse is manifested first and primarily, and as the personality is perpetually recreated, art-work and experience are produced in the same way. Departing from earlier views that the artist creates from his or her own experience, Rank maintained that the artist creates almost in spite of it. "For the creative impulse in the artist, springing from the tendency to immortalize himself, is so powerful that he is always seeking to protect himself against the transient experience, which eats up his ego" (p. 38). Let us consider more deeply his exploration of this relationship between experience and creation.

The artist takes refuge, with all *his own* experience only from the life of *actuality*, which for him spells mortality and decay, whereas the experience

to which he has given shape imposes itself on him as a creation, which he in fact seeks to turn into a work. And, although the whole artist-psychology may seem to be centred [*sic*] on the "experience," this itself can be explained only through the creative impulse — which attempts to turn ephemeral life into personal immortality. In creation the artist tries to immortalize his mortal life. He desires to transform death into life, as it were, though actually he transforms life into death [p. 39].

Relating this line of thought back to the will, Rank (1932) wrote, "I see the creator-impulse as the life impulse made to serve the individual will" (p. 39). This will is a controlling element, in its negative manifestation, and in its positive manifestation is the urge to create. Furthermore, "experience is the expression of the impulse-ego, production of the will-ego" (p. 43). In the artist, the will-ego is ascendant. So, while instinct presses for experience, and possible exhaustion, the will drives toward creation and consequent immortalization.

In Rank's theory (1932), one essential expression of the creative impulse in the artist is the act of self-appointment. So, in this largely unconscious process of becoming an artist, one must declare oneself as such. This "self-labeling and self-training of an artist is the indispensable basis of all creative work" (p. 37).

Interestingly, Rank (1932) believed that the creative process, itself, gives rise to a feeling of guilt. Such guilt feelings arise from "the power of creative masterfulness as something arrogant" (p. 43). And, although the primary conviction of the artist is one of superiority, this guilt may secondarily engender a feeling of inferiority. Then, too, the ego may interpret the artist's own individuality as inferiority, unless there is a public record of achievement that gives evidence of superiority. Wadlington (2001) explained the artist's guilt with the following specifics:

> Guilt is part and parcel of the creative process. Self-appointment brings with it guilt over voluntary separation from the group, creative sacrifice carries guilt over relinquished options, and finally "going beyond," immortalizing oneself in lasting achievements, generates guilt over creation — over changing the order of things by introducing works of art into the world [p. 300].

Rank (1932) acknowledged that two basic types of artist had long been distinguished. The one had been referred to as Apollonian or Classical, the other as Dionysian or Romantic. Rank, quoting Müller-Freienfels, identified these as "formative artists" and "expressive artists," respectively; quoting E. von Sydow, he then distinguished the two types from

the perspective of the aesthetic, as the "eros-dominating" and the "eros-dominated" (p. 44). Rank's contribution to the understanding of these two types of artists consisted of his relating them to his theory, as follows:

> In terms of our present dynamic treatment, the one approximates to the psychopathic-impulsive type, the other to the compulsion-neurotic volitional type. The one creates more from fullness of powers and sublimation, the other more from exhaustion and compensation. The work of the one is entire in every single expression, that of the other is partial even in its totality, for the one lives itself out, positively, in the work, while the other pays with the work—pays, not to society (for both do that), but to life itself, from which the one strives to win freedom by self-willed creation whereas for the other the thing created is the expression of life itself [p. 44].

It is this above stated dynamic that determines the kind and the form of art produced by a given artist. Produced from within, the work of the Romantic is *total*, in the sense that he or she spends himself or herself "perpetually in creative work without absorbing very much of life" (p. 49). The work of the Classicist, in contrast, is essentially *partial*. This artist "has continually to absorb life so that he may throw it off again in his work" (p. 49). That is to say, Romantic art is more subjective and is closely bound up with the personal experience, while Classical art is more objective and linked to life. For the Romantic type, his or her work may be a means to life; for the Classic type of artist, life serves as a means to production of art.

But, regardless of whether the work of an artist evinces a more Apollonian or a more Dionysian bias, "there appears to be a common impulse in all creative types to replace collective immortality—as it is represented biologically in sexual propagation—by the individual immortality of deliberate self-perpetuation" (Rank, 1932, p. 45). In brief, Rank characterized three historical periods of art as follows. First was *primitive art*, which was an expression of a collective ideology. That ideology was perpetuated by abstraction, that abstraction finding religious expression in the idea of the soul. "The primitive artist-type finds his justification in the work itself" (p. 51). Next, in the case of *Classical art*, a social art-concept emerged, being perpetuated by idealization. Such idealization is expressed most purely in the conception of beauty. The Classical artist, in the view of Rank, justifies the work by his or her life. This artist strives to perfect old forms, while making use of old, traditional material with its powerful collective resonance for his or her content. And finally, there is "*Modern art,*

based on the concept of individual genius and perpetuated by *concretization*, which has found its clearest expression in the personality-cult of the artistic individuality itself" (p. 45). With modern art, in stark contrast to primitive art, the artist, and not the art, matters more. Therefore, the experience of the individual artist is afforded a level of significance that is characteristic of the Dionysian type of artist. This Dionysian or Romantic type of artist tends to seek new contents and new forms in order to express his or her personal self more completely.

Discussion of the Dionysian or Romantic type of artist would be incomplete if lacking the inclusion of the *muse*. Rank (1932) proffered that as this type of artist becomes increasingly individualized, he or she seems to need a more individual ideology for his or her art, an ideology which Rank named the *genius-concept*. Concomitantly, his or her work becomes increasingly subjective and personal, to the point that he or she requires an individual "public" for the justification of his or her artwork; that is,

> a single person for whom ostensibly he creates. This goes so far in a certain type of artist, which we call the Romantic, that actual production is only possible with the aid of a concrete Muse through whom or for whom the work is produced [p. 51].

In order for this relationship with the Muse to work, the Muse must be well-suited to the role, or as Rank suggested, at least make no objection to it. In addition, it is of utmost importance that the artist keeps the relationship with the Muse on the ideological plane, and not confuse the relationship with real life. Rank addressed such confusion in the following manner:

> Here the woman is expected to be Muse and mistress at once, which means that she must justify equally the artistic ego, with its creativeness, and the real self, with its life; and this she seldom (and in any case only temporarily) succeeds in doing. We see the artist in this type working off on the woman his inward struggle between life and production or, psychologically speaking, between impulse and will [p. 52].

Another way for the Romantic-type artist to try to resolve the conflict between life and production is to have one significant person who is in the ideological creative sphere and a second who functions in the sphere of actual life. Rank (1932) conceded that the Romantic-type artist may actually "need two women, or several, for the different parts of his conflict" (p. 61). Addressing the vicissitudes of this attempted resolution, he warned

that this is not so simple, since this type of artist harbors "a fundamental craving for totality in life as in work, and the inner conflict, though it may be temporarily eased by being objectivized [*sic*] in such an outward division of roles, is as a whole only intensified thereby" (p. 52). If that were not difficulty enough, Rank added the following concerning the artist who has chosen two women:

> Accordingly he falls into psychological dilemmas, even if he evades the social difficulties. He undoubtedly loves both these persons in different ways, but is usually not clear as to the part they play, even if — as would appear to be the rule — he does not actually confuse them one with the other. Because the Muse means more to him artistically, he thinks he loves her the more. This is seldom the case in fact, and moreover it is psychologically impossible. For the other woman, whom, from purely human or other motives, he perhaps loves more, he often enough cannot set up as his Muse for this very reason: that she would thereby become in a sense de-feminized and, as it were, made into an object (in the egocentric sense) of friendship [p. 61].

In addition, Rank (1932) addressed the situation in which a male artist finds his muse in another man. It is, Rank believed, out of the artist's urge for completion, combined with his desire to find everything united in one person, that it is usually a woman that a male artist makes into his muse. But, juxtaposed to this, Rank noted that "instances of homosexual relations between artists are by no means rare" (p. 53). Rank demonstrated an unusual understanding for his time when he penned the following:

> If the poet values his Muse the more highly in proportion as it can be identified with his artistic personality and its ideology, then self-evidently he will find his truest ideal in an even greater degree in his own sex, which is in any case physically and intellectually closer to him. Paradoxical as it may sound, the apparently homosexual tendencies or actual relationships of certain artists fulfil [*sic*] the craving for a Muse which will stimulate and justify creative work in a higher degree than (for a man) a woman can do [p. 53].

Wadlington (2001) has attended to Rank's interpretation of the *double*, and the special relationship the double has to artistic creativity. By way of an explanatory image, Wadlington cleverly invoked Magritte's painting, "Not to be Reproduced," in which a man is looking into a mirror and seeing a view of his back. Not only does this image demonstrate the double in the mirror, but simultaneously, through its elicitation of an eerie feeling (what cannot happen is happening), contacts us with something *uncanny*, to use Freud's term. With a nod of appreciation to Magritte, we are shown

the figure of a man at once outside and behind himself, as he observes actions in the mirror that are his, but from which he is separated. Wadlington recognized this situation as related to Freud's explanation of the development of the superego, writing, "The subject has taken the stance of a critical observer and the ego has become an object. In Freud's view the double represents this hyperconscious, critical superego state" (p. 294).

Continuing, Wadlington (2001) noted that the topic of narcissism and the double was of interest both to Freud and to Rank. Interestingly, Freud's major paper on narcissism was published the same year that Rank published his book on the double. This was in 1914, but a divergence of views was in the offing. For Freud's part, doubling was one of the experiences of the uncanny, and belonged, therefore, in the realm of that which is secretly familiar. Wadlington explained Rank's elaboration of this view as follows:

> Rank had speculated that in primitive cultures the double emerged first as the soul, the counterpart to the body that inevitably dies. The appearance of the dead in dreams and visions, he believed, gave proof to the primitive of the soul's immortality. Although originally it serves as a reassurance of one's perpetuation, the double eventually takes on a more ghastly form, appearing as the *Doppelgänger*, the spectre [*sic*] of death come to claim the living [p. 295].

Wadlington quoted Freud as expressing this in the following way: "From having been an assurance of immortality it becomes the uncanny harbinger of death" (p. 295). For Rank, still, the double was of one's past, returning as fate. This view honored the unconscious by allowing it a critical and powerful role.

With his development of his ideas about *will*, Rank's view of the double changed markedly (Wadlington, 2001). Demoting the unconscious, Rank emphasized intention and action. Wadlington summarized Rank's revised position as follows:

> The double in this new conception is no longer the haunting reminder of an inescapable past and fate, but rather becomes what Esther Menaker called "a creative announcement of the prospective emergence of the self" [p. 296].

Wadlington pointed to another critical difference from Freud's view in this later view of Rank, writing "that Freud took the double as evidence for a death drive" whereas "Rank saw the double as an aspect of the creative urge to immortality" (p. 296). This "creative urge to immortality" is, of course, from a Rankian perspective, the driving force of art.

Wadlington (2001) suggested that Rank's double has a dual role in creative activity. It is both an obstacle to creation and a means for overcoming obstacles. To begin, consider that to be creative is to face inhibition. Ergo, inhibition can be conceived of as the artist's double. The artist may feel dread with each new act of creation, for inhibition can arise either at the beginning or at the end of the creative process. Getting started, and finishing are both familiar loci for such. "When inhibition becomes the double the creative person assumes a stance outside of the work. One looks over one's own shoulder, judging, and criticizing, and interfering with further creation" (p. 297). And, as Wadlington pointed out, inhibition can assume any of several guises: "avoidance or procrastination, low motivation, self-consciousness, self-criticism, perfectionism" (p. 297).

Remembering, however, the Rankian context of a psychology of intention and action, *inhibition* must be understood in its intimate relationship to *will*. This relationship is made manifest in both negative and positive form, as follows: "the ability to intentionally inhibit action is a counter to impulsiveness; the capacity for overcoming stifling inhibition frees the spontaneous and expressive self" (Wadlington, 2001, p. 297).

Wadlington (2001) stated in definite terms that "the double is both the source of, and the means to overcoming inhibition" (p. 300). Offering practical advice to the artist with self-created conflicts, he suggested that the artist invoke the double as alter-ego.

> The appearance of the double as content in a work of art — as "a character in a novel for instance — gives an indication that its creator has called on a persona, a second self, in an effort to create in spite of inhibition" (p. 300).

Wadlington (2001) reminded his readers that Rank had suggested another way in which the artist could invoke the double for creative assistance. The artist may engage in a process of doubling, in the sense of dividing his or her attention between or among several creative endeavors. This process can take several forms.

> The double may assume the form of two works — two simultaneous works or the current work and the *magnum opus*. Alternately, the artist may work at different times in two creative modes or forms: prose and poetry, portraiture and landscape, film and drama [p. 300].

Whether two works, two forms, or even two studios, creativity may well be served by this practical application of the double.

For Rank, the artist, as the agent of will, represents the individual

factor in art. Importantly, one must distinguish this individual factor from the collective expression of the ideology of the society in which that artist lives. "The artist, as it were, takes not only his canvas, his colours, or his model in order to paint, but also the art that is given him formally, technically, and ideologically, within his own culture" (Rank, 1932, p. 7). Thus, "the artist not only creates his art, but also uses art in order to create" (p. 7). As a creative individual, the artist uses the art form that he or she finds available and makes a personal statement within it. This personal expression of will must not depart too greatly from the ideology of the culture in which it is created, or the art so produced will be ignored or rejected. And yet, if the artist is to be recognized and highly regarded, his or her handling of that ideology must evince a certain freshness, if not a clear mark of innovation. As Rank wrote, "It may be, indeed, that the real giants in art are just those who somehow exceed the limits of their art's proper sphere" (p. 70). With sufficient individualization of art, the cultural ideology transforms, providing a new context from which and in which the artist can now express his or her individual will. This, then, is the play between art ideology and artist will, the collective and the individual.

> A non-contemporary outlook on vital problems is always essential to the artist, an outlook which deviates more or less from the prevailing ideology and its art-style ... the artist's personality, however strongly it may express the spirit of the age, must nevertheless bring him into conflict with that age and with his contemporaries ... he is obliged, in his work to convert the collective ideology into one of his own [pp. 71–72].

Rank (1932) declared that "religion has always drawn art along in its wake" (p. 12). And here, in religious art, Rank found a source for the sense of the esthetic.

> The urge for abstraction, which owed its origin to a belief in immortality and created the notion of the soul, created also the art which served the same ends, but led beyond the purely abstract to the objectivizing [sic] and concretizing of the prevailing idea of the soul. Everything produced objectively in any period by the contemporary idea of the soul was beautiful, and the aesthetic history of the idea of the beautiful is probably no more than a reflection of the changes in the idea of the soul under the influence of increasing knowledge [p. 12].

According to Rank, the religious art of all times, but especially that of the higher cultures such as the ancient Egyptians, Greeks, and Christians, serves to demonstrate that the source of the beauty-ideal is the contem-

porary ideal of the soul. This religious art portrayed the idea of the soul in concrete form as gods, and so, in a psychological sense, proved their existence. Rank concluded that "the redeeming power of art, that which entitles it to be regarded aesthetically as beautiful, resided in the way in which it lends concrete existence to abstract ideas of the soul" (p. 13). The ends which art serves are, thereby, "not concrete and practical, but abstract and spiritual" (p. 14). This means, too, that religion needs the artist to concretize the idea of the soul. Focused as he was on the ancient art of Egypt and Greece, and that of the Christian Church, Rank did not address in detail the situation of a religion without a religious art. He wrote only briefly, acknowledging that within Judaism "there is no room for an earthly representative of God ... let alone for an artificial symbol of him; for, as everyone knows, no representation of him was allowed" (p. 187).

Rank (1932) saw the development of an *aesthetic of feeling*, dependent not on the earlier collective idea of the soul, but dependent on consciousness of personality. It derived from the idea of *genius*, but departed from the early Roman idea of the genius in that it was more personal than collective, and although containing both individual and collective elements, gave much greater weight to the former. This artistic type was born with the Renaissance, and was described by Rank as follows:

> *Psychologically* the notion of genius, of which we see the last reflection in our modern artist-type, is the apotheosis of man as a creative personality: the religious ideology (looking to the glory of God) being thus transferred to man himself. *Sociologically*, it meant the creation and recognition of "genius" as a type, as a culture-factor of highest value to the community, since it takes over on earth the role of the divine hero. *Artistically*, it implies the individual style, which indeed still holds on to the exemplars that later appear in aesthetic as formulated law, but which is already free and autonomous in its divine creative power and is creating new forms from out of itself [p. 24].

With this definition of a modern esthetic of feeling, Rank came, once again, to his artist-type, with roots in the concept of genius. In the narrower sense of the creative artist, the modern artist differs from his or her predecessors by having *individualistic* spiritual needs addressed through an *art of expression*. In contrast, Rank characterized earliest art as *linear art*, developing from the impulse to *abstraction*, based on spiritual needs that were, themselves, *abstract*. In the case of *Classical art*, the impulse to abstraction was replaced by *intuition* and a *naturalistic* spiritual need.

That art can bring great pleasure is no secret. But how does this happen? Perhaps Rank (1932) has solved this mystery, at least in part. At any rate, his proposal is thought-provoking. Art expresses something that is unreal, something Rank called "more than earthly" (p. 109). We experience beauty, he claimed, to the extent that the work is unreal. If the artist has truly put his or her soul in the work, the work represents his or her soul, and this can be recognized by the enjoyer of the art. "Just as the believer finds his soul in religion or in God" (p. 109) the enjoyer finds his or her soul as it is one with that of the artist. The self-renunciation that the artist has felt in the act of creating is relieved when he or she finds himself or herself in the work. "And the self-renunciation which raises the enjoyer above the limitations of his individuality becomes, through, not identification, but the *feeling of oneness* with the soul living in the work of art, a greater and higher entity" (italics his) (pp. 109–110). In the interest of further understanding, Rank called upon the sacred Hindu literature, invoking a passage from the Upanishads.

> This Atman (human being) that I have in my heart is smaller than a grain of rice, smaller than an oat, smaller than a mustard-seed.... This Atman that I have in my heart is greater than the globe, greater than the expanse of the air, greater than all spaces of the universe. In it are all deeds, all scents, all tastes contained; it embraces all, it speaks not and cares for naught. This Atman that I have in my heart, it is this Brahman. With it I become One when I depart this life. He who has attained to this knowledge, for him verily there is no more doubt [p. 111].

Rank, once again, offered his readers a clarifying note, stating that "the will-to-form of the artist gives objective expression, in his work, to the soul's tendency to self-externalization, while the aesthetic pleasure of the enjoyer is enabled, by his oneness with it, to participate in this objectivization [*sic*] of immortality" (p. 110). Most briefly stated, and with acknowledgment of oversimplification, I offer to summarize Rank's theory of pleasure in art in the following manner. Placed within a contextual frame of *unity, separation,* and the *trauma of birth, pleasure is experienced as the individual urge to restore lost unity is fulfilled in the experience of a work of art.*

In *Art and Artist*, Rank (1932) devoted an entire chapter to "House-Building and Architecture." Such attention to architecture was unusual among the psychodynamic theorists who turned the focus of their writing on the arts, and deserves serious attention. Rank began his chapter on

122

architecture suggesting that the earliest conception of the soul of the dead presupposed a subterranean continuation of earthly life, and therefore led to tomb-building. For if one continues to live, as a soul or spirit, one would need a dwelling place appropriately equipped with the necessary grave-furnishings. Rank further suggested that the binding of corpses, which can be traced as far back as the Stone Age, was a way of fettering the corpse to a particular dwelling place. The grave became, therefore, a house, and accordingly, the tomb can be regarded as the casing for the soul. Rank suggested that tomb-building, which arose out of this soul-concept, led to house-building, and in turn, to "architecture proper in the form of temple-building" (p. 162). These architectural developments reflect the self-creative principle.

> This self-creative trend, already visible in the building of a tomb, though this has merely to provide a permanent resting-place for the soul of the dead, becomes still clearer at the stage of building the house which is to provide a dwelling-place for the living soul, the human being on earth, and it finally soars above all animal and chthonian ties in the building of the temple for the shelter of the immortal, the divine, soul [pp. 162–163].

Thus, Rank suggested a three-stage scheme of development of architecture: (1) the tomb — for the soul of the dead; (2) the house — for the soul of the living; (3) the temple — for the soul of God. This evolution was "from tomb-building to sacred architecture by way of house-building" (p. 179).

Rank (1932) cited Karl Borinski's work on body symbolism in medieval church-building, and alluded to Ernest Fuhrmann's work as well, accepting and extending this line of thought more broadly. The following example will begin to demonstrate this:

> Not only does church architecture rise above this primitive protective character of tomb-building: it rises also from the self-creative shaping of the human body in domestic building to be the essential symbol of the spiritual in religious architecture. In this sense Fuhrmann is undoubtedly right when he interprets the church door in detail as the mouth (with teeth, gorge, and so on) and no longer as an abdominal entrance to the underworld. For the cathedral represents precisely the highest architectural expression of the transformation ... of the animal conception of an underworld into a spiritual soul-concept localized in the head. If, then, the church represents rather the head of a man, with its mouth, jaws, and throat, than the whole person, Fuhrmann's ingenious idea of the bell as a "brazen mouth" should not be taken merely as a metaphor.... True, the church has retained much of its pre-animistic body-symbolism; but in cathedral architecture this seems to

have been reworked, or at any rate reinterpreted, in terms of the super-world [p. 178].

Implicated in the above, Rank (1932) identified "two tendencies that are inherent in the art of building" (p. 184). The first leads from the human abdomen to the spatial type of house, which Rank referred to as the "palace of the entrails," or to the protective fortress. The second leads from the head and neck to the "aspiring style of the temple towers or the spirituality of the cathedrals" (p. 184). Rank's terminology and his manner of expressing this theory make paraphrasing perilous, so in order to preserve his meaning, I quote him as follows:

> In the first case it is the animal mother-body with its protective covering (warmth, fur), and in the second the upright attitude proper to man himself (the tower) that forms the natural and the ideological archetype for the structure; and, correspondingly, the structure is either a utility-building or a sacral building [pp. 184–185].

Rank explained that he employed the term "ideological" archetype because, in spite of its corporeal symbolism, the house is more than a copy of maternal protection and has come to symbolize the creative ego arisen to a state of independence.

It was Rank's (1932) contention that "to trace the way from the subterranean tomb and its heavenly counterpart, the sacral edifice, back to earth and earthly dwelling-places, we must again ... resort to an ideological motive of microcosmization [sic]" (p. 185). This motive is reflected in the ancient conception of the earth-center, "the figuration of which as the earth's 'navel' expressed a humanization of the cosmos" (p. 185). The Omphalos (navel) represented the cosmic center, the point of intercommunication among the realms of the dead, humankind, and the gods. The idea of the Omphalos was linked not only to the religious and mythological conceptions of diverse cultures, but it was tied also to practical undertakings such as the layout of towns and roads. By locating it in a specific spot, a sacred zone was designated, around which a town could be laid out and to which roads could lead. This traditional laying out of a town radially from the center reflects, Rank believed, a "cultural development of the earth on the microcosmic, human basis" (p. 197).

The earth became humanized, so to speak, through the idea of the Omphalos, representing what Rank (1932) termed "the macrocosmic broadening out of man to earth-scale" (p. 185). Rank even attributed the

possibility of an earthly geography to the Omphalos idea. In time, civilizations came to erect on the omphalic site the building that symbolized their cosmic ambitions. Such buildings represented "man himself built up 'self-creatively' from the navel" (p. 191). Important in this symbolism is the view that "'Omphalos' the navel of the individual born from the womb of the mother (Earth) grows out ... in the form of a building which symbolizes his own body and no longer that of the mother" (p. 191). Rank noted that this building, in temple form, could be regarded as a tribute to a higher power, but "as a 'skyscraper,' crowning the earthly city, it was an expression of that human pride of which the biblical account of the fiasco of Babel is the moral condemnation" (p. 191). Incidentally, but not unimportantly, many cities throughout history have vied for the honor of being the real center of the empire, and in turn, of the world. Such pride may be reflected in the towering height of what Rank called "the insolent sky-scraper" (p. 196).

Rank (1932) concluded that "town-building, like house-building, is based on abdomen-symbolism (low navel) as symbolized in the earth, while the temple, symbolizing heavenly spiritualism, was erected on the high navel" (p. 195). With the phrase "high navel" Rank referred to the mountain or high-ground on which temples were often built. From this perspective, the house retains more of the character of maternal protection, while the temple, straining away from the earth, represents the upper or higher self. The town, constituted in part by an assembly of houses, has retained some decidedly maternal features.

Incomplete as it may be, this was Rank's theory of architecture and city-planning. Better termed a mini-theory, perhaps, it is a consistent expression of his theory of self-creative eternalization in the work of art. Note bene: that self is an embodied self, and the building or the town layout qua art is an externalization, while it is at the same time an eternalization, of that embodied self.

The poet and the poet's art were especially esteemed by Rank (1932). He assigned the poet a special, if not unique position, writing that "the poet may be so different from the plastic artist, the musician, or the scientifically productive type that it is impossible to bring them all under one head" (p. 25). He located poetry as a modern art form, stating in general that "drawing was characteristic of primitive art, while sculpture is the Classical expression-medium, and the rhythmic arts (poetry and music) the modern" (p. 79). Rank identified the poet as the heir to the hero, not

immediately to the active, Classical hero of an earlier time, but to the modern, passive hero.

> Modern drama, of which *Hamlet* may still be regarded as the type, thus also shows us the passive hero — which means the poet himself— who is not guilty as the Classical hero is because of his overweening actions, but because of his rejection of the heroic role [p. 296].

Rank explained this further in the following passage:

> In the myth ... the hero's creative activity appears as an activity of doing (or suffering), while the individual poet of later times finds his true creativity in the making of the story itself [p. 207].

This difference between the Classical hero of action (or suffering) and the passive hero-cum-poet "springs from a simultaneous and parallel process which transforms the ideologically creative myth into the metaphor, and this survives into modern poetry as a decorative ornament" (pp. 207–208). Rank's use of the phrase "decorative ornament" should not be taken, of course, as a pejorative, for this would surely distort his meaning.

In the case of poetry, Rank (1932) stated, the *logos* takes artistic form in the word. The word, therefore, is the artistic material from which the poet can create freely. Consequently, Rank opined that "the art of words is the culmination of artistic creation" (p. 220).

Rank (1932) dwelt on the poet's use of metaphor, noting that some of the most poetic of metaphors depend on the micro-macrocosmic relation "which leads at one time to the humanizing of the world, and at another to the enlarging of man to the proportions of the world" (p. 224).

> The poet not only may speak of the "backbone" of mountains, the "bosom" of the sea, the "tongue" of a glacier, the "head" of a rock, the "jaws" of hell, but may compare the boughs of a tree to arms, a summit to the crown of the head [p. 223].

Further examples of the micro-macrocosmic relation can be found, Rank noted, in our anatomical nomenclature wherein various organs or locations are interpreted as a microcosm. Examples include the Atlas that holds up the vault of the skull, the seven cervical vertebrae as the seven heavens, the navel as midpoint of the earth, the liver as the center of human life, as well as the mons Veneris, the Adam's apple, and the solar plexus.

Although Rank (1932) did not tackle the problem of the birth of language in detail, he did claim that in order to understand the essential quality of the poet and the poetic art, we have to consider the material in

which the poet works far more than we need to do in the case of the other arts. "For this material, language, is itself a purely human creation, which had a birth and development of its own before it was used in poetry" (p. 235). Crediting others for this idea, Rank stated that the development of language, and language itself, constitutes a metaphorical comprehension of the world. Succinctly stated, the word can be seen as a mythic form. Language, Rank declared, was "not only the first physioplastic creation of man, but his first self-creative achievement in a truly artistic sense" (p. 255). Furthermore, language was regarded by Rank as not only the beginning of artistic creation, but the highest peak of such creation.

The creative side of poetry is primarily concerned with the subjective expressive ability of the poet, the manifestation of which Rank (1932) referred to as "the language of the soul" (p. 265). Rank understood this to differ from ordinary language which serves basically as a medium of communication. The language of the soul, in contrast, expresses the inner processes of the poet, given, if you will, pictorial shaping. As such, poesy is the manifestation of what Rank referred to as "the ideoplastic expression-art of the poet" and its "aesthetic remoulding in the intelligible collective language" (p. 265). The lack of such remoulding in terms of the intelligible collective language would obviously leave the poem unintelligible. There is, then, this dual character of language to be recognized, if one is to understand the poetic art. The language of the poem serves at once as a collective medium of communication, and as an individual creation that emerges from the poet's alembic.

In the interest of analyzing it, the poetic process, itself, can be divided into two separate phases. These have been referred to as the unconscious phase and the conscious phase. Rank (1932), however, utilizing the distinction discussed above, preferred to conceptualize these in terms of the individual creative expression of an experience and the communication of it through the collective language. The first phase he called *conception*, the second he referred to as the *constructive process*. Thus, the creation of poetry involves an initial phase which is unconscious, involving the ideoplastic expressive art, and a second phase which is conscious and involves remoulding in an intelligible collective language. It is only through this second, constructive phase that the poet gains final mastery and settlement of the initial individual experience. Rank warned, however, against stopping with a simple split between these two processes or phases. For in each of the two phases there is both mingling and opposition between the individual

and the collective (the ideoplastic conceptualization and the construction). More specifically, "the first [phase] would be the expression of an individual state of feeling in the collective raw material of inherited language, the second a personal infusion into this linguistic raw material, necessitated by the social urge to communication" (p. 279). Rank clarified further with the following details:

> The poet ... has at hand a rich, perhaps even a poetically fashioned, vocabulary, and ... not only has he to use it as his material and medium of communication, but it turns his creative powers from language to other elements of his productivity. In a word, the poet has no longer to create language; in fact, he can only use his creative energy within certain limits of style and occasional new coinages [p. 280].

Rank mused, "It seems to me to be one of the most complex of all psychological problems to decide in what way this reciprocal action between the individual and the collective, which is inherent in language, comes out in poetic creation" (p. 279).

Rank (1932) issued the ambitious challenge of studying the whole of poetry from a tripartite perspective which included the human need of communication, the egocentric standpoint of the poet, and the angle of the hero. This would provide, he believed, a history of the poet such that biography alone is unable to offer. In addition, it would reveal something of the history of the hero, a special interest of Rank (2004). Rank (1932) distinguished the hero of the Age of the Soul, found primarily in the folklore of primitive peoples, from the hero of the Age of Sexuality, described in the myths and poetry of what he called civilized peoples. "The will to immortality makes the hero — whose successor is the singer — actually and historically immortal, quite apart from the fact whether he solves his problems with the simplicity of a fairy-story or tragically fails in them" (p. 283). In discussing these heroes, Rank addressed "the relation of word and deed, of action and narrative" which, he pointed out, "distinguishes ... the two poetic forms of drama and epic" (p. 283). However, to pursue this line of thought, as Rank developed it, would take us away from our present focus. Suffice it to say that Rank believed immortality was first sought religiously, then heroically, and finally artistically.

The artist may experience a level of pleasure in his or her act of creativity that approaches the pleasure of play. This fact was elevated from the level of a mere truism by Rank's (1932) suggesting that the reason for this is that in both cases there is motor activity. This is most understandable

in the realm of dance, of course, but Rank saw his hypothesis as having much more general application in the arts. In terms of a relationship between play and art, Rank cited Freud in the latter's belief that play is a prelude to art. In order to understand this, Rank wrote that "at a primitive stage there was no difference between the two worlds of reality and super-reality, so that the control of the one in play at the same time guaranteed control of the other by magic" (p. 323). Continuing his explanation, Rank stated that "both ... primitive magic and later art, have the same impulse at bottom, the element of control which developed out of the original deception of nature" (p. 323). Furthermore, Rank believed that play may diminish fear and thereby liberate energy which subsequently can be expressed through creative endeavors.

Art originated, in Rank's (1932) view, to serve spiritual purposes of a magical or a religious sort. Like play, art evolved from this more-or-less compulsory activity that was believed to be necessary for life, into the realm of freedom. This liberation of art, or play for that matter, is never completely successful, but remains partial. Based on this view, Rank suggested two types of artists: those who create from an inner need, and those who create from an inner surplus. The clarity of this distinction faded, however, with the following:

> But in both cases the greatest part of creative force can come only from an excess that arises, during and out of the actual creation, just as in play the playing itself is needed to liberate the energy of the individual. The productive process itself, combined with the incessant struggle for individual freedom against the bonds of the data (collective ideology or material), sets free excess forces with a greater accompaniment of pleasure the further its successful progress continues [p. 328].

Rank (1932) saw in this a divergence of *truth* and *beauty*. "The [magical or religious] ceremony, in rising from the compulsory sacrifice to nature into the realm of pleasure by the individual's liberation from nature, acquired not only the psychical quality of play, but its aesthetic quality also" (p. 328). As long as the ceremony is tied to nature, it remains essentially a simulacrum of nature. But the freedom of play allows, importantly, for *stylization*. The ceremony tied to nature is nearer the *truth*, while ceremony liberated from nature tends to seek *beauty*.

The complexity of Rank's (1932) thought continued to abound as he explained that one's dependence on nature is more honest than the freedom-ideology, for the latter constitutes a negation of that dependence.

This fundamental dishonesty with regard to nature results in guilt, "which we see active in every process of art, and which is not wholly absent from play" (p. 329). And, it is this guilt that prevents neither play nor the creation of art to eschew compulsion and rise to complete freedom. The stronger one feels this freedom, however, the more intense is one's conscious sense of guilt. This guilt, Rank believed, both restricts the artist and serves creativity. The freedom of the ideology of beauty is dampened by another ideology that is represented in the community, that of truth. Rank juxtaposed these ideologies as the *freedom-ideology of art* and the *guilt-ideology of science*. The artistic ideology of the "head," as Rank remarked, has not fully escaped its origins in the chthonian mother earth, having basically only changed the animal content into an esthetic form. In contrast, the scientific ideology of the "head" is formal and phenomenological and regards the animal content as beneath its dignity. This latter ideology leads to *hybris*, insofar as the over-valuation of intellectual faculties requires the denial of the animal nature of the human being. Both art and play, Rank maintained, deny the dependence of the human being on nature. However, this dependence on nature reappears out of the guilt feeling in the form of an impulse to scientific knowledge. Rank proclaimed that art has not escaped being influenced — his word was "infected" — by scientific ideas. As evidence he pointed to the use of laws of geometric proportion in architecture and sculpture and the use of mathematics in music and the meter of poetry. A later example, offered by Rank, of the intrusion of the ideology of science into that of art is the modern psychological biography.

Continuing in his recondite manner, Rank (1932) explored the issue of content versus form. In science, he contended, truth is a problem of content, whereas in art, beauty is a problem of form. Having identified ornament and music as the most primitive forms of art, Rank asserted that both of these have rhythm as principle of form, "which is manifested in music as temporal and in ornament as spatial repetition. Music we may therefore regard, analogically, as a pure temporal metaphor" (p. 350). Together, they display the "fundamental essence of metaphor," which Rank emphasized by use of italics, "*extension into the infinite*" (p. 350). Most succinctly put by Rank, "Ornament in line and melody in music are not only abstractions of what is seen or felt in space and time, but abbreviations of the infinite, in spatial form in the one case, in temporal in the other" (p. 351).

At this point in his explorations, Rank (1932) was able to introduce

dance, suggesting that it was a combination of space-rhythms and time-rhythms, thus representing a combination of the "temporal and the spatial rhythms of infinity" (p. 352). Music, Rank asserted, having origin in song and dance, was a pure body-art. Reaching for an anagogical plane, Rank proclaimed that later, under the influence of mathematics, music developed into an abstract practice of art, thus describing a "path leading from the rhythmically continuous repetition of the body and its organs to the infinite melody, elevated to cosmic immortality, of the music of the spheres" (pp. 356–357).

Still in the realm of body-art, Rank (1932) considered tattooing. Closely related to body ornamentation with skins, shells and feathers, Rank asked if tattooing represents a move beyond the animal identification of the former and an attempt to liberate oneself from the animal.

> If this were so, this primitive painting (of which the traces survive in the feminine world even today) would be the origin of artistic activity not only in the sense assumed by the pragmatic and mimetic theories, but also in the psychological sense of a self-creative liberation of man from his dependence on nature and her purposiveness [p. 356].

As an aside, Rank noted that clothing replaced tattooing in harsher climates. He quoted Joest as claiming that "the less a man clothes himself, the more he tattoos, and the more he clothes himself, the less he tattoos" (p. 356).

Rank (1932) acknowledged what have often been termed the *Zeitgeist* versus the Great Man theories of genius, applying these to the arts. Consistent with material discussed above, Rank reminded that the artist must perforce use the art-ideology that is provided by his or her culture. Still in the perspective of the *Zeitgeist*, Rank affirmed that "the individual, however powerfully his personality may develop, appeared more as an instrument, which the community uses for the expression of its own cultural ideology" (p. 365). Rank acknowledged that this view fit with what he referred to as the "environmental" theories of genius. The question which arises is that of the motivation of the artist. To wit, why would the artist orient himself or herself through the existing ideology? Rank, recognizing that the basic issue is relevant not only to the artist, proffered the following:

> The human individual must have at his disposal from the start some sort of ideology ... not only that he may find his place in the society which is built up on these ideas, but also that he may find relief from the inner conflicts which would otherwise compel him to create for himself some ideology for

the objectification of his psychic tensions. This ideologization [*sic*] of inner conflicts manifests itself in the individual in a form which psycho-analysis [*sic*] has called that of "identification"—with parents, teachers, and other ideal patterns.... The motive of these identifications is the individual's root fear of isolation [p. 370].

The artist identifies specifically with the *artistic* ideology. But, at some point, in response to the restriction he or she feels from this identification, the artist turns against this collective ideology. This leads to what Rank (1932) termed, the "liberation of the ego" (p. 370). And it is here that we hear the echo of the Great Man theory as the artist opposes the prevailing art-ideology "with all the vigour [*sic*] of his personality" (p. 365).

A further level of understanding may be gained by relating the present discussion to the trauma of birth. As the artist struggles to liberate himself or herself from the moral, social, and especially the esthetic ideologies and the people who represent them, the artist goes through a disjunctive process of which Rank's (1932) trauma of birth was the prototype. Not only does the template of the birth trauma add a level of understanding of the artist, but it also contributes to an understanding of his or her work.

> Every production of a significant artist, in whatever form, and of whatever content, always reflects more or less clearly this process of self-liberation and reveals the battle of the artist against the art which expresses a now sur-mounted phase of the development of his ego [p. 375].

From this perspective on the conflict between art and the artist, Rank (1932) explored the styles of Egyptian art, ancient Greek, that of the Renaissance, the Baroque, and Rococo.

> Thus the ideological art-will of form and human art-willing of the artist stand in opposition, and the work of art which results from this conflict, differs in the different epochs of cultural development according to the strength of the personal or that of the collective will [p. 366].

However, the details of this discussion would take us away from our focus, so I will come back to the conflict, *per se*. Out of the impulse to self-preservation, that is, the complete absorption of the artist's ego by the collective, then, the artist must carve his or her own individuality out of the prevailing collective ideology. And, with one more step Rank reached the point of rapprochement, declaring that "the artist, like art, is not to be comprehended through a specialized study of creative personality or of the aesthetic standards of art-ideology, but only by a combination of the two"

(p. 369). "We owe," as he remarked, "our artistic development ... to none other than ourselves and the conditions of our time" (p. 379).

Rank (1932) saw in the artist both the "mortal man" and the "immortal soul of man" (p. 395). By way of explanation, he suggested the following:

> In this entire creative process, which begins with this self-nomination to be an artist and concludes in the fame of posterity, two fundamental tendencies — one might almost say, two personalities of the individual — are throughout in continual conflict: the one which wishes to externalize itself in artistic creation, the other which wants to spend itself in ordinary life [p. 395].

The creative type, because of his or her "totality-tendency" (p. 395), is inclined to give up either the life of the mortal or the life of the immortal soul. Rank proclaimed this to be the basic conflict of the artist. On the one hand he or she desires to live a natural and ordinary life, while on the other hand there is the desire to produce ideologically. Rank identified these two desires as individuality and collectivity, on the social level, or as ego and genius, on the biological. There is peril, asserted Rank, in living life to the full, and compromise must be reached between "ideologized life" [*sic*] and "individualized creativity" (p. 416). This compromise is ongoing for the artist, and painful, for as Rank revealed, "creation tends to experience, and experience again cries out for artistic form" (p. 416). Rank suggested the acceptance of moral conventions, as well as artistic standards, as a means of compromise through which the artist may stave off premature and complete exhaustion. Is this what Rank had in mind when boldly proclaiming that "the mature artist can only be born from victory over the Romantic in himself?" (p. 418).

At any rate, Rank (1932) explored three specific modes of escape from total absorption in one's art. Although his exposition can be appreciated as a source of practical advice, this was not likely his intention, given the overall tone of his book. Rank introduced this discussion as follows:

> The conflict of the artist *versus* art becomes a struggle of the artist against his own creation, against the vehement dynamism of this totality-tendency which forces him to complete self-surrender in his work [p. 385].

Having conceded that each artist may find his or her own mode of escape, Rank proceeded to enumerate three ways which he deemed universally accessible and most typical. The first is the division of attention among two or more simultaneous projects. The work on the second is often an

antithesis in style or in character from the first, and is most often undertaken at the point where the first threatens to become all-absorbing. The second means of escape for the artist from his or her own creation is simply to put aside the work for a period of time. Interestingly, Rank (1932) pointed out, this withdrawal from the work may take place at the very beginning, thus delaying a threat of being overwhelmed by the artistic work. So, too, this putting aside of the work can occur near the finish. The third path of "salvation from this total absorption in creation" (p. 385) is that of "diversion of artistic creation from a formative into a cognitive process" (p. 387). We may hear in this the echo of Rank's notion of the ideological conflict of beauty and truth, or more mundanely stated, art and science. Thus, the artist may shift from simply making the art that threatens to be all-absorbing to "conscious reflection about creativity and its conditions and about all the aesthetic laws of artistic effect" (p. 388). This involves the "diversion of creation into knowledge, of shaping of art into science" (p. 387), such that the artist-turned-scientist tries to establish psychological laws of creation or esthetic effect.

Crediting several writers on the subject, and specially citing Gustav Ichheiser, Rank (1932) noted the distinction between "achievement-competence" and "success-competence" (p. 400). The distinction is important insofar as achievement in art and success as an artist are not necessarily highly correlated. Rank suggested that "achievement and success are psychologically representative of the two basic tendencies that struggle against one another in the artist, the individual and the social" (p. 400). Achievement, then, can be understood as an ideological matter, while success is a personal phenomenon expressed in the social world. Rank expressed with considerable confidence that "the more the artist achieves in idea, the less disposed will he be to follow this up by personal success" (p. 400). It is not necessarily the case that the ideological achievement is, in itself, sufficient, but as Rank opined, great achievement will be transformed into success without the artist's efforts. Artistic success or fame, to use Rank's synonym, is dependent on critics and dealers who perform those tasks of pushing and publicity which may even be anathema to the artist. Rank stood firm in his belief in "the artist, whose only desire, indeed, is to achieve indirectly through his work." The public, however, or to use Rank's term "average man," has difficulty dealing with ideologies, and needs, instead, concrete personifications. Therefore, there is great interest on the part of the public in the person of the artist, and for that matter, in the

attribution of success or fame. Rank preferred to use the term "success" to refer to the living artist, and "fame" in connection with an artist now dead. Fame, as he designated it, has more ideological significance and concerns the work more than the artist. The complexity of this phenomenon was addressed as follows:

> Fame, which we have taken as a collective continuation of the artistic creative process, is not always, certainly not necessarily, connected with the greatness of a work; it often attaches to an achievement whose chief merit is not its high quality but some imposing characteristic, sensational either in itself or in its topical circumstances. Putting it roughly, we might say that an achievement marked by supreme quality tends to bring success, and one marked by something other than this quality to bring rather fame, both then and thereafter; not only because the masses are probably inaccessible to the supreme quality and can only be gradually educated up to it, but because the qualitatively supreme achievement leaves nothing for the public to do — at most to imagine another equally perfect creator [pp. 402–403].

Fame, as understood by Rank (1932), is hollow, almost a depersonalization. It, too, is transitory, depending as it does on certain circumstances which gave rise to it and which may lead to its perishing, "even though later ages may give it a new life for other purposes" (p. 403). Thus, many of the greatest artists attained fame only long after their own time, while other artists of mediocre gifts are awarded seemingly undeserved success.

Interestingly, Rank (1932) declared that fame both threatens the personal immortality of the artist by making such immortality collective, and forces the artist to remain in the same mode of creation. Success is, then, "a stimulus to creativity only so long as it is not attained" (p. 408). The desire for success and fame may act as motivation for the artist, but for the mature artist, other ideologies must take its place. Rank offered his final judgment of success and fame, writing that "the community annexes the man and his work, depersonalizes him, and thus really robs him of the fruit of his work — in return for which he is offered the distinction of fame" (p. 411).

Near the end of his tome on art and artists, Rank (1932) made some statements which for the art lover may convey a sober if not pessimistic tone. It is here that he touts, once again, the self-creative person as the ultimate artist, but in so doing seems somewhat denigrating of all traditional art forms. I will let him speak.

> The more an individual is driven towards real life, the less will traditional art-forms help him — indeed, they have for the most part already been

shattered individualistically. Especially in poetry, which of course represents in general this conscious level of artistic creation, this permeation by the personal psychology of the poet and the psychological ideology of our age is almost completed. Even the last element of art which poetry retains, language, is becoming more and more an echo of realistic talk or a psychological expression of intellectual thought, instead of being a creative expression of the spiritual. But the reality which modern art seeks to reproduce cannot be represented in language, and other traditional forms are suited only to the creative form of the spiritual and not to a realistic expression of the actual [p. 426].

Rank extracted an interesting side note from this: "That is why the film and talking film have become the most popular art, because this art reproduces the real faithfully, and the more so, the more it progresses" (p. 426).

Furthermore, Rank contended, "the artistic individual has lived in art-creation instead of actual life ... and has never wholly surrendered himself to life" (p. 430). Despite the date of his writing this, long after his break with Freud, this statement certainly sounds like an echo of his master's voice.

One can easily get lost in the labyrinthine paths of Rank's thought, if not first hung up on trying to decipher his sometimes peculiar vocabulary. But, one is well rewarded for persistent effort by the theoretical insights and broad perspective that he brought to art.

In his panegyric, Ludwig Lewisohn (1932) nicely summarized Rank's contributions to the understanding of art and the artist. In his words,

the free creative and self-representative character of all art, its tendency of liberation from the biological, its self-justificatory and immortalizing urge, its need of and yet resistance to the collective culture of its age, the artist's conflict within the dualism of creativity and experience, his need of Muse and mate and the difficulty of combining the two, his resistance to his art itself, his desire for fame and his fear of being depersonalized by that essentially myth-making process — all these explanations and revelations made by Dr. Rank I cannot conscientiously call otherwise than literally epoch-making [pp. ix–x].

How better to conclude discussion of Otto Rank?

CHAPTER 6

Further Insights — Sabina Spielrein, Ernest Jones, W.R.D. Fairbairn, Jacques Lacan, Anton Ehrenzweig, Julia Kristeva, Lawrence Kubie, Phyllis Greenacre, Philip Weissman, and Ernest G. Schachtel

Given the depth of her personal as well as professional relationships with both Freud and Jung, and her prominence in psychoanalytical circles at a time when women were certainly in the minority, it is not surprising that Sabina Spielrein touched upon art in her writing. In a 1911 paper that she presented to Freud's psychoanalytic group in Vienna, she wrote about the battle of schizophrenics not to lose themselves in a oneness with collectively given symbols (Sayers, 2007). (Incidentally, it was her thesis supervisor, Eugen Bleuler who in that same year wrote of the *schizophrenias*, a term that he minted to replace the earlier name *dementia praecox*.) Clearly stated, she wrote that "the collective psyche wants to make the ego-image into an impersonal typical image. The personal psyche tries to restrain this dissolution" (p. 43). But, according to Spielrein, the schizophrenic patient eventually gives into this process and uses collectively given symbols as a defensive flight *from* his or her personal experience. Thus alienated from himself or herself, the patient may become apathetic, and as she observed, "ego-differentiated images are assimilated (and dissolved) and transformed into universal images that are typical, archaic, and collective" (p. 43). But, in the case of the artist, Spielrein averred an important difference.

Spielrein recognized alternate processes between the schizophrenic

patient and the artist. Whereas, as we just saw, schizophrenic patients defend against their individual experience by identifying with collectively given symbols, artists *use* such symbols in the production of their art in order to be able to convey their experience to others. With clarity and simplicity, Spielrein explained this process in the artist as follows:

> A personal image-content, derived from material of times past, blends with a similar content and comes into being as a typical collective wish at the expense of the individual. The new content is then projected externally as a work of art [Sayers, 2007, p. 43].

Thus, we see the role of personal experience and the role of symbols, the two interacting and blending in the emergence of a work of art.

Unlike Jung, Spielrein located symbols in the *preconscious*, not the collective unconscious. She, like Freud, accepted the preconscious as a storehouse of words that mediates the transfer of drive-based unconscious hallucinations and fantasies to consciousness. States of fatigue or intoxication weaken directed conscious thought, thus ushering in symbolic thought, visual as well as acoustical, from the preconscious (Sayers, 2007). Such easily afforded access to preconscious material could account for the appeal of long hours of intensive work to many artists, as well as the use of mind-alternating substances.

Ernest Jones, Freud's most well-known biographer, and psychoanalyst in his own right, added to our understanding of symbols by detailing two forms of symbolism, *personal symbolism* and *social symbolism*. In the course of making this distinction, he emphasized social progress in the development of symbolism, particularly in religion and science. The art historian Ernst Gombrich, however, has pointed out that Jones's views were as applicable to the development of symbolism in art (Sayers, 2007). But, getting back to Jones, social progress in the development of symbols involves

> the constant unmasking of previous symbolisms, the recognition that these, though previously thought to be literally true, were really only aspects or representations of the truth, the only ones of which our minds were — for either affective or intellectual reasons — at the time capable [p. 49].

Jones referred to personal symbolism as *true symbolism*, that is, symbols that are created in the course of repressing and displacing unconscious material onto more acceptable objects. In this spirit of sublimation, said objects arise, then, as true symbols. Referring to such true symbols, Jones

contended that "only what is repressed is symbolized," and furthermore, "only what is repressed needs to be symbolized" (Sayers, 2007, p. 49).

This distinction which Jones drew between two types of symbolism may be valuable in alerting us to consider whether a particular symbol in a work of art represents the artist's repressed and displaced, that is, sublimated unconscious urges, or if that symbol is a representation of the truth as that truth is understood within a particular cultural context. The former or personal symbol, of course, may allow a peek into the psyche of the artist, whereas the latter reveals something of the beliefs and values of the socio-historical context of that artwork.

W. R. D. Fairbairn has explored art in terms of a process of destruction and repair. Indeed, he proclaimed that art is impelled by destruction. Perhaps, at first glance, this seems surprising, if not shocking. His reasoning may be found interesting.

> Since the chief source of inner tension is found to lie in the pressure of destructive urges, and since artistic activity both relieves this inner tension and is essentially creative, we are justified in concluding that the principle of restitution is the governing principle in art [Sayers, 2007, p. 56].

Note that Fairbairn began his argument with the premise that it is aggression, or in his words "destructive urges," that is the basic source of psychic tension, not sex and aggression as is the more orthodox or traditional psychoanalytic view of Freud. He then posited the relief of such tension through the production of art. Creation through art is the restitution. Fairbairn analyzed many works of art, deriving evidence for his conclusion that this principle of restitution is the governing principle in art. Among them were works by Vermeer, Paul Klee, Picabia, and Picasso. In reference to Picasso's "The Woman with the Golden Breasts," he claimed that the artist showed destructive tearing to pieces followed by integrating repair of these "objects reduced to fragments" (p. 56).

Others, too, have held a similar view to that of Fairbairn. Most notable, perhaps, is Georges Bataille, the surrealist writer. It was Bataille who wrote of art as developing out of "progressive destruction and the childish impulse evoked by a blank piece of paper to cover it in scribbles" (Sayers, 2007, p. 56). Even if not original, Fairbairn's view is important for its having been expressed within the context of psychodynamic theory.

Influenced by surrealist art and particularly by Salvador Dali's method of *paranoia-criticism*, Jacques Lacan opposed the ego psychology that developed in the United States, the work of such analysts as Anna Freud, Heinz

Hartman, Ernst Kris, Rudolph Lowenstein, and Erik Erikson. At the risk of oversimplification, the ego analysts took the position that the analyst should foster the child analysand's identification with the ego and superego of the analyst. Thus, weaker, less-developed egos and superegos could become stronger and more fully developed. In diametric opposition, Lacan declared that the task for the analyst is to expose the analysand's identification with the analyst's ego or superego as illusory and self-alienating (Sayers, 2007). Just as André Breton and other surrealists rebelled against the ego and superego of the art establishment of their time, so to speak, with a literal focus on the ego and superego, Lacan turned against the ego and superego of the psychoanalytical establishment of his time. To get a flavor of his position, consider the following. "Just as the superego's insane oppression lies at the root of the well-founded imperatives of moral conscience, mad passion — specific to man, stamping his image on reality — is the obscure foundation of the will's rational mediations" (Lacan, 2004, p. 23). His sentiment is clear.

Sayers (2007) further explained Lacan's position:

Lacan conceptualized the ego, ego-ideal or ideal-I as seductive effect of others, artists included, showing and inviting us to lose ourselves in identification with what they show us to desire and see. This centres [sic], he said, on phallic symbolism in the patriarchally [sic] structured societies [p. 81].

Ironically, Lacan's position may be adopted as a tocsin, a warning that one's very self may be at risk as the artist shows us what to see and to desire. Allow me to suggest that the seductive power of the invitation issued by the artist may be an index of the quality of the art. Great art may pull strongly for identification with the artist's perspective, and importantly, with attendant potential loss of one's own.

One would be in error, however, to conclude that Lacan was unappreciative or in some sense hostile to art. (As stated above, he was influenced by surrealist art.) Quite the contrary, Lacan (2002) was quick to pay homage to art through apropos references to it. For example, in a chapter dedicated to the exploration of "Aggressiveness in Psychoanalysis," he expressed the following:

One must leaf through a book of Hieronymus Bosch's work, including views of whole works as well as details, to see an atlas of all the aggressive images that torment mankind. The prevalence that psychoanalysis has discovered among them of images based on a primitive autoscopy of the oral organs and organs derived from the cloaca is what gives rise to the shapes of the demons

in Bosch's work. Even the ogee of the *angustiae* of birth can be found in the gates to the abyss through which they thrust the damned; and even narcissistic structure may be glimpsed in the glass spheres in which the exhausted partners of the "Garden of Earthly Delights" are held captive.

These phantasmagorias crop up constantly in dreams, especially when an analysis appears to reflect off the backdrop of the most archaic functions [pp. 13–14].

The work of Anton Ehrenzweig may be of special interest in that he called attention to aspects of art that can instruct one's viewing and thereby enhance one's appreciation. He suggested, for instance, that the use of condensed and overlapping forms and perspectives invites the viewer to wander in and out of the picture plane. In this, Ehrenzweig agreed with Herbert Read's statement that "most works of art do not admit of any possible fixed focus — they deliberately invite a wandering eye" (Sayers, 2007, p. 112). As particularly illustrative examples, Ehrenzweig discussed the oneness of various shapes, forms, and perspectives that Picasso achieved in *Les Demoiselles d'Avignon* as well as cubist paintings by Braque. With reference to Picasso, Ehrenzweig instructed "we might find a guitar superimposed upon a human limb," thus creating "form ambiguity" (p. 112). "As the eye glides over the superimposed and overlapping forms the whole structure of the picture seems to shift continually as each form calls up a new juxtaposition of forms" (p. 112). Ehrenzweig mentioned, too, and with appreciation, Picasso's superimposition of different perspectives in depicting faces.

Ehrenzweig distinguished art in which the sequence in which we view each detail on our route to apprehending the whole makes no difference from that in which the artist invites a particular path of visual stops. Exemplary of the latter, Ehrenzweig analyzed *The Dead Christ* by Mantegna and works by Cézanne. Featuring Cézanne's work as his example, Ehrenzweig proposed that very good art dynamically unifies conscious and unconscious perception. It is not just the unification of different perspectives, then, that may define good art, but necessarily and specifically the unification of conscious and unconscious perception. The dynamic of such unification mirrors the dynamic of dreaming. In both instances, images flow together and separate, condensing and differentiating. By way of elaboration, Ehrenzweig invoked Nietzsche's view of art as bringing together Dionysian chaos and Apollonian order, as well as William James' suggestion that thinking unites vagueness and clarity in the flow of the stream of consciousness (Sayers, 2007).

The method used by artists has essentially been the same throughout time, Ehrenzweig suggested. However, in modern art there is less restriction in using the vague and ambiguous forms that emerge from the artist's unconscious during the early stages of art formation. Sayers (2007) quoted Ehrenzweig as presenting this idea in the following manner:

> Automatic form-control means that the depth mind has taken over the form-production which therefore now reflects the gestalt-free structure of the depth mind. Hence, the lack of a pregnant eye-catching pattern, the superimposition, overlapping and general ambiguity of forms which could never be achieved by conscious form control [p. 119].

In this statement, Ehrenzweig revealed his firm appreciation of the necessary and powerful role of the unconscious process in the creation of good modern art.

Sayers (2007) explained Ehrenzweig's position in this way.

> Modern art allows these vague forms to permeate the whole picture plane. This is achieved by the artist contriving to retain fluid, gestalt-free, vague perception from start to finish by suppressing all definitive form ideas in keeping with modernist distaste for secondary revision reason and logic.... In their pursuit of vagueness modern artists are helped in starting each new work of art by projecting marks on their chosen medium in the form of scribbles and doodles [p. 119].

The mention of "secondary revision" is, of course, an allusion to Freud's dream theory, secondary revision being that final step in dream formation in which, as the dreamer awakens, he or she imposes some measure of coherence and consistency on the dream material in order to render it more logical and comprehensible in the waking world. Sayer's mention of "scribbles and doodles" is a reminder of the nexus between psychoanalytic techniques such as free-association and techniques used by the surrealists.

Ehrenzweig offered a perspective on the creation of art which is at once somewhat unusual and dramatic. A three-stage process, it begins with a paranoid schizoid state of mind. At this stage the artist projects fragmented parts of self into the work. These fragmented parts of the artist may appear as accidental, unwanted, and persecuting. Therefore, the artist must at this stage be able to tolerate, as Ehrenzweig put it, "without undue persecutory anxiety" (Sayers, 2007, p. 120). To identify the state of mind of this stage as paranoid schizoid is to acknowledge fragmentation of self as schizoid and to acknowledge projection of unwanted, even persecutory fragments of self as paranoid.

Following this projection stage is the stage of oceanic scanning. Herein, the artist enters a *manic-oceanic* oneness with his or her emerging work of art. Previously emergent unconscious forms are integrated into consciously perceived shapes and forms. Incorporating Ehrenzweig's own words, Sayers (2007) wrote, "This is achieved through the artist's 'scanning that integrates art's substructure' ... through 'cross-ties [which] bind the single elements together [so that] an unbroken pictorial space emerges as the conscious signal of unconscious integration'" (p. 120).

At the third stage, part of the hidden substructure of the work is re-introjected into the ego of the artist, but at a higher mental level. This three-stage process of art-making can then be summarized as *projection*, *oceanic scanning*, and *re-introjection*. The creativity of the artist depends on his or her ability to deal effectively with all of these stages. Ehrenzweig argued that this is a process parallel to that of psychoanalysis, writing that "the analyst must allow the patient's fragmented material to sink into the containing womb of his own (the analyst's) unconscious without premature wish to re-articulate it and put it back into the patient on a fully articulate level" (Sayers, 2007, p. 122). And with this, the art of analysis merges with the analysis of art.

Another psychoanalyst who was able to bring art into the discussion of psychoanalysis was Julia Kristeva; in so doing, she was able to illuminate, in a reciprocal manner, each in terms of the other. In one such instance she addressed color. "Kristeva highlights the importance to psychoanalytic treatment of perceptual qualities ... with the example of the use made by artists of colour in painting" (Sayers, 2007, p. 155). Color, unlike other aspects of art such as form and perspective, is relatively free from convention and rules for its use. Because of this, color tends to revivify meaning that has been repressed. In language deeply imbued with psychoanalytic terminology, Sayers wrote:

> Colour serves to bring back to consciousness what is repressed by the "over-signifying logic," as Kristeva puts it, of secondary revision ruled by superego convention. Colour lends itself to this because, she says, "it inscribes instinctual 'residues' that the understanding subject has not symbolized" [p. 155].

In this, we can see that both psychodynamic process and color theory are raised to an enhanced level of understanding. Grounded in this understanding, Kristeva launched a focused analysis of Giotto's frescos and several paintings by Bellini. These discussions were characterized by reciprocal understanding of psychoanalysis through art and art through

psychoanalysis. Keep in mind that I have touched only on Kristeva's exploration of color; she was prolific in her other explorations, and summoned works by Cellini, Dali, Dostoevsky, Holbein, O'Keeffe, Piero della Francesca, and Poussin to illustrate and to illuminate.

Kristeva also called upon the work of Hans Haacke, *Germania*, in order to address installation art. Appearing at the 1993 Venice Biennale, this installation required its visitors to participate in it by walking on broken, crumbling ground. Describing such art, Kristeva wrote that "the entire body is called on to participate through its senses — sight, of course, but also hearing, touch, sometimes smell ... communicating ... what was once celebrated as incarnation ... the desire to make one feel — through abstraction, form, color, volume, sensation — a real experience" (Sayers, 2007, p. 171). This description, elegant as it may be in its clarity and simplicity seems to beg the question. "A real experience," yes, an "incarnation," but what deeper meaning can be found if we probe the core? With precise psychoanalytic penetration, Kristeva enucleated this experience of incarnation. Installation art "produces an unsettling complicity with our regressions, for when faced with these fragments, these flashes of sensations, these disseminated objects, you no longer know who you are" (p. 171). I would add only an exclamation mark!

Although remaining within the framework of Freudian theory, Lawrence Kubie was firm in his position that creativity is a product of the preconscious, and not of the unconscious (Arieti, 1976). He maintained that conscious mental activity may sometimes hinder the creative process through the rigid use of symbolic functions. This is not too difficult to understand. For example, the use of a dictionary of dream symbolism for the selection of an image for a poem could drown out the voice of one's own spontaneously arising images. More startling, however, was Kubie's assertion that the unconscious may interfere with the creative process with an even more rigid anchorage in unreality! This idea reflects, I believe, Kubie's recognition of both the ubiquity and the power of the unconscious. Acknowledging the strong possibility of interference from both conscious mental activity and unconscious processes, Kubie concluded, therefore, that it is the preconscious that takes the lead in artistic creativity.

In an impact-laden article in 1957, Phyllis Greenacre asserted that creativity derives from a "love affair with the world" (Arieti, 1976). This intriguing asseveration, as well as the phrase embedded within it, certainly cries out for explanation. According to Greenacre, the infant who has

144

potential as an artist is characterized by greater sensitivity to sensory stimulation than is true of the less gifted, and by the possession of an ego that is capable of dissociating itself from real objects. Possessing this greater sensitivity to sensory stimulation, he or she would be susceptible to both intensification and a widening of experience. An implication of this intense reaction is, then, the need for a harmonization of inner object relations (e.g., mother's breast) and the world of sensory impingement. Out of this situation, and with the ability to dissociate from real objects, comes what Greenacre chose to label "the love affair with the world" and, hence, creativity.

Inspired by Greenacre, Philip Weissman contributed a small but interestingly complex note to the psychodynamic theories of artistic creativity. In his view, the potential artist has, as an infant, the ability to hallucinate the mother's breast *independently of the presence of oral needs*. At the same time, this potential artist may to some extent decathect the breast and hypercathect his or her image of it by means of what Weissman termed the *dissociative function of the ego* (Arieti, 1976). That is, energy is withdrawn from the external object (mother's breast) and invested in the imaginary object (hallucinated breast). Note, importantly, that the energy is not simply *re*-cathected, but is *hyper*-cathected or excessively invested. The artist is, in his or her creativity, driven to preserve if not immortalize this non-need-based response to the hallucinated breast. In essence, then, the artist is motivated by the wish to preserve through symbolic repetition an infantile experience that differs from those of non-artists. Art reflects that experience by being, itself, divorced from in-the-moment need and, in a sense, powerfully hallucinatory.

In contrast to the several complex theories already discussed, Ernest G. Schachtel suggested what for some may be a refreshingly simple theory. To wit, the creative person is not mired down in the societal clichés, but is open to new experiences, open to the world. In terms of motivation, it is the need to relate to the world that is at the root of creative experience. Quoting Schachtel, Arieti (1976) wrote that "the quality of the encounter that leads to creative experience consists primarily in the openness during the encounter and in the repeated and varied approaches to the object, in the free and open play of attention, thought, feeling, perception" (p. 28). Although certainly plausible, Schachtel's theory has a hollow quality in so far as he neglects discussion of any internal forces or processes that could provide the creative form to the encounter. It seems his theory addresses

the attitude of the artist, important as that may be, but not mechanisms for the substitution of new forms for society's clichés.

These "further insights" of Spielrein, Jones, Fairbairn, Lacan, Ehrenzweig, Kristeva, Kubie, Greenacre, Weissman, and Schachtel, although not grand theories as are those of Freud, Kris, Jung, Reich, and Rank, have a well-deserved place in any fairly exhaustive discussion of psychodynamic theories of art. In each case they are best viewed and most fully understood against the backdrop of the grand theories, most especially that of Freud. Each offers something that can be recognized to fill some lacuna in a larger and grander edifice.

CHAPTER 7

Psychodynamics in Color and Black and White — Hermann Rorschach

Some readers will no doubt be surprised to find that I have included a chapter on Hermann Rorschach's Form Interpretation Test, better known by the eponymous title, the *Rorschach*, in a book focused on psychodynamic theories concerning arts and artists. Recently, over a leisurely dinner, I mentioned to a long-time colleague of mine that I was going to write such a chapter. Rarely at a loss for words, wide-eyed he sat and stared at me for some time before speaking. Finally, he expressed curiosity bordering on astonishment. After hearing my rationale, however, he energetically declared that he wanted to read this when it was completed. Other clinical psychologist colleagues have reacted similarly, even if less intensely. These reactions have stimulated and encouraged me, for they strongly suggest that the idea of applying Rorschach's work to the understanding of art is fresh and potentially intriguing.

Including Rorschach's work in a book concerning arts and artists is further suggested by a tie-in made by Ernest Schachtel. Writing about Rorschach, Schachtel (1966) offered the following:

> Long before he wrote his book and throughout his life, he was interested in the differing ways in which different people see and experience a painting. When visiting an art exhibition, he would try to imagine how one or another person of his acquaintance would feel when looking at a certain painting [p. 4].

Rorschach published his *Psychodiagnostik* in 1921, the year prior to his untimely death at 37 from appendicitis complicated by peritonitis (Exner, 2002). In this work he explained the clinical use of his set of ten

inkblots. Rorschach (1921) assumed that the way in which the inkblots were interpreted was "characteristic of the various categories of normal individuals and of the psychoses" (p. 181). But, beyond this he did not offer a theoretical position, let alone a theory of personality. However, he was well versed in the theories of both Freud and Jung, and suggested that his instrument could be useful in studying changes in personality dynamics following psychoanalytic treatment (Exner, 1969). The fact that he was familiar with Freudian and Jungian theory, as they had been developed to this point, suggests that these theories influenced his own theorizing about his diagnostic instrument. In addition, it is easily noted that the research and development of the Rorschach took place during the time that psychoanalysis dominated the clinical scene. All of the pioneers who developed scoring and interpretive systems after Rorschach's death were trained in psychoanalysis. One might say with justification that the Rorschach and psychoanalysis grew up together.

Readers who are familiar with the Rorschach are well aware that the instrument has been shrouded in controversy. It has been seriously challenged both as to its *reliability* and its *validity*. As for the first, questions have been raised concerning both the consistency of scoring by different administrators (*inter-scorer reliability*) and the stability of the scores obtained (*test-retest reliability*). In other words, can two different clinicians independently score a given Rorschach protocol and demonstrate an acceptable level of agreement? In addition, are those scores stable enough to be in essence unchanged if the Rorschach is repeated a short time later? That is, does repeat performance on the Rorschach reflect something other than random fluctuations, whims of the moment, or other nonce factors? In terms of validity, the nuclear question is whether or not the Rorschach assesses what it purports to assess. For example, if certain scores are claimed to reflect schizophrenic thought process, is it in fact this process that is being measured, or if certain scores are purported to predict violent behavior, do they actually do so, or if another set of scores are believed to assess introversion, do they? These are examples respectively of *criterion-related validity* (*concurrent validity* and *predictive validity*) and *construct validity* (a theoretical or hypothetical trait). It is primarily these reliability and validity issues that have been the focus of controversy around the Rorschach. The administration, scoring, and interpretation are complex and require considerable training, and when used clinically, the administration, scoring, and interpretation are time-consuming. These constitute further objections

by some to the clinical use of the Rorschach. Interestingly, an enormous body of research on the Rorschach exists. Yet, the controversy continues. Many clinicians defend the Rorschach on grounds of clinical experience and reject the many non-supportive studies as poorly designed, or simply irrelevant. If these clinicians are the *tender-minded*, to use William James's rather poetic term, the *tough-minded*, to use his antipodal term, invoke the non-supportive research findings to justify tossing the Rorschach onto the dust pile of disproved and outmoded clinical tests.

Granted, the Rorschach cannot boast the consistently demonstrable levels of reliability and clinical validity that are the pride of paper-and-pencil psychometric instruments such as the Minnesota Multiphasic Personality Inventory (MMPI), or of the Wechsler Adult Intelligence Scale (WAIS)). For our purposes, however, we need not be concerned about clinical reliability and validity measures, for we are not employing the Rorschach as a diagnostic test or instrument for clinical assessment. But, what I am going to suggest is that *Rorschach theory is a highly sophisticated, valuable template for the observation and exploration of art, offering a rich and highly nuanced perspective.*

I trust that a brief history of the development of Rorschach's test will provide a cultural context that may be of interest, but more importantly, a comfortable, gradual entry into a complex theory. To begin, the idea that ambiguous stimuli can be used to stimulate the imagination can be traced back at least to Leonardo da Vinci and Botticelli in the fifteenth century (Exner, 1969). From Leonardo's *Introduction to the Painter*, Zubin, Eron, and Schumer (1965) quoted as follows, regarding the stain made from throwing a wet sponge on a wall. "Various experiences can be seen in such a blot, provided one wants to find them in it — human heads, various animals, battles, cliffs, seas, clouds or forests and other things" (p. 167). Many instances can be found of the use and fascination with unstructured stimuli in the stimulation of the imagination. In time, this led early psychologists to more formalized and systematic efforts to capitalize on this human penchant. Allow me to list, briefly, some of the sequential developments along this line.

In 1895, Binet and Henri used a series of inkblots in order to investigate several personality traits, including visual imagination. Shortly thereafter, in 1897, a Harvard psychologist by the name of Dearborn investigated imagination, memory, and the content of consciousness using inkblots. Stella Sharp, in 1899, evolved a personality typology based on inkblots as

149

a test of imagination. Kirkpatrick, in 1900, noted age differences in children's inkblot responses, as did Pyle between 1913 and 1915, as well as differences based on sex and intelligence. Whipple stimulated work with inkblots in the United States when the technique and data from his *Test 45*, using a series of 20 inkblots, were reported in the 1910 publication of the *Manual of Mental and Physical Tests*. He considered this test as one of "active imagination" (Exner 1969). Further work with inkblots was done by Parsons in 1917, as well as by Wells and Bartlett in England, and Rybakow in Russia. So, we see there was considerable interest and experimentation with inkblots during the quarter of a century prior to Rorschach's publication of his work (Exner, 1969, 1993, 2002, Rabin, 1981). And, although "it is doubtful that any of this work stimulated Rorschach's original study ... it is quite likely that he became familiar with much of it before he wrote his monograph" (Exner, 1993, p. 4). This referred-to monograph was, of course, the *Psychodiagnostik*.

In addition to the professional interest in inkblots, there was a popular game known as *Klecksographie* or Blotto which Rorschach played as a youth (Exner, 2002). This game, which had flourished in Europe for nearly a century, had several variations.

> Inkblots (*Klecksen*) could be purchased easily in many stores or, as was more commonplace, players of the game could create their own. Sometimes the "game" was played by creating poem-like associations to the blots (Kerner, 1857). In another variation the blot would be the centerpiece for charades. When children played the game, they usually created their own blots and then competed in developing elaborate descriptions [Exner, 1993, p. 4].

Konrad Gehring, a teacher in an intermediate school, discovered that his adolescent male students worked more diligently if, after a period of work, he allowed them to play Blotto. Learning of this, Rorschach was intrigued, and also wondered if his psychotic patients would respond differently to the game from the students. This interest led to several experiments. Rorschach also compared the Blotto responses of his schizophrenic patients and his patients with "forms of psychosis reflected in organically induced dementia," finding that they responded quite differently (Exner, 1993, p. 4).

Rorschach became increasingly interested in investigating inkblots after Syzmond Hens developed a series of eight inkblots and administered them to 1,000 children, 100 non-patient adults, and 100 psychotic patients. In addition to analyzing the similarities and differences among the three groups, Hens suggested a classification system for the contents of their responses.

Setting out with about 40 inkblots, of which he used 15 most frequently, Rorschach begin his investigations in earnest. Of greatest significance, perhaps, in Rorschach's experiment is the fact that, unlike his predecessors who were primarily concerned with the content of the associations to inkblots, he stressed *how* the inkblots were perceived (formal characteristics such as shape, color, and apparent movement) rather than *what* was seen (content). This point deserves strong emphasis. It was truly a mark of Rorschach's genius that he recognized the importance of the determining factors in an inkblot percept, that these were more revealing of personality than were the contents of what was seen. The content paled in importance before the formal characteristics, or *codes*. In Rorschach's (1921) words, "The problems of the experiment deal primarily with the formal principles (pattern) of the perceptive process. The actual content of the interpretations comes into consideration only secondarily" (p. 181). Here is how Exner (1993) expressed this.

> His major thrust avoided and/or minimized content, but instead focused on the development of a format for classifying responses by different characteristics. Thus he developed a set of codes ... that would permit the differentiation of response features. One set of codes, or scores as they have come to be called, was used to represent the area of the blot to which the response was given.... A second set of codes concerned the features of the blot that were mainly responsible for the image perceived by the subject, such as *F* for form or shape, *C* for chromatic color, *M* for the impression of human movement, and so on. A third set of codes was used to classify contents [p. 5].

As indicated above, Rorschach worked mostly with 15 inkblots, selected from his original 40, and by 1919 had settled on 12. His publisher, finding reproduction of the inkblots difficult, allowed only 10 of them to be printed in the *Psychodiagnostik* (Exner, 2002). These 10 inkblots have become the standard set. The inkblots had to meet certain criteria. As quoted by Exner, Rorschach wrote about inkblots as follows:

> Not all figures so obtained can be used, for those used must fulfill certain conditions ... the forms must be relatively simple ... [they] must fulfill certain requirements of composition or they will not be suggestive, with the result that many subjects will reject them as "simply an inkblot" [p. 12].

Exner has suggested that in order to meet these criteria, Rorschach may have "used his considerable artistic talent to detail and embellish the figures that he produced, and added some of the colorings" (p. 12).

Extrapolating from Rorschach's statement of conditions that had to

be fulfilled by an inkblot in order for it to serve his purpose, I derive three essential criteria that are met by the set of Rorschach plates. First, they are *standardized*; second, they are *ambiguous*; and third, they are *pregnant with possibilities*. Standardization of the order in which the plates are administered, as well as with the plates, themselves, has allowed normative data to be obtained. With these empirically generated data in place, a given person's performance on the Rorschach can be compared with the norms. The ambiguity of the stimulus material means that the person responding to it cannot simply identify a realistic rendition of something as one would do with mimetic art, but must bring his or her imagination to bear in order to create meaning. The Rorschach plates have stood well the test of time in terms of being pregnant with possibilities. On average, observers report more than 30 percepts when viewing the set of 10 plates, and one person to whom I administered the Rorschach gave more than 100 associations!

Following Rorschach's death, several very creative clinicians developed their own systems for scoring the Rorschach, as well as guidelines for its administration and interpretation. None of these several clinicians actually studied with Rorschach, and each worked independently of the others, although to various degrees they were aware of each other's work. The result was five quite distinct major Rorschach systems, even though "all of the Systematizers [sic] endorse[d] some form of psychoanalytic theory and all have accepted many of Rorschach's original interpretive hypotheses" (Exner, 1969, p. 8). The systems are those of Samuel J. Beck, Marguerite Hertz, Bruno Klopfer, Zygmund Piotrowski, and that of David Rapaport and Roy Schafer. After decades of this division, John Exner undertook to integrate the empirically defensible components of the five predominant Rorschach systems into what he called the Comprehensive System, and it is that which enjoys most widespread use today (Exner, 1993).

The task before us, now, is to identify which of the Rorschach scores or concepts may be relevant in assessing a work of art, and how to interpret them in this context as opposed to the context of the Rorschach as a test. In the interest of greatest utility, I will include aspects of the various Rorschach systems from Rorschach, himself, to Exner.

In order to contextualize the scores or determinants that we will be considering, I will first mention the symbols that Rorschach (1921) presented in his *Psychodiagnostik*.

R = Total number of responses to the plates.

W = Plate interpreted as a whole.

DW = Plate interpreted as a whole only secondarily, based on a detail.

D = A frequently chosen detail.

Dd = A less frequently chosen detail.

S = A figure-ground reversal in which the white space is used as figure.

Do = A detail interpreted where the whole is usually interpreted.

Apper. = Apperceptive Type. The ratio of W, D, and Dd locations chosen.

Sequence = The sequence of W, D, or Dd response within each plate.

F = Interpretation based primarily on the form or shape of the blot.

M = Movement. Attribution of human movement to a percept.

FC = Form-Color. Interpretation based primarily on shape and secondarily on color.

CF = Color-Form. Interpretation based primarily on color and secondarily on shape.

C = Color. Interpretation based on the color of the blot alone.

Experience Type = Ratio of movement responses to color responses, calculated M / (FC + CF + C).

H = Interpretation of human content.

A = Interpretation of animal content.

Hd = Interpretation of part of a human.

Ad = Interpretation of part of an animal.

Obj. = Interpretation of an inanimate object.

Ldscp. = Interpretation of a landscape.

A% = Animal percent, calculated A + Ad / R × 100.

Orig. % = The percent of responses that are original, "original" being defined as occurring no more than once in 100 protocols.

In addition to these symbols, Rorschach identified what he termed *color shock* as a possible reaction to the plates which include color.

In a paper published posthumously in 1923, "The Application of the Form Interpretation Test," as well as elaborating some of the concepts that he had introduced in *Psychodiagnostik*, Rorschach added *Vulgar* responses and *shading* as codes (Exner, 2002). He defined a vulgar response, known now as a *Popular* response, as one which occurred for a particular location at least once in every three protocols (Exner, 1993). Interestingly, the coding of shading developed serendipitously. As Exner informed, "Rorschach made no mention of shading or 'chiaroscuro' features in his original monograph because the cards on which his basic experiment was based contained no variation in hue. These characteristics of the blots were created through a printing error" (p. 122). Recognizing the possibilities that emerged from this less-than-perfect inking technique, Rorschach was quick to score all references to shading.

The fact that Rorschach (1921) referred to his instrument in *Psychodiagnostik* as the "Form Interpretation Test," is more than a clue to the central importance of the scoring of *form*. This is affirmed and briefly explained by Samuel Beck and his associates in the following passage:

> The F+ response — Rorschach's *gute Formen* — is a cornerstone of his experiment. Its usefulness in appraising the S's ability to perceive accurately, and hence to know realities, gives F+ this importance. The realities include the social values; they are "good form" in the social sense. It follows that a normative and operational practice in scoring F+ is of the essence in the clinical use of the test [Beck et al., 1961, p. 130].

Let us delve into this a bit further. The idea is that one of the prime factors that determines the percept reported by an observer of the Rorschach figures is shape or form. That is to say, upon inquiry, the person indicates that he or she saw what he or she did because the Rorschach plate or a chosen part of that plate was shaped in a particular way. In keeping with the language of psychological research of the time, and using the conventional symbol in the above passage, Beck and his colleagues referred to the person observing the figures as a "subject," or "S" (a term now replaced with "participant"). By administering his experiment to many participants, Rorschach was able to generate norms with respect to the frequency with which participants attributed various identities to the figure as a whole or to specific areas of each blot. Later researchers have increased the size of the normative sample and, at the same time, updated the norms. Thus, certain identities attributed to the various areas of each blot are statistically frequent enough to be taken as somewhat consensual; these are considered *good form* and are scored *F+*. Conversely, identities attributed to the various areas of the blots that are statistically uncommon are considered *poor form* and are scored *F−*. It is this consensual definition of good form that is the underpinning for Beck's reference to the "social sense" of the F+ score, and to the "social values" thereby reflected. When used as a clinical test, the percent of reported percepts that are determined by form and are scored F+ becomes an index of the degree to which the person's perceptions are consensually valid. The F+ % covers a range from the nonconsensual perceptions of the schizophrenic through the perceptions of the highly creative individual whose perceptual world, while based in the consensual, is additionally liberally sprinkled with imaginative percepts that are non-consensual by definition, through the mostly consensual perceptual world of the average person, to the perceptual world of the highly

conventional person who demonstrates a nearly total lack of originality. Stated more simply and succinctly, form perception varies from clouded or indefinite perception to rigid accuracy. As such, F+ % relates to creativity and optimal functioning in a curvilinear manner. Note that poor form is not undesirable, per se; it is the ratio of good to poor form that is significant, and then only when considered within the context of several other Rorschach variables.

Form, as a determinant of a percept is, then, related to cognitive activity. Thus, it is one of the several Rorschach variables that are used in evaluating both level and type of intelligence. As suggested by Schachtel (1941), and based on ideas proffered by Rorschach, form responses are most often generated through a conscious process of critical comparison between the form perceived and similar forms that are remembered. Sometimes, of course, repressed and thus unconscious material will enter into this process. This process is, then, one of perception and *apperception*, a process requiring not only perception, but memory, association, and critical judgment as to degree of likeness between the image perceived and remembered images. Schachtel (1966) used the summarizing phrase *perception-association hypothesis* to refer to this complex process, asserting that the person who enters into this process must *encounter* the Rorschach image.

When looking at a painting, drawing, or similar type of art, we can ask if *form* is a determinant of what is presented. That is, does this work of art invite an intellectual encounter, an engagement of our cognitive processes? If so, what is the perception-association process that the work seems to invite? The steps in that complex process may be traced. And, what is the specific content of that process? Are these forms of an F+ quality, easily recognizable by their realism? Are they rigidly-cum-photographically accurate? Or, are they of an F– sort, less mimetic and thereby inviting of a more abstract and symbolic comprehension? Or, alas, are there examples of F– that bespeak weakness of technique? The questions may be shifted subtly from the artwork itself to the artist by asking in each case what the *artist* seems to have been inviting through his or her communication. What is his or her intellectual message? So, on the one hand we can focus on a particular work of art, or we can look across that artist's oeuvre and note if there is a tendency for that artist, or for that artist during a particular period, to lean more heavily toward F+ or F–, or even absence of F. As we relate this F+ / F– perspective to other Rorschach

variables, we will be increasing the complexity of our template and, in turn, the richness of the questions which we can ask.

If *form* as a determinant of a percept invites cognition, *color* invites affect. Otherwise stated, form calls forth intellectual apprehension and color elicits emotion. The significance of this was emphasized by Beck et al. (1961) in stating that "the importance of the color response in Rorschach's test lies in the sector of the personality that is reflected in it: the individual's outwardly expressed feelings" (p. 98). In a sense, affect is thus excitement. Furthermore, "response to color ... presents information as to the individual's sensitivity to events known to be exciting to the healthy persons of his cultural group generally" (Beck, 1945, p. 27).

As articulated by Schachtel (1966), integrating color with form can enrich perception in two major ways. First, "it can be a useful cognitive aid, making possible more rapid, effective, well-articulated recognition or grasp of an object" (p. 177). Second, color may have "an immediately enlivening, enjoyable sensory quality, or sometimes, a disagreeable, unpleasant one" (p. 178). "In Rorschach records it is not infrequently apparent from the specific color response or from the over-all color reaction that one or the other quality, cognitive usefulness or sensory-affective tone (which may be positive or negative), predominates" (p. 178).

Color may be the sole determinant of what one sees on the Rorschach, it may combine with form, dominating the latter, or it may be secondary to form. The representative scores would be C, CF, and FC, respectively. Of course, when form is a co-determinant, a scoring of + or − is relevant, and thus we have C, CF+, CF−, FC+, and FC−. As indicated above, Rorschach (1921) included these scorings in his original system. Although some of the authors of the subsequent systems elaborated on this basic scoring as they saw the need for even greater nuance, Rorschach's interpretation of the color responses remained basically unchanged.

Boldly stated, "the undiluted color reaction, C, is the test's equivalent of the uninhibited feeling experience" (Beck, 1945, p. 27). In a descriptive and non-pejorative sense, and speaking developmentally, it is an infantile response mode. Therefore, when found in older children or adolescents, it suggests a good possibility of tantrums or other emotional outbursts. In the adult, this may mean a tendency for ungovernable impulses and rage. When dominated by C, one is a slave to one's emotions. One's "response to feelings is exclusive and instant" (p. 30).

When color is combined with form, but is dominant (CF), less impul-

sivity may be expected, but highly labile reactivity would nevertheless be predicted. Developmentally speaking, this is more advanced than the level represented by pure C. Herein, the infantile reaction trend is restrained by virtue of the intellectual process of awareness of reality.

Form dominant over color, FC, Beck (1945) maintained, was a greater developmental advance over CF than of CF over C. FC reflects reaction to emotions, but emotions tempered with regard for reality, including social reality and regard for the feelings of others. The total amount of color used, what is referred to as the *C sum* on the Rorschach and calculated by means of a weighted sum of C, CF, and FC, may reflect "the extent to which the individual's affective energy is available for response to the environment — whether through a self-centered, irritable, petulant, demanding display or in an allocentric and understanding emotional identification with those around him" (p. 31). Likewise, "the lower the C total, the duller and more phlegmatic is his effort" (p. 31).

In the case of FC– or CF–, the minus suggests that the element of conscious control in the response is weak. Beck (1945) contended that FC– is closer to CF than to FC+, and CF– approaches closely pure C. Even in the case of FC– wherein form is dominant over color, or more to the point, intellect is dominant over emotion, cognitive control is weak, thus destabilizing the affective urges. Less accurate form perception in combination with elicitation of emotion surely points to less modulation of affect.

Schachtel (1966) wrote concerning the contrast between form and color:

> In contrast to the actively structuring and objectifying allocentric perceptual attitude characteristic of the perception of form and structure, the perception of color and light does not require such an attitude. Nor does color perception, by itself, permit objectification, while perception of form does. The visual recognition of a particular object is not possible without form perception. The perception of color, if not accompanied by and integrated with form perception, typically occurs with a passive, more autocentric perceptual attitude [p. 159].

In his writing, Schachtel (1966) emphasized both the passivity of the perceiver and the immediacy of the experience in the perception of color.

> A particular *feeling tone* or *mood quality* is often immediately connected with various colors. Thus, colors are not merely recognized, they are felt to be exciting or soothing, dissonant or harmonious, clamorous and shrill or tranquil, vivid or calm, joyous or somber, warm or cool, cheerful or drab,

disturbing and distracting or conducive to tranquility and concentration [p. 161].

These are things, Schachtel reminded, that have been known by artists from time immemorial and are basic to the art of the decorator.

Interestingly, Schachtel (1966) quoted Rorschach on the significance of the selective pattern of a testee's responses to certain colors and avoidance of others. "'Emotion-controllers' show a preference for the blue and green figures ... and avoid the red in a striking way" (p. 171).

When looking at a painting or drawing that involves color, we can bring to bear the several Rorschach determinants directly relevant to color. In addition to the questions that we posed about art involving form alone, we can ask the obvious questions that each color determinant suggests. Is the work of art characterized by C, CF−, CF+, FC−, or FC+? Based on that judgment, then, what is it that this work, or the creator of this work, is inviting in terms of emotion? What is the relationship between the intellectual apprehension and the affect that is invited? Which emotions are called forth? What may this cognitive/affective relationship suggest about the artist himself or herself? Is there evidence that that relationship changed during that artist's career? These and surely other potentially fascinating questions can be formulated.

A further determinant that was recognized by Rorschach (1921) was M, or *human movement*. Almost always, M implies the presence of form, and therefore is judged to be of good or poor form, that is, M+ or M−. Considerable psychodynamic importance is attributed to this determinant, as reflected in the following passage from Beck et al. (1961):

> In the movement response, Rorschach makes his most original contribution to method in personality study. The response, as Rorschach understands it, really reproduces movements or activities that S is carrying on within his mental life. Since these mental activities are those in which we should like to engage in the outer world but cannot, or dare not, they are our wish-fulfilling activities. Thus, they are our fantasy life — which means that the associations encased in them actually project S's intimately personal living. The more original and deviating movement associations are representatives of very deep wishes, innermost psychologic [sic] activity. The content of the response is thus identical with the material of Freud's unconscious and of the psychoanalysts' dreamwork [sic] [p. 72].

It is but an easy extrapolation from Beck's statement to the position that human movement responses on the Rorschach may be approached as one

158

would approach the interpretation of a dream. Completely consistent with this extrapolation is the fact that F. L. Wells referred to it as an *experimentally induced dream* (p. 72).

Note that it is precisely *human* movement that is designated by M. Rorschach was most clear about this. It was explained by Beck et al. (1961) in this way. "The psychologic [*sic*] activities that M projects to the surface are therefore of a kind that can only materialize in the image of a human being. The fantasies in which people realize themselves have their own likenesses, i.e., human forms, as heroes" (p. 72). The essential criterion that pertains to this scoring, then, is that the activity must exist within the normal anatomic repertoire of human beings. Content-wise, the movement may be perceived either in a whole human, scored *H*, or in a human part, scored *Hd* for *human detail*. In addition, and at first seemingly contradictory, human movement may be scored with animal content, either a whole animal, scored *A*, or part of an animal, scored *Ad* for *animal detail*. In order to qualify as M when the content is A or Ad, two criteria must be met. In addition to the criterion that the activity is within the human anatomic repertoire, the second criterion is that the activity is one *specifically characteristic of humans*. Thus, it becomes apparent that what is projected in M is, by virtue of its being a characteristically human activity, in essence the image of a human being, regardless of whether the content is H, Hd, A, or Ad.

Like dreams, "all M has *ex hypothesi*, a latent meaning differing from that in the manifest content. In the M with animal form S must keep the meaning much further away from his system conscious" (Beck et al., 1961, p. 74). Beck et al. reiterated this, writing that the person projecting human movement into animal content "is more effectively concealing the wish or the fear," and therefore "it is essential ... to take account of the deeper significance of the M in animal forms as possible leads to ideas against which the patient is doubly defending" (p. 74). In other words, M in A and Ad has been regarded as indicating an even deeper level of repression than is true of M in H and Hd.

Although he did not attach scoring signs to these, Rorschach identified two stances taken by the actor in M. The German terms that he chose are especially interesting when compared with the translations that are commonly accepted. In German the words that Rorschach chose were *streck* and *beuge*, stretch and bend, or bow, respectively. The English words which came to be used are *extensor* and *flexor*. Extensor movement is movement

away from the center of the card, whereas flexor is the opposite. "They are of great importance in interpretation, disclosing S's attitude in his unconscious in relating to others as self-assertive or submissive" (Beck et al., 1961, p. 77). When the stance is mixed, containing both extensor and flexor movement, perhaps beginning with one and moving on to the other, Beck et al. regarded this as an indicator of an ambivalent stance and referred to it as a *static* stance. Growing out of Rorschach's work with movement, Piotrowski studied movement responses extensively and suggested such differentiations as *active-passive, cooperative-noncooperative*, and *aggressive-friendly*. Based on the research evidence, Exner (1993) retained the *active-passive* dimension in his comprehensive system, using a superscript of *a* or *p* to enhance the movement scoring.

Those who developed other Rorschach systems elaborated Rorschach's foundational work on human movement in additional ways. In some cases this led to serious disagreements. Klopfer introduced *animal movement, FM* in order to recognize percepts in which an animal was performing some act that is characteristic of such an animal (Exner, 1993). FM may be found with a whole animal or an animal part and is thus scored A or Ad as far as content is concerned. It could even be a mythological animal. Given the presence of form quality the scoring may be FM+ or FM−. The presence of FM seems to be related to an awareness of impulses or unmet need states that are striving for gratification (Exner, 1993).

Piotrowski introduced *m* to designate movement of inanimate, inorganic, or insensate objects. While used in several of the Rorschach systems, the respective scoring criteria differed somewhat (Exner, 1993). The intricacies of these debates need not concern us here beyond the mere acknowledgement of this historical state of affairs. For our purposes, we can simply accept *m* as movement that is *characteristic* of inanimate, that is, non-human and non-animal objects. A + or − sign attached to the m would reflect the form quality involved. Research suggests that m increases in response to the situational stress of tension and conflict (Exner, 1993).

In summary, we can differentiate perceived movement that is characteristic of humans, scored M; movement that is characteristic of an animal, scored FM; or movement that is characteristic of something inanimate, scored m. In each case, form quality can be assessed as good, +, or poor, −. For human movement (M), the content may be human (H), human detail (Hd), animal (A), animal detail (Ad), or even something

inanimate. Conceivably, any content could have a characteristically human movement projected into it, and thereby qualify as M.

Some readers may question the legitimacy of extrapolating from the projection of movement onto an inkblot by someone taking the Rorschach test, to looking at a painting in which the artist has depicted movement easily agreed upon by consensus. Admittedly, this is a trickier extrapolation than is the case with form or color. I will make the case, nonetheless, that this more difficult extrapolation can be interesting and useful. On a strictly descriptive and analytical level, one can ask what kind of movement is presented — human, animal, or inanimate movement. If it is human movement, is it in human (or human detail), animal (or animal detail), or inanimate content? Does the movement occur with good form or poor form? These questions, while in themselves may not be profound, offer a particular perspective that contributes to the richness of the experience of viewing a work of art. From this we may embark on the more hazardous journey of interpretive hypotheses. First, by virtue of the depiction of movement, has the artist not invited the viewer into the realm of fantasy? I suggest that the viewer can ask of a work of art, what kind of fantasy has the artist invited? And, upon giving the work the time that any good art deserves for its viewing and perhaps repeated viewing, how deeply does one enter into the movement? In other words, to what extent does the viewer feel movement in his or her body, either the movement the artist depicted or some other movement? And, with such kinesthetic identification, once again, what fantasies are evoked? Shifting focus to the artist, what does the depiction of this particular movement suggest about him or her? Abstract art opens yet another level, for in its case movement perceived by the observer is, in balance, less depicted and consensually agreed upon than it is a quality projected onto the work of art. In this case, if the observer perceives movement, the question of projection of tension, unmet need states, wishes, or fears becomes most pregnant and can lead the observer into potentially fascinating introspection. A thoughtful reading of the above paragraphs which address movement as a determinant of a percept will no doubt inspire further questions to ask oneself when studying a work of art.

Having now presented both color and movement as potential determinants of a percept, we are in a position to consider their relationship. As we have seen, Rorschach (1921) introduced the *Experience Type* in his original monograph. *Erlebnistypus* or Experience Type is the ratio of move-

ment responses to color responses, and was calculated in the following manner M / (FC + CF + C). The tradition has been to weight the color scores with FC receiving 0.5, CF receiving 1.0, and C receiving 1.5.

> Rorschach's (1921) explication of the Experience Type is most instructive. The relationship between movement and color factors represents the relation between introversion, the faculty of doing "inner work," and extratension, the faculty of turning to the outer world, in the subject.... This relationship may be formulated in terms of the "experience type." The following types may be distinguished:
> 1. Introversive Experience Type: Predominance of kinaesthetic [*sic*] responses. (Example: Imaginative subjects.)
> 2. Extratensive Experience Type: Predominance of color responses. (Example: Practical subjects.)
> 3. Coartated (narrowed) Experience Type: Marked submergence of movement and color factors to the extent that the subject reacts with form responses exclusively. (Examples: Pedants, subjects in depressive mood)
> 4. Ambiequal Experience Type: Many kinaesthetic and equally many color responses. (Examples: Talented individuals, compulsion neurotics, manics [*sic*]) [pp. 181–182].

Rorschach (1921) was remarkably emphatic in his regard for the importance of the Experience Type, indicating that certain definite experience types are correlated with certain components of intelligence, affective dynamics, character (personality) structure, perceptual and imagery types, potentialities for the development of talents, the sensory system in which hallucinations occur (when they do occur), and the form of neurosis or psychosis present (when such is present). Importantly, he wrote, "the experience type indicates form or pattern, not content; it represents apparatus with which to act, not action itself" (p. 183).

While Schachtel (1966) supported the importance that Rorschach had attributed to the experience type, he was dubious that it represented the relation of extratensive to introversive attitudes. In the work of Rorschach, himself, Schachtel noted, the experience type has two dimensions. First, is the continuum of predominant introversiveness to predominant extratensiveness, as reflected respectively in movement dominant over color or color dominant over movement. Secondly, there is the continuum from coartation to dilation as reflected by the relation of pure form to the combination of movement and color. It is the latter continuum which was of greater interest to Schachtel. "The coartation-dilation dimension of the experience type tells us something about the relation of the

emotional capacity for experience ... to the conscious, critical logical, intellectual functions.... The quality of this relation can enhance or stifle the person's capacity for a full experience of reality" (p. 77). Schachtel quoted Rorschach as follows:

> Coartated types are distinguished by the extreme predominance of those factors which can be increased by direction of conscious attention to them ...; these types are distinguished primarily by logical discipline. In achieving this discipline, however, introversive and extratensive features become atrophied; in other words, they sacrifice their ability to experience fully [p. 77].

Despite Schachtel's considerable caution over relating experience type to introversiveness and extratensiveness, much of the research does support Rorschach's view (Exner, 1993). In the interest of precision and clarity, I must add that Rorschach did not equate his concepts of introversion and extratension with Jung's concepts of introversion and extraversion. Note that he did not use the term *extroversion*, but introduced in its stead *extratension*. The important differentiation of his concepts from those of Jung is perhaps best explained by Exner.

> Whereas the Jungian introvert is generally conceptualized as being distanced from people and frequently perceived as isolated or withdrawn into him- or herself, Rorschach's notion of introversion focuses on the manner in which the resources of the person are used *but* does not necessarily imply direct overt behavioral correlates. Thus, introversive persons may be regarded by others as outgoing in their social relationships, but internally, they are prone to use their inner life for the satisfaction of their important needs.... Extratensives are prone to use the interactions between themselves and their world for gratification of their more basic needs. It is the *depth* of affective exchange that often marks the extratensive person; that is, they manifest affect in *their world* more routinely than do introversives [p. 410].

Exner (1993), being cautious in interpreting a considerable body of research, indicated that Rorschach may have been "too expansive in assuming that either style was *directly* linked to gratification" (p. 410). In other words, an introvert does not necessarily derive gratification from his or her inner life and a person of extratensive experience type does not necessarily derive gratification from affective experience or discharge. However, Exner immediately added the following:

> The psychological tactics involved in each style are those typically used to gain need reduction or gratification, and the consistency of their use probably does have some secondary gratifying elements because the subject is

doing that with which he or she is psychologically accustomed and comfortable [p. 410].

An interesting detail that was reported by Schachtel (1966) is that Rorschach believed that the M type or introversive person is more capable of intensive rapport, whereas the C type or extratensive person tends more toward extensive rapport. Schachtel explained intensive rapport as "feeling inside oneself as one believes the other person to feel" (p. 234). He emphasized, however, that intensive rapport is subject to distortion or outright misunderstanding of how the other person actually feels.

> The projecting and at the same time identifying and empathic process which is characteristic of the M responses ... is also the most important factor in intensive rapport, be it with a person, a landscape, a piece of music, architecture, a tree, a word, a poem, the movement or posture of an animal, and so on [p. 234].

Herein, and by implication, he acknowledged the very real possibility of projecting M into non-human, even inanimate content. By way of further clarification, Schachtel pointed out that the absence of M does not mean that the person lacks the capacity for empathic projection and for creative experience.

In his original monograph, Rorschach (1921) offered several interesting observations and resultant hypotheses concerning the relationship of movement and color. Since the following contains some redundancy with respect to what has already been related, and at the risk of making it sound more absolute than is the case, I will present this material succinctly. For instance, he declared that movement and color are less influenced by conscious control than are other scores. As a rule, the more color, the more unstable the emotions, and the more movement, the more stable the emotions. Unstable affectivity, when disciplined and restrained, results in emotional adaptability and rapport. Unstable motility, when controlled and restrained, results in motor adaptability, that is, skill. Optimal control of both affectivity and motility results in social skill. But, too great a control of motility and affect converts emotional rapport into etiquette, and motility into stiffness. Coartation, that is, movement and color about equal and both low, indicates suppression. Disciplined thinking narrows the experience type. Rorschach also juxtaposed movement and color on a number of dimensions that may be of interest, even if some seem overstated when presented as dichotomies.

M dominant	C dominant
Individualized intelligence	Stereotyped intelligence
Greater creative ability	More reproductive ability
More "inner" life	More "outward" life
Stable affect	Labile affect
Less adaptation to reality	More adapted to reality
More intensive than extensive rapport	More extensive than intensive rapport
Measured, stable motility	Restless, labile motility
Awkwardness, clumsiness	Skill and adroitness

Before leaving the topic of experience type, I want to mention that there are several indices involving movement and/or color that are included in the various Rorschach scoring systems and that depend on the multiple responses to the entire set of Rorschach cards for their calculation. Since these are not applicable to our use of Rorschach theory for analyzing art or looking for insights into the artist, I have omitted most of them from our discussion. Two of them which are of use, however, are *experience balance* (EB) and *experience actual* (EA). Without identifying them by name, we have used them on a conceptual level in the above discussion. Experience balance refers to that *ratio* between M and weighted Csum. Experience actual refers to the *sum* of M and weighted Csum. In our use of these concepts we cannot make the calculations, of course, since we are not working with multiple responses. Conceptually, however, we can use them respectively to identify the dimension of introversion-extratension and that of coartation-dilation. For our purpose these may be useful qualitative, conceptual tools, even though we can not use them quantitatively.

Putting the concepts of EB and EA to work, we might, for instance, characterize contemporary fantastic art such as that of Frank Frazetta as being *dilated*, or to use Rorschach's term, *ambiequal*, noting that both movement and color are much in evidence, and in balance with respect to introversion-extratension. The former suggests lack of suppression. While we are at this, we could note, too, that the M tends to be both *active* and *aggressive*. The colors often lean heavily toward the warm (it would better be said *hot*) side of the palette. The form quality within M is uniformly good. But, we are getting away from EB and EA, per se. I suggest, though, that an important part of the definition of contemporary fantastic art may be captured in the concepts of EB and EA. May I say, by way of definition, then, that contemporary fantastic art tends to be dilated, with respect to EA, and balanced with respect to EB? We could

expand this definition by bringing to bear other determinants, of course, but when enucleated, the definition must surely contain EB and EA descriptions.

Next, let us consider *chiaroscuro* or shading as a determinant of a percept. Exner (1993) declared that "the coding of responses in which the light-dark features of the blot are used as a determinant has been one of the most controversial aspects of the Rorschach" (p. 122). Little consistency can be found among the five major Rorschach systems in the scoring of shading. Additionally, he reported, it has been the least researched of the major determinants. In his own system, Exner followed the lead of Beck and derived three categories of shading, namely *texture* (T), *vista* (V), and *diffuse shading* (Y). He found this breakdown of chiaroscuro to be most consistent with empirical research results. Analogous with the blends of form and color, blends can be recognized between form and each of the shading determinants. Thus, we have the potential to differentiate texture dominant over form (TF), form dominant over texture (FT), vista dominant over form (VF), form dominant over vista (FV), shading dominant over form (YF), and form dominant over shading (FY). These categories are, of course, in addition to pure texture (T), pure vista (V), and pure shading (Y).

Even though Rorschach did not in his original monograph address the meaning of shading, as his original plates had none, he did express his opinion in his final paper before his death. Therein, he opined that shading responses

> have something to do with the capacity for affective adaptability, but an anxious, cautious, unfree [*sic*] type of affective adaptation, a self-control in the presence of others and particularly a tendency toward a basic depressive mood and the attempt to control this in the presence of others [Schachtel, 1966, p. 243].

He wrote further of "cautiously adapted and consciously controlled affectivity" as being indicated by the shading responses" (p. 243).

Let us look at these three variations of chiaroscuro one at a time. Beginning with *texture*, Beck et al. (1961) noted that "the sense modality in which the texturally determined association has its origin is touch. It reports an experience in which the skin feels directly" (p. 110). More commonly, he observed, it is something "soft," such as fur, although "hard" associations, such as rocks, are also reported on the Rorschach (p. 110). In his elaboration, Exner (1993) listed, in addition to soft and hard, "smooth,

rough, silky, grainy, furry, cold, hot, sticky, and greasy" as not uncommon (p. 124).

Klopfer, who was the first to recognize the importance of texture as a determinant, interpreted it as related to needs for affection and dependency (Exner, 1993). Consistent with this, it was Beck et al.'s (1961) belief that the presence of texture was a clue to *affect hunger* in the subject reporting it. Having reviewed the research, Exner concluded that "the data concerning T are quite compelling" (p. 385). To wit, people with significantly more textural responses than is the norm have a greater need for interpersonal closeness and experience more loneliness or needs for dependency. Conversely, those who do not show texture tend to be more concerned with interpersonal space, and are more guarded and/or distant in interpersonal contacts. An additional point, and one which may be of great importance, was made by Schachtel (1966).

> The difference between pleasurable and unpleasurable [*sic*] contact is significant in the interpretation of the texture responses. There is a difference between the person who sees in the shading a soft, warm fur and the one who sees a slimy snail, usually the difference between pleasure and disgust. There is also a difference between seeing a hard and a soft surface.... The hard surface may be experienced with positive or negative overtones, as may the soft, although there more usually the pleasurable tone predominates [p. 254].

Exner (1993) wrote that the least common use of chiaroscuro involves the interpretation of *vista*, that is, apparent depth or dimensionality. Specifically, he explained, vista involves the use of shading to alter the flat perspective and, in most cases, the contours created by the light and dark are used to create a sense of depth. Surprisingly, even though as shown by the research, vista is the least common use of chiaroscuro, Beck et al. (1961) declared that "vista is the percept, among these light-determined ones, concerning which we know the most" (p. 109). Perhaps this situation changed with the research findings which emerged between Beck's publication and that of Exner, yielding relatively more knowledge of the other shading responses. At any rate, these two researchers displayed a considerable amount of agreement in their interpretations of vista.

> As for interpretation, let us look first to Rorschach, himself. A special talent for perception of the spatial, of depth and distance, appears to be correlated with affectivity of somewhat anxious, cautious, measured character, in one way or another depressively toned, and there seems to be often — perhaps

always—a correlation with certain feelings of insufficiency, the content of which is a consciousness of absence of support, of instability, or being out of groove [Beck, 1945, p. 34].

A key phrase, herein, is "feelings of insufficiency."

Early in his work, Beck (1945), addressed vista as it related to the work of Alfred Adler. He began in his usually succinct and straightforward style, declaring that "self-appraisal appears always to be the psychologic [*sic*] activity that emerges in V" (p. 33). He added, however, an important specification to this self-appraisal.

As to the rationale behind this relation, one of Alfred Adler's shorter papers gives a good lead. It is not a publication on the Rorschach test, although Adler knew the test; it is an exposition of the personal dynamics involved in looking at distant objects, and of the significance of this distance gaze in the neuroses especially. Adler's logic helps to clarify the most important meaning of V in the Rorschach test—the feeling of inferiority. This is the generic psychologic [*sic*] value of the vista association usually. Not that self-appraisal is necessarily carried on to one's disadvantage. But it appears to be a common liability that the more the individual is given to evaluating himself, the more self-depreciating he is.

One basis for this inference is the frequency of V in neurotics—probably greater than in any other one group. In these subjects it is the indicator of the well advertised "inferiority complex," in the Adlerian sense, as the principal cause of the personality incoordination [*sic*] and maladjustment. In this personality setting it expresses a destructive consciousness of inadequacy and of smallness, all very unsatisfying [pp. 33–34].

Klopfer hypothesized that the meaning of perspective in shading responses is that they show "an attempt by the person to handle his affectional [*sic*] anxiety by introspective efforts, by an attempt to objectify his problem by gaining perspective on it, by putting it at some distance from himself so he can view it more dispassionately" (Schachtel, 1966, p. 251).

We see, then, that Rorschach and Beck related vista to feelings of insufficiency and feelings of inadequacy or inferiority, respectively, a trio of synonymous terms. As pointed out by Exner (1993), both Klopfer and Beck related vista to a form of introspection. They differed only in that "Klopfer posited that [vista responses] represent efforts at taking distance to handle anxiety, whereas Beck perceived them as related to a more morose feeling tone created by depression and/or feelings of inferiority" [pp. 386–387].

Based on the empirical research, Exner (1993) reached these important conclusions.

The data concerning vista answers appear to support the Klopfer-Beck positions that it is related to a "taking distance," introspective process; however, it is doubtful that the relation is direct. Instead, it seems to be related to a negative emotional experience that is generated by the self-focusing behavior.... When V is present, it signals the presence of discomfort, and possibly even pain, that is being produced by a kind of ruminative self-inspection which is focusing on *perceived* negative features of the self [p. 387].

As I have noted already, there is considerable disagreement with respect to the scoring and interpretation of chiaroscuro among the five major systems of the Rorschach. In no instance is this more in evidence than in the case of *diffuse shading*, Y. In the interest of avoiding what I would consider to be unnecessary complexity in the present context, I will use only Y and omit the several highly nuanced additional scoring categories related to shading which can be found in the literature.

Shading, as scored Y, refers to the use of shading features either as primary in the formation of a percept, or secondary as a way to provide greater specification to a form answer. In his straightforward manner, Beck et al. (1961) stated that "the flat gray responses are those in which the light values as such recall the thing seen" (p. 109). Or, as Exner (1993) explained, "the coding for diffuse shading incorporates all shading answers which are neither vista nor texture" (p. 128). Having provided a number of examples of FY and YF, Beck et al. (1961) elaborated, writing that "in all these the shading, as an element in the black-white series, is the essential factor in evoking the association. Thus, it closely parallels the forces of color in determining certain associations" (p. 110). Beck made, I believe, two important points. First, shading as he defined it and scored it is inclusive of black and white, and not limited to in-between gray tones. Second, shading may be used as a potent determinant of a percept just as color can be so used.

Altering his focus to the interpretation of Y responses, Beck et al. (1961) stated with clarity, "they represent a personality trend diametrically opposite to the elation with which color is connected. The grays, especially the massive ones, go with an unhappy mood" (p. 110). Elsewhere, he elaborated as follows:

> The Y response stems from an anergic state, one in which the vigor has apparently been drawn out of the organism; S is listless, "washed out;" ... disquieting, oppressive affect (Binder's "dysphoric mood") essentially always accompanies Y, as the emotional tone; it can be absent ... but is very seldom lacking [Beck, 1945, p. 35].

For emphasis, as well as summary, he added that "the generic service of Y consists in uncovering S's recourse to inactivity" (p. 35). Continuing, he again compared shading to color. "As such, its significance is exactly complementary to that of the color response" (p. 35). Very importantly, however, Beck asserted that Y is not a reflection of *withdrawal*.

> That is represented by M, which is not an expression of inactivity. On the contrary, M usually reflects a very vigorous activity; its theater of operations happens to be within the psyche rather than out of it, the latter belonging to C. Y expresses really an absence of activity, which can go all the way to passivity. In the healthy it indicates a letdown. In the neurotic it signifies a drastic countermeasure against the individual's own affective energy. Implicit in this affect is always its liability to emerge in the form of opposition to the environment, possibly with violence. Inherent in this contingency is the threat to S, as the environment's reaction to his action. His safety lies in inactivity. In the Rorschach test this recourse is projected in Y [pp. 35–36].

Exner (1993), having reviewed the empirical literature, concluded that there is support for Beck's shading-passivity hypothesis.

Having mentioned that both shading and color can exert a certain puissance in the determination of a percept, as I have done, it may be important in understanding shading to consider how it is psychologically different from color. Not only do shading and color reflect opposite mood states (dysphoria and elation, respectively), and different action tendencies (inactivity and activity, respectively), there is a difference in the process of perceiving them. As Schachtel (1966) instructed, "In contrast to the different chromatic colors, the different nuances of shading are not striking. They have to be sought out; they become significant only when attention is focused on them" (p. 251). It is in this respect, he added, that they resemble form responses, F. They differ from form, of course, in that they involve attention to the achromatic values which can be found in the shading.

> The perceiver attends to and often feeds into the tonal quality of these different nuances, he responds to them; but he has to seek them out in order to respond to them because, by and large, they form not striking but rather subtle contrast patterns; perceptual sensitivity is required to discover them [p. 251].

In further exploring the difference between perception of shading and that of color, Schachtel (1966) evoked the example of painting versus etching. Given our focus on art, I believe an excerpt from his presentation will be of interest.

170

Whatever else is involved in seeing an oil painting, its colors stand out immediately because of the inherently striking quality of color. They call attention to the painting. Of course this does not preclude the detailed attention to and "tasting" of the finer nuances of color which occurs in a different attitude. An etching cannot be seen without detailed attention, except as a gray or dark mass of shading. But to see what is in the etching, more detailed attention to the nuances of shading and form has to be paid than in order to see what is in a painting. The latter can be taken in at a glance although, of course, it cannot be fully appreciated in this way [p. 251].

Adding the chiaroscuro determinants, texture (T), vista (V), and shading (Y) to our Rorschach-based template for viewing art suggests some obvious questions. Descriptively, is T, V, or Y present in a work of art? If so, is it pure, or does it combine with form (F)? If in combination with F, which is the more common occurrence, does it predominate or is it secondary to F? And, is good form or poor form involved? More interesting, perhaps, is taking the next step and asking the questions that involve the meaning of these several chiaroscuro determinants — T, TF, FT, V, VF, FV, and Y, YF, and FY. We can ask if, in his or her inclusion of the suggestion of texture, the artist has invited from us an experience of affect hunger, of a need for interpersonal closeness, or even dependency needs. Or has the artist invited us to take distance and become introspective, perhaps even to experience insufficiency, inadequacy, or inferiority? Finally, in the case of diffuse shading, has the artist called upon our passivity born of dysphoric mood? If a particular artist has demonstrated a penchant for the use of texture, vista, or shading, we, of course, can speculate that the psychological meaning of such leanings may be characteristic of that artist.

In his Comprehensive System, Exner (1993) included no fewer than 26 symbols covering nine categories of Rorschach determinants. As he instructed, "none have exacting correlations with behavior or with personality characteristics, but collectively they are used to form a caricature of response styles and personality characteristics" (p. 137). In addition, blends of the determinants are recognized and scored as such. Total number of responses; relative number and sequence of responses to whole plates, major details, and rare details; reaction time to each plate, as well as average time per response, and fluctuations in response times across plates; the number of the most common responses given; organization of parts of a plate or lack thereof; figure-ground reversals; and still other items are added to the data set. Finally, content is a focus of attention. In order both to further and to expand the task of interpretation, a number of frequencies

and ratios of scores are systematically considered, thereby creating an extremely complex instrument. I have discussed only those aspects of theory and scoring that I believe can be extrapolated to our advantage from this instrument into the realm of describing and understanding art and artists.

Perhaps a brief consideration of content would be in order. "The range of associational content projected by the Rorschach test figures has no boundaries. Anything may be seen and is seen" (Beck et al., 1961, p. 217). The same, of course, can be said of art. In a not-surprising explanation of the meaning of content for a person, Beck stated that "it is thus a source of knowledge concerning his interests, and through the avenue of these, in many instances, concerning his personal needs" (p. 221). Certainly more surprising, in terms of the metaphor that he chose, Beck suggested that content "reveals the mental furniture" of the person (p. 221). Surely, we are safe in believing that whatever the testee sees in the Rorschach and, likewise, whatever content the artist paints is of interest to that person.

Schachtel (1966) acknowledged that "content is more subject to conscious control than any other factor of the [Rorschach]" (p. 259). This may be a limiting factor in interpreting the meaning of content at a deeper level than that of a reflection of interests. Therefore, he instructed, "some, but not all, of the pitfalls of content interpretation can be avoided by a thematic analysis of the major trends in the content of all the responses" (p. 259). Or, I may add, by a thematic analysis of the major trends in the content of the overall oeuvre, in the case of an artist. Furthermore, one may gain a clue as to which content is more psychodynamically revealing by considering the determinants that attend that content. Rorschach believed, for example, that "the form responses represent the conscious functions; the M, especially the specific quality of the movement perceived, come closest to central unconscious attitudes; the C and CF he considers closer to the unconscious than the F" (Schachtel, 1966, p. 258). (We can include consideration of chiaroscuro, based on research after Rorschach's time.) He further made the point that "unique responses and genuinely original ones tell us more about psychoanalytically significant material (namely, individual strivings and preoccupations) than do popular ones" (p. 258). This point, too, can easily be applied to the content of the artist's work.

Schachtel (1966) issued a warning, one that I consider extremely important, and thus I emphasize it. It applies to any depth interpretation of content, be that of a Rorschach, a dream, or a work of art.

Unfortunately, many students and quite a few professionals tend to "interpret" the content of single responses not only without considering the perceptual qualities of the response and the relation of its content to the over-all themes in the content of other responses, but by assuming a fixed symbolic meaning, in dictionary fashion, for a particular content, either whenever this content appears or when it is seen in a particular inkblot ... the mistakes to which every dictionary type of interpretation is prone [pp. 260–261].

Schachtel's caveat evokes for me the psychological literature on symbolism, including the work of Freud and Jung discussed earlier in the present volume. Those discussions are highly relevant in considering depth interpretation of Rorschach content, as well as content in art, as we have already seen.

Conclusion

If at this point the reader has truly explored the several psychodynamic theories that address the arts and the creation thereof that I have endeavored to explicate, surely he or she has gained an appreciation of their richness. Each theory, hopefully, is now identifiable by its special concepts and by the vocabulary peculiar to it. Perhaps, beyond this ability to recognize the theories in their uniqueness, the reader is now able to converse in these new languages — Freudian, Jungian, Rankian, Reichian, and so on — and even some dialects within such major languages — Lacanian, Lowenian, Spielreinian, and so forth — as he or she thinks about art and discusses it with others. It is in such thought and conversations, imbued with these theories, that their resplendence will blossom and be fully in evidence.

These theories are complex, to be sure. Their understanding is not easily gained, and rereading and periodic review may be required if they are to be learned. In addition, they must be used, their application practiced if they are to be mastered. This task will be, I believe, well rewarded. The payoff will be a greatly enhanced depth of appreciation of the arts. No matter how rich one's phenomenological experience of art, that is, naïve (without preconceived moral, intellectual, or aesthetic judgment) taking in of the art, to be able to place that experience in a broader psychological frame is value added. The not-to-be-forgotten caveat, of course, is to allow for the full phenomenological experience of *simply taking in* before imposing the perspective of any theory. For me, the ideal is to look or listen naively, then try on one or more theories, and then set aside the theoretical templates for a return, as much as possible, to a relatively naïve position. Doing this, perhaps in several rounds, I find the greatest sense of combined pleasure (or displeasure) and understanding. Recognizing that this is an oversimplification, the naïve viewing or listening is a more affect-laden

experience while the application of theory is more an intellectual exercise. Taken together, emotion and cognition intertwine, perhaps highlighting one another by contrast.

As discussed earlier, each theory offers a vocabulary and a set of concepts. Furthermore, each linguistic-conceptual system is best suited for a particular focus. So, by knowing several theories, one can choose which one or ones to bring to bear in considering a particular piece of art. In addition to such practical consideration, there is also an aesthetic one. A question of which theory or theories sound good or feel good, this is a matter of taste. Thus, on the basis of both pragmatic and aesthetic considerations, the reader may find his or her favorites. Other theories may not hold interest either because they do not offer a better grasp of art, or because they do not have appeal.

The obvious thrust of the present volume has been to understand the arts and their creation through the application of various psychodynamic theories, these theories acting as lenses or templates. Thus, art and psychodynamic theory have, in a sense, been introduced to one another. They have been set face-to-face, so to speak. But the gaze has been one-way, psychodynamic theories looking at art. Art has sat passively as theory has taken the active role. Let us consider, however, a sort of chiastic inversion. Let us imagine, as we continue anthropomorphizing, that as art and theory get acquainted each is affected by the other in a cross-wise manner, art now coming to assume the active role. Let us invite an art form now to illuminate by means of analogy with itself, and the body psychodynamic to be revealed in this light focused specifically on psychotherapy.

Psychotherapy as a performing art. Consider this as one of several possible perspectives that may be assumed when viewing the enterprise of psychotherapy, a lesser-taken perspective but one that may hold some advantage. To elaborate this perspective and to clarify it, psychotherapy is surely not a performing art in the sense of entertainment. Neither is it conducted (note this word) for the distraction or the amusement of an audience, nor is it engaged in by the therapist or the person in therapy to such end. It does, however, involve live appearance by the therapist and the person in therapy. And, while theorizing about psychotherapy and conducting research on psychotherapy are scientific endeavors, performing it arguably falls heavily into the realm of art. In support of this view, I offer the fact that the prominent psychotherapist James Bugental (1987) titled one of his books *The Art of the Psychotherapist: How to Develop the*

Skills That Take Psychotherapy Beyond Science. Note that not only did he suggest that the work of the psychotherapist is art, but that such skills are *beyond* science.

In the interest of analogy, and to be specific, we may invoke the art of ballroom dance. Consider the following general features. Two persons meet at a designated arena, designed to allow and to support the activity, at a designated time. By design a good ballroom has a quality sound system with appropriate music, a floor that is conducive to gliding and sliding, sufficient space, and protection from intruding activities. Traditionally, one of the dancers leads, while the other follows. The leader and follower format is made possible and an aesthetic level of performance reached only when the two dancers have learned the dance. Earlier, the leader may be the instructor. As the follower learns more, the differentiation of leader and follower becomes less based on skill and more a matter of tradition. Each dance may be viewed in terms of placement on a dimension of correct form-cum-formality. Consider, for instance, the waltz or even disco dancing as compared to the jitterbug, the dirty boogie, or most especially freestyle ("Get out there and do whatever you feel!") There is *the dance* in the abstract, be it waltz, fox-trot, or tango, but it is only when brought to life by two persons that the dance becomes manifest and concrete.

Turning to one-on-one psychotherapy, we can easily recognize this analogy. It is conducted at a designated time, in a designated place designed to support the activity. There is a status differential that by tradition since the time of Freud asks that the person in therapy come to the place of the therapist, and not the other way around. Although exceptions may occur, the tradition maintains. The place of therapy should be comfortable and ensure visual and sound privacy, as well as protection from interruption. In addition, by dint of education and training it is the therapist who leads the therapy qua enterprise, and overall. Just as in the case of the dance instructor, it is the therapist who knows the steps, so to speak. The person in therapy is taught to follow the steps, that is, the procedure, the method, the technique. Some of these are more formalized, such as in classical psychoanalysis or in systematic desensitization by reciprocal inhibition, while others are less so, for instance in existential therapy and some forms of experiential psychotherapy. So, the performance, be that dance or psychotherapy, may be more or less choreographed. As the person in therapy learns the steps, the therapy becomes increasingly collaborative, with the leader (therapist) and follower (person in therapy) distinction shifting

somewhat. And, as with the dance, the procedure, the method, the technique of psychotherapy exists as an abstraction that can be written about and discussed, and as a concrete lived event. Thus, the paradox: "Psychotherapy exists only as it is given life through the person of a particular therapist, yet psychotherapy exists, like a Platonic Form, apart from the practitioner" (Smith, 2003, p. 21).

The analogy under discussion could be extended to include group psychotherapy by considering group dances such as the Bunny Hop, the Hokey-Pokey, the Stroll, and the Electric Slide when led by someone. The leader leads with the steps, and the other dancers follow the form. Group dancing without a designated leader is analogous to a leaderless or peer therapy group. Here, too, the dance takes place at an agreed-upon place and time, both selected so as to support the activity.

As two ballroom dancers dance, their way of being together is significantly defined by the dance that they have chosen. Waltzing, doing the fox-trot, and doing the tango emerge as different experiences. All are dancing, but each, as a subset of dancing, offers its own nuance of interactive experiential possibilities. Likewise, as a psychotherapist offers to lead a person in a particular method of psychotherapy, that method enters into the definition and experience of the participants. Often it is the technique that is regarded as the hallmark and identifying feature of a particular therapy, and in the rush to oversimplification, therapies are discussed only in terms of their techniques, thereby neglecting the role of personhood, that of therapist and that of the person in therapy. By such abstract focus on the reflection, the interpretation, the empty-chair dialogue, cognitive reframing, the homework assignment, or on particular combinations of techniques, technique is given undue emphasis, overshadowing the role of the therapist as person and person in therapist qua person. But therapeutic interventions breath life only as lived events, events lived by persons. The method of therapy, just as the type of dance chosen, can be seen as a template for the interaction, both opening up possibilities for interaction and setting limits on that interaction. As such, the method or the dance offers approbation of certain behaviors, exclusion of others. Within these parameters, space is reserved for spontaneous and artful interaction. Thus, through skillfully executed techniques, the dancers are revealed as persons-cum-artists. Likewise, the person of the therapist is revealed and the person of the one in therapy is acknowledged in the artful execution of psychotherapy.

Just as in the choice of the dance, the choice of therapy technique, method, or procedure may be made on aesthetic grounds. (The therapist is ethically obligated, of course, to restrict his or her choices within the parameters suggested by the efficacy research on psychotherapy.) That is to say, the dancer may choose the dance that allows him or her to be most graceful and artistic; the therapist, too, may seek grace and artistry in making his or her choice of method. It is not uncommon to hear a psychotherapist comment upon having witnessed a very good psychotherapy demonstration, "That was a beautiful piece of work." The artful performance is predicated on *interpretation*. Each dancer chooses his or her style or school of dance, each psychotherapist his or her style or school of therapy. What is true for the dancer is equally true for most any artist, a style must be chosen. Perhaps, as stated above, the choice itself was aesthetically based. But the manifestation of beauty will depend on the interpretation by that dancer or that therapist. Even after mastery of a particular style or therapeutic method, some abjure, seeking a new way of conducting their art or therapy. Others add styles or methods and become eclectic. But in the end, it is the interpretation that creates the aesthetic.

Consider, then, the following analogical forms, understanding "Dancer" as both singular and plural and "Therapist" as exclusive of or inclusive of the person in therapy:

Dancer : The Dance :: Subject : Verb
Therapist : Technique :: Subject : Verb

The two first terms of each analogy, "Dancer" and "Subject" or "Therapist" and "Subject," animate the two second terms. They are the agents that activate, enliven, and make manifest that which was until then an abstract form. In this act of bringing to life that which was until then an abstract form, these agents become the interpreters of the form. Ergo, *the dancer or the therapist is at once agent, interpreter, and creator of lived technique through her or his person.* This analogy, in which the verb is taken in its active voice, must not be extended to the verb in passive voice, however. To say that the dancer or the therapist is animated by the technique would be to lose agency through misattribution. The dance, the technique is but an abstraction until animated by the agency of the dancer or therapist agent. The dancer or therapist does, however, actively accept influence by the dance or the technique that he or she chooses to animate. In dancing, I define myself moment-by-moment *in terms of* the steps; in conducting

psychotherapy, I define myself *in terms of* the reflection, interpretation, confrontation, or self-disclosure that I make in the moment. Thus, the verb may be taken, at once, as reflexive as well as active, and the analogy preserved as one that offers illumination.

And so, art may thus illuminate psychodynamic theory, as the psychotherapist takes a lesson from Terpsichore. May art and psychodynamic theory continue their dance!

References

Adler, A. (1980). *Co-operation between the sexes*. H. Ansbacher and R. Ansbacher (Eds.). New York: Jason Aronson.

Aebersold, J. (1992). *How to play jazz and improvise* (Vol. I). New Albany, IN: Jamey Aebersold Jazz.

Arieti, S. (1976). *Creativity: The magic synthesis*. New York: Basic Books.

Atwood, G. E., and R. D. Stolorow (1993). *Faces in a cloud*. Northvale, NJ: Jason Aronson.

Baker, E. F. (1967). *Man in the trap*. New York: Collier.

Barth, L. (1964). "The wall with holes: An orgonomic look at the writer." *The Creative Process*, 4(1), 25–30.

Beck, S. J. (1945). *Rorschach's test: II. A variety of personality pictures*. New York: Grune & Stratton.

Beck, S. J., A. G. Beck, E. E. Levitt, and H. B. Molish (1961). *Rorschach's test: I. Basic processes* (3rd ed.). New York: Grune & Stratton.

Bierlein, J. F. (1994). *Parallel myths*. New York: Ballantine.

Breger, L. (2000). *Freud: Darkness in the midst of vision*. New York: Wiley.

Bugental, J. F. (1987). *The art of the psychotherapist: How to develop the skills that take psychotherapy beyond science*. New York: Norton.

Carotenuto, A. (1982). *A secret symmetry*. New York: Pantheon.

Dunne, C. (2000). *Carl Jung: Wounded healer of the soul*. New York: Parabola.

Ellenberger, H. F. (1970). *The discovery of the unconscious*. New York: Basic Books.

Exner, J. E. (1969). *The Rorschach systems*. New York: Grune & Stratton.

Exner, J. E. (1993). *The Rorschach: A comprehensive system*. (Vol. I: Basic foundations) (3rd ed.). New York: Wiley.

Exner, J. E. (2002). "Early development of the Rorschach test." *Academy of Clinical Psychology Bulletin*, 8(1), 9–14.

Fenichel, O. (1945). *The psychoanalytic theory of neurosis*. New York: Norton.

Ferenczi, S. (1952). *Theory and technique of psycho-analysis*. New York: Basic Books.

Fodor, N., and F. Gaynor (Eds.). (2004). *Freud: Dictionary of psychoanalysis*. New York: Barnes & Noble.

Freud, S. (1949a). Foreword. In M. Bonaparte, *The life and works of Edgar Allan Poe: A psycho-analytic interpretation* (p. xi). London: Imago.

Freud, S. (1949b). *An outline of psychoanalysis*. New York: Norton.

Freud, S. (1950). *Totem and taboo*. New York: Norton.

Freud, S. (1960a). *The ego and the id*. New York: Norton.

Freud, S. (1960b). Letter 18 to Martha Bernays. In E. L. Freud (Ed.), *The letters of Sigmund Freud* (pp. 50–52). New York: Basic Books.

Freud, S. (1960c). Letter 241 to Romain Rolland. In E. L. Freud (Ed.), *The letters of Sigmund Freud* (p. 388). New York: Basic Books.

Freud, S. (1960d). Letter 242 to Romain Rolland. In E. L. Freud (Ed.), *The letters of Sigmund Freud* (p. 389). New York: Basic Books.

Freud, S. (1960e). Letter 246 to Romain Rolland. In E. L. Freud (Ed.), *The letters of Sigmund Freud* (pp. 392–393). New York: Basic Books.

Freud, S. (1961a). "Civilization and its discontents." In J. Strachey (Ed.), *The standard edition of the complete psychological works of Sigmund Freud* (Vol. XXI). (pp. 57–145). London: Hogarth.

Freud, S. (1961b). *The interpretation of dreams.* New York: Wiley.

Freud, S. (1963a). "The instincts and their vicissitudes." In P. Rieff (Ed.), *General psychological theory* (pp. 83–103). New York: Collier.

Freud, S. (1963b). "The Moses of Michelangelo." In P. Rieff (Ed.), *Character and culture* (pp. 80–83). New York: Collier.

Freud, S. (1963c). "The relation of the poet to day-dreaming." In P. Rieff (Ed.), *Character and culture* (pp. 34–43). New York: Collier.

Freud, S. (1963d). "The " 'uncanny.'" " In P. Rieff (Ed.), *Studies in parapsychology* (pp. 19–60). New York: Collier.

Freud, S. (1966). *Introductory lectures on psychoanalysis.* J. Strachey, (Ed. and Trans.). New York: Norton.

Gibson, M. (2006). *Symbolism.* Köln: Taschen.

Gifford, S., D. Jacobs, and V. Goldman (Eds.). (2005). *Edward Bibring photographs the psychoanalysts of his time.* Hillsdale, NJ: Analytic Press.

Goldberg, V. (1977). "Horror in art: The good, the mad, and the ugly." *Psychology Today, 11*(6), 24, 28, 138.

Goldenson, R. M. (Ed.). (1984). *Longman dictionary of psychology and psychiatry.* New York: Longman.

Golomb, J. (1995). *In search of authenticity: From Kierkegaard to Camus.* New York: Routledge.

Hamilton, E. (1942). *Mythology.* New York: Mentor.

Hauser, A. (1958). *The philosophy of art history.* Cleveland, OH: Meridian.

Hirsch, E. (2002). *The demon and the angel.* New York: Harcourt.

James, W. (1973). "The stream of consciousness." In R. E. Ornstein (Ed.), *The nature of human consciousness* (pp. 153–166). San Francisco: W. H. Freeman.

Jung, C. G. (Ed.). (1964). *Man and his symbols.* New York: Dell.

Jung, C. G. (1966a). *The practice of psychotherapy* (Vol. 16 of the Collected Works). Princeton, NJ: Princeton University Press.

Jung, C. G. (1966b). *The spirit in man, art, and literature* (Vol. 15 of the Collected Works). Princeton, NJ: Princeton University Press.

Jung, C. G. (1971a). "Aion: Phenomenology of the self." In J. Campbell (Ed.), *The portable Jung* (pp. 139–162). New York: Viking.

Jung, C. G. (1971b). "Psychological types." In J. Campbell (Ed.), *The portable Jung* (pp. 178–269). New York: Viking.

Jung, C. G. (1971c). "The spiritual problem of modern man." In J. Campbell (Ed.), *The portable Jung* (pp. 456–479). New York: Viking.

Jung, C. G. (1971d). "The transcendent function." In J. Campbell (Ed.), *The portable Jung* (pp. 273–300). New York: Viking.

Jung, C. G. (1980). "Psychology and literature." In B. Ghiselin (Ed.), *The creative process* (pp. 217–232). Berkeley, CA: University of California Press.

Keleman, S. (1979). *Somatic reality.* Berkeley, CA: Center Press.

Kelley, C. R. (1964). Editorial. *The Creative Process, 4*(1), 1.

Kelley, C. R. (1974). *Education in feeling and purpose.* Santa Monica, CA: The Radix Institute.

Kiremidjian, D. (1984). "Dante's *Inferno*, Canto 17: Treachery and mysticism." *The Journal of Orgonomy, 18*(1), 65–77.

Kris, E. (1952). *Psychoanalytic explorations in art.* New York: International Universities Press.

Lacan, J. (2002). *Ecrits.* New York: Norton.

Levy, L. H. (1963). *Psychological interpretation.* New York: Holt, Rinehart and Winston.

Lewisohn, L. (1932). Preface. In O. Rank, *Art and artist* (pp. vii–xi). New York: Alfred A. Knopf.

Lowen, A. (1958). *The language of the body.* New York: Grune and Stratton. (Originally titled *The physical dynamics of character structure*).

Lowen, A. (1964). "Beethoven: Music and the cosmos." *The Creative Process, 4*(1), 31–54.

Lowen, A. (1966). "The rhythmic movements of the body." In *The rhythm of life* (pp. 22–29). New York: Institute for Bioenergetic Analysis.

Lowen, A. (1972). *Depression and the body.* New York: Penguin.

Lowen, A. (1975). *Bioenergetics.* New York: Penguin.

Lowen, A. (1980). *Fear of life.* New York: Collier.

Lowen, A., and L. Lowen (1977). *The way to vibrant health.* New York: Harper.

Ludy, B. T., Jr. (2003). "Behavioral science and the Nobel Prize." *American Psychologist, 58*(9), 731–741.

May, R. (1975). *The courage to create.* New York: Bantam.

Mullahy, P. (1955). *Oedipus: Myth and complex.* New York: Grove.

Munroe, R. L. (1955). *Schools of psychoanalytic thought.* New York: Holt, Rinehart and Winston.

Pierrakos, J. C. (1987). *Core energetics.* Mendocino, CA: LifeRhythm.

Pilhofer, M., and H. Day (2007). *Music theory for dummies.* Indianapolis: Wiley.

Rabin, A. I. (1981). "Projective methods: A historical introduction." In A. I. Rabin (Ed.), *Assessment with projective techniques* (pp. 1–22). New York: Springer.

Raknes, O. (1970). *Wilhelm Reich and orgonomy.* Baltimore: Penguin.

Rank, O. (1932). *Art and artist.* New York: Alfred A. Knopf.

Rank, O. (2004). *The myth of the birth of the hero.* Baltimore: Johns Hopkins University.

Reich, W. (1949). *Character analysis.* New York: Noonday Press.

Reich, W. (1970). *The mass psychology of fascism.* New York: Farrar, Straus and Giroux.

Reich, W. (1973). *The function of the orgasm.* New York: Simon and Schuster.

Reich, W. (1974). *Listen, little man.* New York: Farrar, Straus and Giroux.

Rieff, P. (1966). *The triumph of the therapeutic.* New York: Harper & Row.

Rorschach, H. (1942). *Psychodiagnostik.* (H. H. Verlag, Trans.). Bern: Bircher. (Original work published 1921).

Rouget, G. (1985). *Music and trance*. Chicago: University of Chicago Press.

Rycroft, C. (Ed.). (1968). *A critical dictionary of psychoanalysis*. New York: Basic Books.

Sayers, J. (2007). *Freud's art—psychoanalysis retold*. London: Routledge.

Schachtel, E. G. (1941). "The dynamic perception and the symbolism of form — with special reference to the Rorschach test." *Psychiatry, 4*, 79–96.

Schachtel, E. G. (1966). *Experiential foundations of Rorschach's test*. New York: Basic Books.

Segal, R. A. (2004). Introductory essay. In O. Rank, *The myth of the birth of the hero* (pp. vii–xxxviii). Baltimore: Johns Hopkins University.

Shapiro, D. (1965). *Neurotic styles*. New York: Basic Books.

Shapiro, M. (1964). "Movement and expression in art." *The Creative Process, 4*(1), 16–24.

Sharf, R. S. (2004). *Theories of psychotherapy & counseling* (3rd ed.). Pacifific Grove, CA: Brooks/Cole — Thomson Learning.

Singer, J. K. (1972). *Boundaries of the soul*. New York: Anchor.

Smith, E. W. L. (1975). "The role of early Reichian theory in the development of Gestalt therapy." *Psychotherapy: Theory, Research and Practice, 12*(3), 268–272.

Smith, E. W. L. (1985). *The body in psychotherapy*. Jefferson, NC: McFarland.

Smith, E. W. L. (1997). "The roots of Gestalt therapy." In E. W. L. Smith (Ed.), *The growing edge of Gestalt therapy* (pp. 3–36). Highland, NY: Gestalt Journal.

Smith, E. W. L. (2003). *The person of the therapist*. Jefferson, NC: McFarland.

Smith, E. W. L. (2007). "Art, artists, and the Gestalt approach: An introduction." *International Gestalt Journal, 30*(2), 1–26.

Sterba, R. F. (1982). *Reminiscences of a Viennese psychoanalyst*. Detroit: Wayne State University.

VandenBos, G. R. (Ed.). (2007). *APA dictionary of psychology*. Washington, DC: American Psychological Association.

von Franz, M. L. (1964). "The process of individuation." In C. G. Jung (Ed.), *Man and his symbols* (pp. 157–254). New York: Dell.

von Franz, M. L. (2000). *The problem of the puer aeternus*. Toronto: Inner City Books.

von Unwerth, M. (2005). *Freud's requiem*. New York: Riverhead.

Wadlington, W. (2001). "Otto Rank's art." *The Humanistic Psychologist, 29*(1–3), 280–311.

Wolman, B. B. (1960). *Contemporary theories and systems in psychology*. New York: Harper & Brothers.

Zubin, J., L. D. Eron, and F. Schumer (1965). *An experimental approach to projective techniques*. New York: Wiley.

Index

185

Printed in the USA
CPSIA information can be obtained
at www.ICGtesting.com
LVHW041939251123
764838LV00004B/827